Judy Chicago

An American Vision

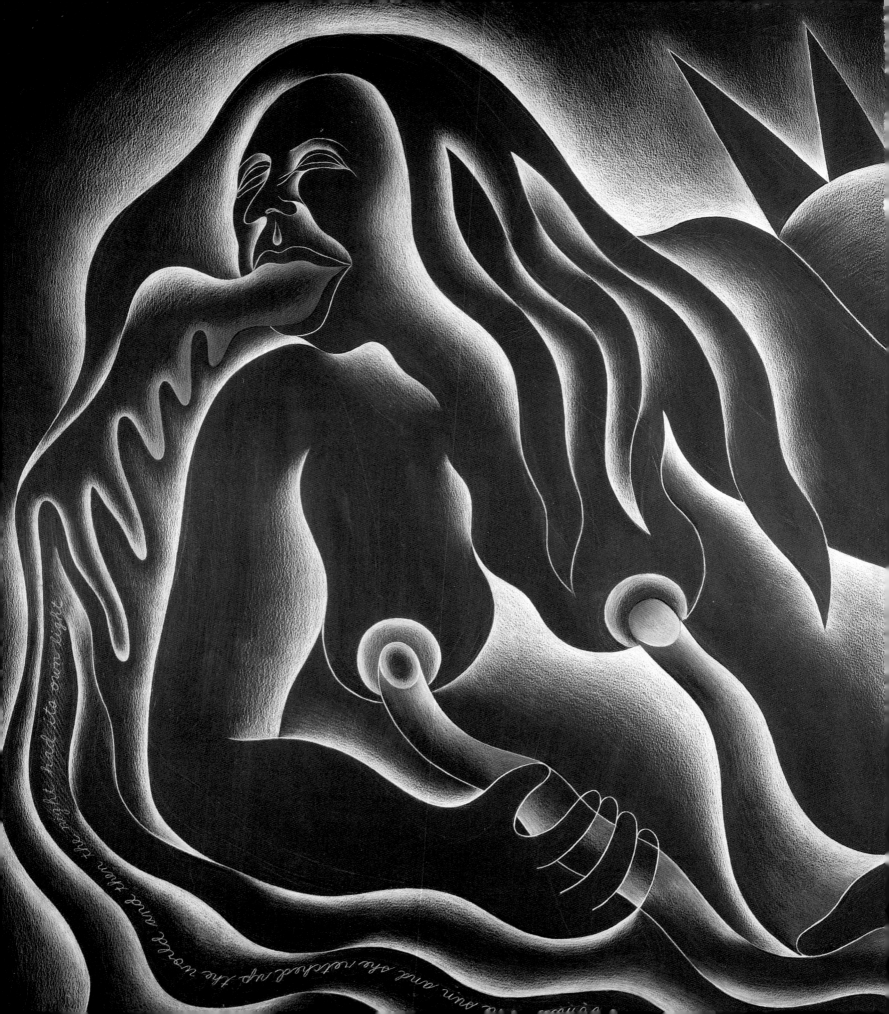

Judy Chicago

An American Vision

EDWARD LUCIE-SMITH

Watson-Guptill Publications

New York

First published in the United States in 2000 by

WATSON-GUPTILL PUBLICATIONS

a division of BPI Communications, Inc.,
1515 Broadway, New York, NY 10036

Art Director: *Peter Bridgewater*
Editorial Director: *Denny Hemming*
Managing Editor: *Anne Townley*
Designer: *Angela Neal*
Senior Project Editor: *Rowan Davies*
Editor: *Lindsay McTeague*
Picture Researcher: *Liz Eddison*

Library of Congress Cataloging-in-Publication Data
Lucie-Smith, Edward.
 Judy Chicago: an American vision/Edward Lucie-Smith.
 p. cm.
 Includes index.
 ISBN 0-8230-2585-3
 1. Chicago, Judy, 1939—Criticism and interpretation. I. Chicago, Judy,
 1939- II. Title.
N6537.C48 L83 2000
709.2–dc21
 99-055367

ISBN: 0-8230-2585-3

This book was conceived, designed, and produced by

THE IVY PRESS LTD

The Old Candlemakers, West Street, Lewes
East Sussex BN7 2NZ England

This book is set in Helvetica Light 9/18
Reproduced and printed in China
by Hong Kong Graphic and Printing Ltd

First printing, 2000

• Front cover illustration: *Female Rejection Drawing #3 (Peeling Back)*,
Judy Chicago, 1974. Collection: San Francisco Museum of Modern Art,
San Francisco, California.
• Back cover illustration: One-third scale clay maquette for *Find It in Your
Heart*, 1999. Collection: The artist.
• Frontispiece: Detail from *And Then There Was Light*, Judy Chicago, 1982.
Collection: Weisman Foundation, Los Angeles, California.

1 2 3 4 5 / 04 03 02 01 00

Contents

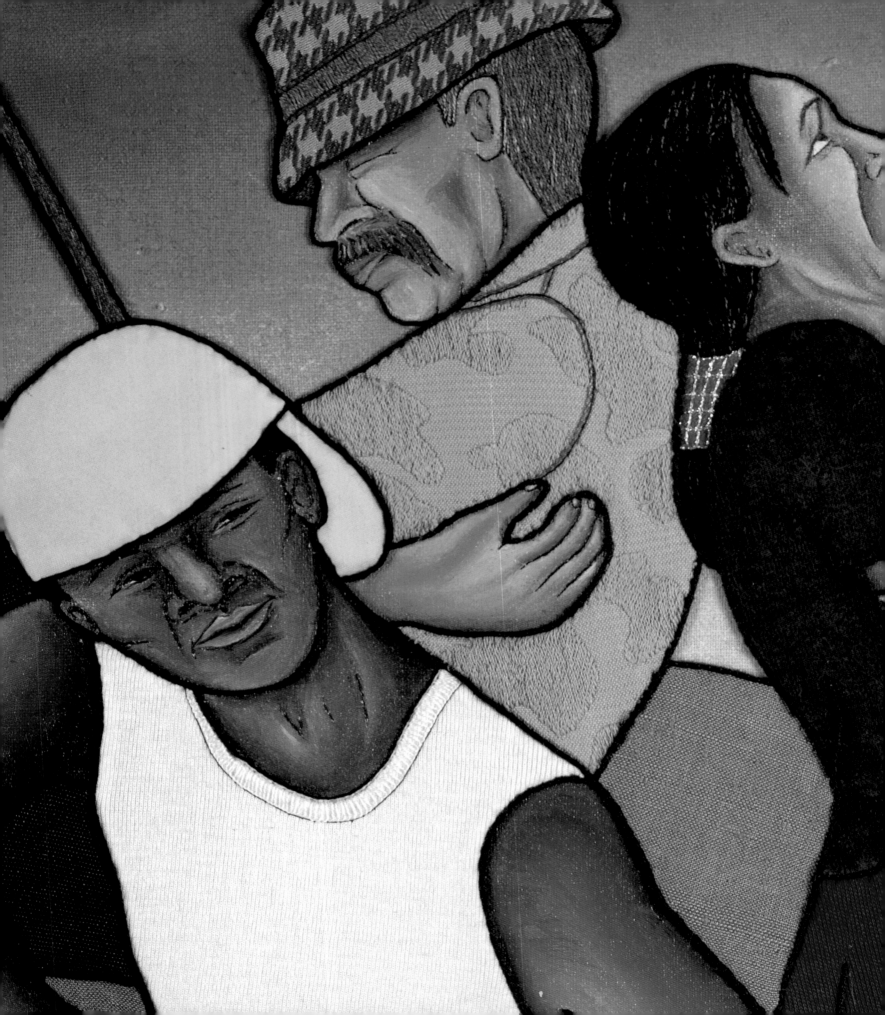

Introduction

Judy Chicago is one of the best-known, but also one of the most controversial, artists now working in the United States. Her celebrity stretches well beyond the boundaries of what is commonly known as "the art world," just as it stretches beyond the borders of her own country—this despite the fact that, unlike a number of other American artists of equal or even lesser reputation, she has received little official help in establishing her work abroad. Nevertheless, she crosses both intellectual and physical boundaries. Because of her status as a feminist icon, she is revered by many women throughout the world who do not count contemporary art among their primary interests. Part of this fascination

Detail from
We're All in the Same Boat
from Resolutions: A Stitch in Time, *1999.*
Painting, appliqué, embroidery, and smocking, needlework by Mary Ewanoski, assisted by Jacquelyn Moore; 22in x 28in (56cm x 71cm). Collection: The artists.

springs not simply from the impact made by her art but also from that of her two volumes of autobiography: *Through the Flower: My Struggle as a Woman Artist*, first published in 1975; and *Beyond the Flower: The Autobiography of a Feminist Artist*, published in 1996. This present book, the first fully illustrated survey of her entire career, is an attempt to give a coherent account of what is, by any standards, an incredibly productive life in art. It is also an attempt—written by a male, European critic—to locate Judy Chicago's work both within the story of North American art and within the parameters set by the development of late 20th-century art as a whole. It is a book that asks the reader to look at Chicago as an artist—because art, after all, has been her primary activity throughout her life—not simply as someone who has been conspicuously active in the feminist movement. Judy Chicago would, I think, be the first to say that her art is addressed to everyone, not only to members of her own gender.

There are some qualifications to this statement. From the early 1970s onward, feminism is a pervasive aspect of her work. This needs to be emphasized for several reasons. During the early 20th century, the most influential guides for art theoreticians—indeed for critics in all the arts—were Karl Marx (1818–83), Friedrich Nietzsche (1844–1900), and Sigmund Freud (1856–1939). All of them were born in the 19th century. All, it is reasonable to say, had 19th-century attitudes to women, assigning them a permanently inferior status, in terms both of intellect and creativity.

The first protests against these attitudes had already been made by the time the first of them—Marx—was born. The pioneer feminist Mary Wollstonecraft (1759–97) published her *Vindication of the Rights of Women* in 1792 (it was inspired by Thomas Paine's *Rights of Man*, published the previous year). However, the evolution of a fully developed feminist theory did not take place until more than a century and a half after its publication. One of the first signs of the emergence of a new feminist discourse was the publication, in 1949, of *The Second Sex* by Simone de Beauvoir (1908–86). It was followed, in 1963, by the publication of Betty Friedan's *The Feminine Mystique* and by the foundation, in 1966, of the National Organization for Women (NOW). The emergence of an active feminist movement in the United States provided the context within which Judy Chicago's art evolved.

The rebirth of feminism in the United States led to the rapid evolution of new theories of art. Many of these new feminist theories were founded on a reinterpretation of French Structuralist philosophy, as elaborated by Claude Lévi-Strauss (b. 1908), Roland Barthes (1915–80), Jean Baudrillard (b. 1929), and others (Baudrillard, however, is not particularly friendly to feminism; see GAME, 1993, PP. 47 AND 152). Structuralism saw human society as a complex pattern of structural relationships, in which each element affected all the others, though

not always in the most immediately obvious way. As feminist art theory was expounded by a series of distinguished women critics, quarrels arose between commentators and practitioners. Chicago's work was identified by commentators, favorable and unfavorable alike, with what was called an "essentialist" position—with the belief that women were essentially different in some important respects from men, rather than being forced into difference by social constraints.

The differences are explored in one of the most recent publications on Judy Chicago's work—*Sexual Politics: Judy Chicago's "Dinner Party" in Feminist Art History* (a collection of essays edited by Amelia Jones), published in conjunction with a 1996 exhibition at the Armand Hammer Museum of Art and Cultural Center in Los Angeles, that explored the same theme. Fascinating as many of these studies are, it is my contention that they have tended to illuminate important aspects of Chicago's achievement while obscuring others. Among the things I would like to consider, in addition to Chicago's feminism, are her position as a peculiarly North American artist and her role as a pioneer of postmodernism. One also needs to consider topics such as her attitudes to collaboration and her attempts to redefine and reposition the boundaries between "high art" and "craft." And, finally, one needs to look at her

Frederic Edwin Church
(1826–1900)
The Iceberg
1891.
Oil on canvas;
20in x 50in (50.8cm x 76.2cm).
Collection: Carnegie Museum of
Art, Pittsburgh, Pennsylvania.
(above)

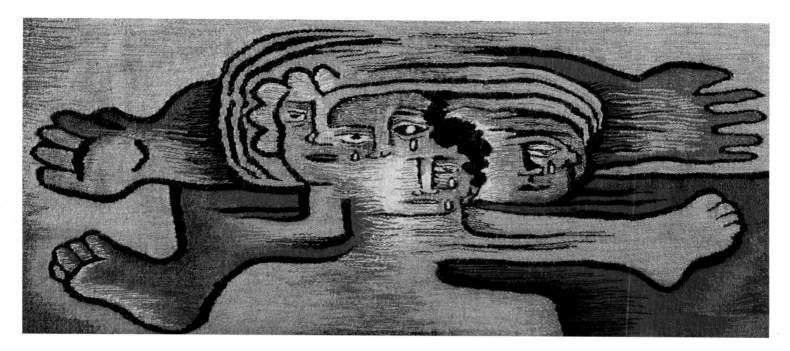

use of visual artworks as vehicles for conveying moral and social statements. This is an area where 20th-century art seems to have come full circle, first rejecting moral content as Victorian, then, in the last three decades of the century, reverting to moral issues once again, sometimes with more enthusiasm than discretion.

These issues will arise naturally, for the most part, in the course of the body of the book, but the first two at least—Chicago's North Americanism and her postmodernism—need to be looked at immediately here. North Americanism, in particular, is a quality that it is perhaps easier for an outsider to locate and define.

When I look at Chicago's work, which predecessors most immediately come to mind? One name is not unexpected—that of Georgia O'Keeffe (1887–1986)—not merely because she was the foremost woman painter in the United States during her lifetime but also because of the evident links between some of her "flower" imagery and that used by Chicago, although O'Keeffe tended to deny that her flowers had sexual connotations. The other two names may be less expected—Frederic Edwin Church (1826–1900) and Thomas Hart Benton (1889–1975). Church is generally regarded as a Romantic, but he was much more than that. His panoramic landscapes of the Andes were tributes to the power of nature as well as assertions of his own ability to undertake projects beyond the reach of any other artist of his time. Chicago resembles him not only in her reverence for natural forces and in her feeling that there are ethical lessons to be learned from them, but also in her confidence in her own ability to carry through projects beyond the reach of most of her peers and in her conviction that art still offers a viable means of making public statements about things that concern the whole community.

The resemblance to Benton is closer, and perhaps even more surprising. Benton rebelled against the orthodox modernism of his time, as well as against the constrictions the New York art world attempted to impose on him. He went back to the North American heartland to paint vast murals in which American achievements and the American

way of life were celebrated. In many ways he was Chicago's opposite—isolationist, conservative, and male chauvinist. Yet as much links them as divides them. Both are self-made artists—creators who developed a new image concerning the artist's status and the nature of his or her activity because none of the available stereotypes seemed to fit. Both throw a great deal of material into the work, some only partially digested. Both prepare their big enterprises in a meticulous and strikingly traditional way, making numerous preliminary drawings, for example. (There is, in fact, a close stylistic resemblance between some of Benton's drawings of the human figure and some of Judy Chicago's.) Both make use of "high" and "low" forms—in this respect one can cite Benton's frequent use, in his murals, of compositional formats derived from the interlocking frames of popular strip cartoons.

Another artist who reinvented modernism to serve new political and social purposes was Diego Rivera

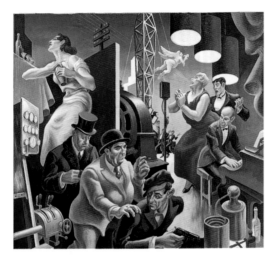

(1886–1957). Here, too, one can see certain resemblances to Chicago's activity—notably the effort to reshape art to serve the purposes of a different society. In some of Chicago's more private works, such as her little-known notebook drawings, there are also strong resemblances to work done by Rivera's wife, Frida Kahlo (1907–54). The fact that Chicago emerged not from the New York art scene but from California may have something to do with her need to remake art, and at the same time remake herself as an artist.

This may also have something to do with her particular variety of postmodernism. Until the 1960s—the epoch when Chicago herself first began to exhibit—California was always considered to be stronger in the crafts than it was in painting or sculpture. In the 1950s, distinguished Californian painters like Sam Francis (1923–94) had to make their reputations elsewhere—Francis lived and worked in Paris from 1950 to 1957. As a result, there was a

Thomas Hart Benton
(1889–1975)
Arts of the City
(Detail) 1952.
Tempera with oil glaze;
8ft x 22ft (2.44m x 6.7m).
Collection: New Britain
Museum of American Art,
New Britain, Connecticut.
(above)

less stringent division between different forms of art making. Chicago took advantage of this to explore quasi-industrial materials such as spray paint and molded fiberglass, as well as rediscovering skills identified as "feminine," such as china painting and embroidery. Her definition of art was formed not by the technique used, and its position within an established hierarchy of activities, but by the artist's intention. If the intention was to make art, any technique was legitimate. This assertion lies at the very roots of postmodernism. Equally postmodern is Chicago's inclination toward the decorative. A number of younger artists, among them Lari Pittman (b. 1952), one of the leaders of the present-day Californian school, have paid tribute to her influence over them in this respect.

Everyone Was Going to
See Who She Really Was
from Autobiography of a
Year. *1993–94.*
Mixed media on Magnani paper;
15in x 11in (38cm x 28cm).
Collection: The artist.
(right)

Chicago's work is sometimes criticized as being inherently kitsch, an accusation that springs largely from her use of decorative elements, which are anathema to modernist critical doctrine. In fact, she employs these supposedly kitsch elements for complex reasons. Like Jeff Koons (b. 1955), she manipulates our feelings about demotic artifacts. In addition, and far more often, she uses images that may be thought of as kitsch simply because they are appropriate—the most direct way of saying what she wants to say. If she has a grievance against what she thinks of as "masculinist" art, it is to be found in its denial of basic human emotions.

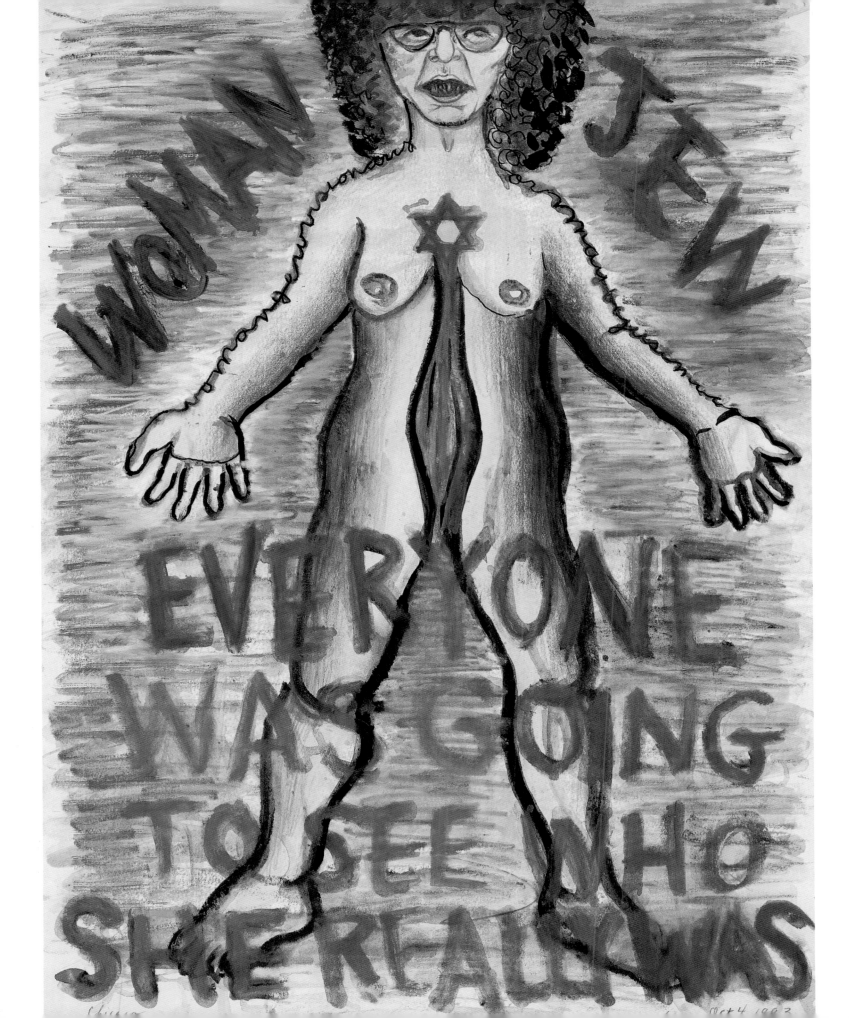

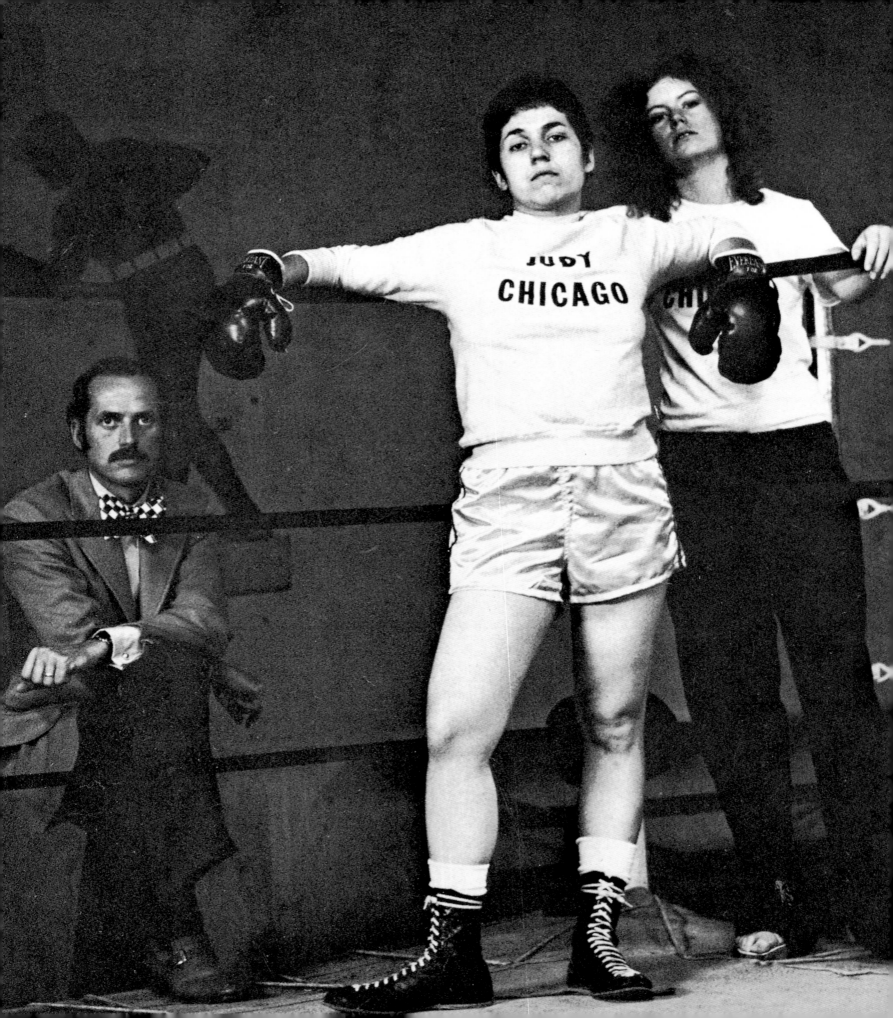

Chapter One

From Free Spirit to Male Drag

Judy Chicago was born Judy Cohen in 1939, to a Chicago-based Jewish family with little religious background. Her father was a union organizer, and her mother also worked throughout Chicago's childhood. Chicago remembers that she first began to draw when she was about three years old.

"My mother, who had wanted to be a dancer, gave me a lot of encouragement. She told me many stories about her life prior to her marriage, when she went to the Jewish People's Institute and mingled with musicians, poets, and other creative people. Throughout my childhood, she told me colorful tales about the creative life, particularly when I was sick in bed, and these stories contributed to my developing interest in art, for, from the time when I was young, I wanted to be an artist. My father, on the other hand, could never relate to my artistic impulse, so it was to my mother that I brought my artistic achievements and to my father that I brought my intellectual ones."

CHICAGO, 1975; PP. 3–4

She remembers that it was her father who, by devising games for her and asking her questions, trained her in logic and mathematics and who gave her a sense of human values. She also remembers that because her mother worked, and because women—among them aunts and cousins—participated fully in the discussions that went on in the household, she "grew up with a sense that I could do what I wanted and be what I wanted."

Detail from
Announcement in *Artforum* for Jack Glenn Gallery
(Judy Chicago solo exhibition), 1971.

Professional Beginnings

In 1947, she began to go to art classes at the Art Institute of Chicago, attending every Saturday. Aged nine, she switched to junior school, where the classes were smaller, and continued until she was eighteen. The training she received was a classical one—she made still-life studies, drew from the model, and went to the nearby Field Institute to study human and animal bones. By the time she was ten she had come under the influence of her most important teacher there, Emmanuel Jacobsen. He encouraged her

Childhood drawing (landscape)
1945.
Fingerpaint on paper;
15in x 19in (38cm x 48cm).
Collection: The artist.
(right)

without stunting her growth with too much criticism: "He had a thing that you shouldn't do any critiquing of children's work till they got into high school" (INTERVIEW, JANUARY 1999). At the Chicago opening of *The Dinner Party* in 1979, she met Jacobsen again (he was by that time an old man) and gave him a personal tour. He moved her greatly by saying, "I always knew you were going to do something important" (INTERVIEW, JANUARY 1999).

The Art Institute's superb collection, particularly of impressionist and post-impressionist works, had as big an impact on Chicago as the classes themselves. She recalls that on those Saturdays,

"Time was quite different. I came out of there at 3pm feeling that all my senses were open."
INTERVIEW, JANUARY 1999

The major sadness of these years was her father's untimely death in 1953. It happened shortly after they had had an intense talk about his political beliefs. McCarthyism was at its height, and he revealed that he was in fact one of those left-wingers whom McCarthy taught everyone to hate:

"My adolescence was spent in a repressed, painful confusion, trying to make sense out of what had happened, trying to reconcile the wonderful, generous father I loved with the terrible word 'Communist,' which, in 1953, had all the connotations of the devil."
CHICAGO, 1975; P. 11

When Judy Chicago applied to go to college, the Art Institute itself was naturally her first choice, and she felt confident that she would receive a scholarship there. The scholarship did not materialize and she was bitterly disappointed by this failure. However, she had also put herself down for the University of California at Los Angeles. She was accepted there and she had a scholarship from her high school that could be applied anywhere. Under the influence of the daughter of one of her mother's old friends (the daughter lived in Los Angeles but had arrived in Chicago for a visit), she decided to pack up and go. California proved to be a liberating experience in more than one respect:

"I was having a wonderful time, going to folk music concerts, NAACP [National Association for the Advancement of Colored People] dances, riding round on the backs of motor scooters, drawing, painting, and doing well in school."
CHICAGO, 1975; P. 16

"I felt that I could be what I wanted. The purpose of life was to make a contribution."
INTERVIEW, JANUARY 1999

Untitled
(from sketchbook), 1960.
Collage;
14in x 10½in (36cm x 25cm).
Collection: The artist.
(above)

It was at this point that she met the man who was to become her first husband, Jerry Gerowitz:

"Jerry was extremely gifted and completely undirected. He wandered from job to job, lived on unemployment, borrowed money from his parents, or gambled and won. He was brilliant and witty and terribly self-destructive, and I tried again and again during the next two years to break up with him, but I kept going back. If Leslie [her first lover] bore a vague physical resemblance to my father, Jerry was his intellectual reflection, and I couldn't seem to stop myself becoming involved with him."
CHICAGO, 1975; P. 18

In 1959, Judy Chicago's mother and brother decided to move to California, but Chicago continued to pursue an independent life. Jerry gambled their remaining funds and lost. They decided to hitchhike their way across the country and spent some time in New York. They lived there for a year, and some of Chicago's earliest surviving works date from this period. A notebook filled with

Mother Superette
1963.
Acrylic on paper;
19½in x 26in (48cm x 66cm).
Collection: Elizabeth A. Sackler,
New York, New York.
(left)

**Lavender and
Yellow Sculpture**
1963–64.
Acrylic on plaster;
14in x 8in x 4in
(36cm x 20cm x 10cm).
Collection: Unknown.
(below)

collages and drawings shows her strongly under the influence of the abstract impressionist movement, then drawing to a close. The collages show little interest in color, and their abstraction is not complete—there is also a landscape element. Probably the New York School artist whose work they most resemble is Arshile Gorky (1904–48), who had already been dead for more than ten years. There is also a link, through the use of small fragments of cloth, to the work of European abstractionists such as the Italian Alberto Burri (1915–95). In neither case is the resemblance especially close.

When their year in New York was up, Judy and Jerry decided to return to California. Judy reenrolled at UCLA and now, for the first time, she began to encounter resistance to her work from the male professors in the painting department. One professor, confronted with the acrylic on paper *Mother Superette*, made the disgusted comment that "it looks like breasts and wombs" (INTERVIEW, JANUARY 1999). Her reaction to this was to shift toward making sculpture because the teacher of sculpture, Oliver Andrews, wasn't prejudiced against women. He offered to make her a teaching assistant in sculpture if she came into the sculpture program, and she accepted, not knowing how unusual it was for a woman to be offered a post of this type. After a number of breakups and reconciliations, she and Jerry had finally

Untitled
1963.
Acrylic on paper.
Collection: Unknown.
(above top)

Arshile Gorky
(1905–48)
Garden in Sochi
1941.
Oil on canvas;
3ft 8in x 5ft 2in
(1.12m x 1.58m).
Collection: The Museum of
Modern Art, New York,
New York.
(above)

married in the spring of 1961. They were now both in therapy, trying to work through the problems that had made their relationship such a stormy one. One morning, in June 1963, Jerry left for a therapist's appointment, driving the car they had recently bought. He never returned, but was killed instantly as the car went over a cliff. Judy Chicago says, describing the day of Jerry's funeral:

"I knew that day about death, but I knew about it in a grown up way. My father had become my husband, and I had lost them both. Jerry's death gave me my father's death and for a year and a half I grieved. My friends moved me into a big green house at the beach, and I turned to my work as my refuge and my salvation and as the one thing in life that I could never lose."
CHICAGO, 1975; PP. 26–27

One of the images made as part of this grieving process was *Bigamy*, which, in its use of symbolic forms, shows many resemblances to much later work. In her autobiographical memoir *Through the Flower*, Judy Chicago describes its content thus:

"[It] held a double vagina/heart form, with a broken heart below and a frozen phallus above. The subject matter was the double death of my father and husband, and the phallus was stopped in flight and prevented from uniting with the vaginal form by an inert space."
CHICAGO, 1975; P. 33

But *Bigamy*, with its strictly symmetrical, frontal format, seemed at the time to point in a somewhat different direction from the one Chicago's work ultimately took—toward the newly emergent "Fetish Finish" school of California art.

Until the 1960s, San Francisco had seemed the preeminent Californian art city—the place to which artists migrated to live and work. The volatile commercial culture of Los Angeles did not seem a good place for artists to try to root themselves. This changed with the rise of the Pop sensibility. Though Pop was originally a New York phenomenon, many of the things that most fascinated the new generation of US artists—from near-nude pinups to flashy cars—were more naturally at home in California than they were in New York. Even more than the new art stars associated with New York, the new generation of southern California painters and sculptors was marked by its swaggering machismo:

Bigamy
1963.
Acrylic on Masonite;
8ft x 4ft (2.4m x 1.2m).
Now destroyed.
(left)

Billy Al Bengston
(b. 1934)
Clint
1961.
Polymer and lacquer on Masonite;
4ft x 3ft 10in (1.22m x 1.18m).
Collection: The artist.
(below)

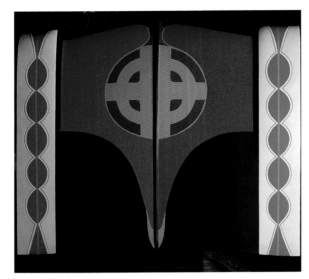

Carhood
1964.
Sprayed acrylic lacquer
on carhood;
4ft x 6ft (1.2m x 1.8m).
Collection: Rad and Elaine
Sutnar, Los Angeles, California.
(above top)

Cubes and Cylinders
1967.
Gold-plated stainless steel;
2in x 2in (5cm x 5cm) each.
Collection: Lanhan Foundation,
Santa Fe, New Mexico.
(above)

"Halfway through my last year in graduate school, I became involved with a gallery run by a man named Rolf Nelson. He used to take me to the artists' bar, Barney's Beanery, where all the artists who were considered 'important' hung out. They were all men, and they spent most of their time talking about cars, motorcycles, women, and their 'joints'... They made a lot of cracks about my being a woman and repeatedly stated that women couldn't be artists. I was determined to convince them, as I had convinced the men at school, that I was serious. In an effort to be accepted, I began to wear boots and smoke cigars. I went to the motorcycle races and tried to act 'tough' whenever I saw them."
CHICAGO, 1975; P. 35

There were, however, some other, more artistically significant, aspects to this association. The California school was interested, far more than its New York counterpart, in new industrial techniques, especially in those that could be used to give the artwork an immaculate finish, which seemed to put it on the same footing as a high-quality manufactured object. Like her male contemporaries, Judy Chicago was fascinated by this aspect of the new art. After finishing college, she decided to go to auto body school in order to learn to spray paint. She was the only woman among 250 men. She commented later:

"I learned quite a bit that was actually beneficial to me as an artist, the most important being an understanding of the role of craft. I had never actually seen artmaking in terms of 'making an object,' and learning this concept improved my work."
CHICAGO, 1975; P. 35

One direct product of going to auto body school was the painting *Carhood*.

"The vaginal form, penetrated by a phallic arrow, was mounted on the 'masculine' hood of a car, a very clear symbol of my state of mind at this time"
CHICAGO, 1975; PP. 36-37

Later, she was to go to boat-building school, in order to learn how to mold fiberglass, and later still, she was to apprentice herself to a maker of firework displays. Judy Chicago had now formed a new relationship, with the sculptor Lloyd Hamrol (b. 1937), whom she later married. In 1965, they moved to Pasadena. This marked

the beginning of a period when her work was at its most formal and abstract, in step with the prevailing Californian idiom of the time. Her work, as she notes, fell into opposing categories:

"My pieces were either very small and rearrangeable, which made the viewer huge in relation to them, or were large simple pieces that one walked through and was dwarfed by. In my studio, I was large and able to manipulate my own circumstances; in the world, I was small and could get lost in values and attitudes that were hostile and foreign to me."
CHICAGO, 1975; P. 43

She began working on the problem of color in her sculptures and achieved considerable recognition with pieces like *Rainbow Picket*. It was shown at the important "Primary Structures" show held at the Jewish Museum, New York, in 1966, where Clement Greenberg, perhaps the most influential US critic of the period, singled it out as one of the best works in the exhibition.

She was still, however, looking—if only subliminally—for forms that would in some way express the concept of "femaleness." This led her to consider using dome shapes for her sculptures—domes that would be basic emblems of female fecundity. The *Domes* were made of clear acrylic, sprayed on their inner surfaces with successive layers of acrylic lacquer. This gave both transparency and luminosity, and a complete fusion of color and surface. The female aspect of the *Domes* was not brought fully home to her until another woman artist visited her studio:

"She looked at the *Domes* and remarked scornfully, 'Oh, the Venus of Willendorf,' a reference to early female fetishes. I was devastated. It was one thing to approach issues about my own femaleness, no matter how indirectly. It was another to be identified as doing so."
CHICAGO, 1975; P. 53

The *Domes* triggered a return on Chicago's part to painting. The basic image that emerged was one in which the centers of the forms were hollow spaces. If the *Domes* could be read as breasts and bellies, then these forms could, of course, also be read in the same terms as abstract representations of the female physical core—of the cunt. The color systems that Chicago had painstakingly developed in

Detail from
10 Part Cylinders
Exhibited in "Sculpture of the 60s" exhibition, Los Angeles County Museum of Art, Los Angeles, California, 1966; Now destroyed. Fiberglass; 10ft x 20ft x 20ft (3m x 6m x 6m).
(below top)

Rainbow Picket
1965.
Exhibited in "Primary Structures" exhibition, Jewish Museum, New York, New York, 1966; Now destroyed. Plywood, canvas, and latex paint; 10ft 6in x 9ft 2in (3.2m x 2.8m).
(below)

relation to the *Domes* were now even further refined so that they could be perceived clearly by the viewer as representations of various emotional states. She entitled the 15 paintings that emerged from this exploratory process *Pasadena Lifesavers* (1969–70). They were sprayed onto the back of clear acrylic sheets, with a sheet of white Plexiglas placed behind the clear sheet. There were five images, painted in three different color series. Thirty years later, Judy Chicago now thinks of them as

"a first step in my struggle to bring together my point of view as a woman with a visual form of language that allows for transformation and multiple connotations."

CHICAGO, 1975; P. 57

Domes #1
1968.
Sprayed acrylic lacquer inside successive formed clear acrylic domes;
Base: 30in x 30in (76cm x 76cm); Each dome 5in x 10in (12.5cm x 25cm).
Collection: The artist.
(left)

Study for
Pasadena Lifesavers
1968 (from 1967–70 sketchbook).
Prismacolor on paper;
4 studies: 15in x 15in (38cm x 38cm) each.
Collection: The Capital Group of Companies, Inc., Los Angeles, California.
(left)

Pasadena Lifesavers Yellow #3
1969–70.
Sprayed acrylic lacquer on acrylic; 5ft x 5ft (1.5m x 1.5m).
Collection: Unknown.
(right)

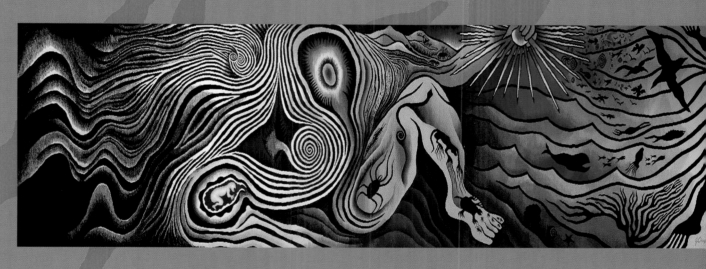

The Creation

1984.

Modified Aubusson tapestry,

weaving by Audrey Cowan;

3ft x 14ft (0.91m x 4.27m).

Collection: Bob and Audrey Cowan,

Santa Monica, California.

See Birth Project, pages 80–99.

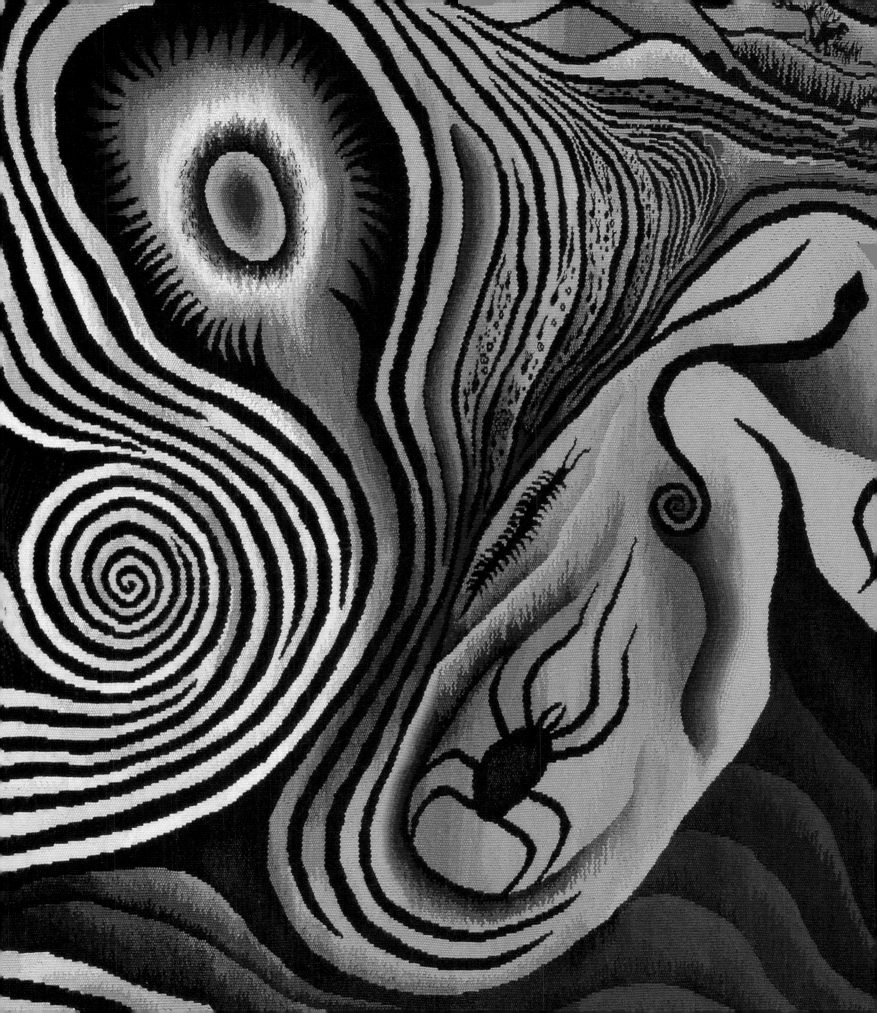

"When I scrutinized the art-historical record, I was shocked to discover that there were almost no images of birth in Western art, at least not from a female point of view. I certainly understood what this iconographic void signified: The birth experience was not considered important subject matter, not even to women."

CHICAGO, 1980

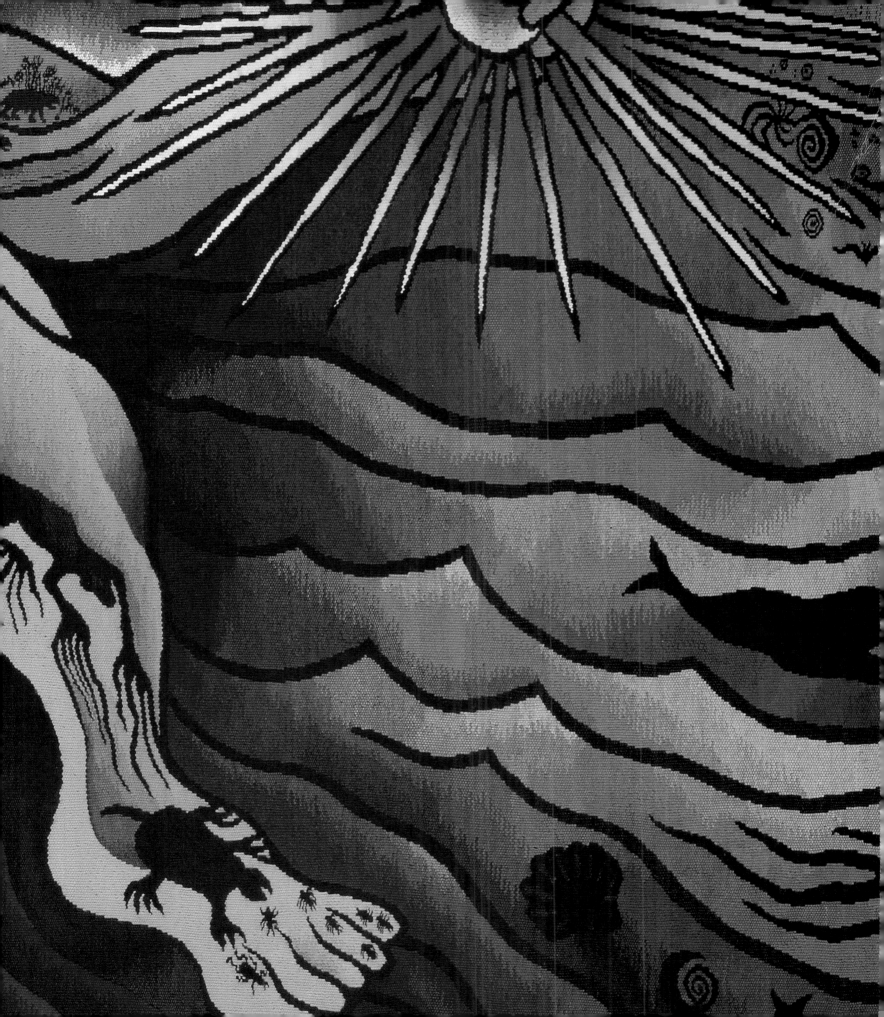

In 1971, she was to use the techniques she had evolved for the *Pasadena Lifesavers* for further series of large-scale paintings, among them the *Fresno Fans* (1971), which are 5ft x 10ft (1.5m x 3m), and *Sky Flesh*, from the *Fleshgardens* series. Judy Chicago made these paintings while she was teaching the pioneering Feminist Art Program at Fresno (led by Judy Chicago and Miriam Shapiro at the California Institute of the Arts) and they were, as she says,

"attempts to fuse flesh and landscape references."
CHICAGO, 1996; P. 24

Made just as Chicago's career was taking an entirely new direction, these hugely outwardly self-confident works represent a high point in the development of the "Fetish Finish" Californian school, exemplifying all the aesthetic qualities the artists of the group seemed to strive for. Yet they also strike me as being much less important to Chicago's own development than the *Lifesavers* had been.

In 1971, Judy Chicago held a major show of new work, including the *Domes* and the *Pasadena Lifesavers*, at the California State College at Fullerton. She decided the moment had come for a change of name. Up to this point she had been exhibiting under the name of Judy Gerowitz. Her original Los Angeles dealer, Rolf Nelson, had nicknamed her Judy Chicago because of her distinctive Chicago accent, and this had already become a kind of "underground" designation. She decided that this would be her new official name, borrowing something, in this casting off of her first husband's name, from the way in which the Black Panthers had changed their names to others not associated with slavery. She put an inscription on the wall directly across from the entrance to the show. It read:

"Judy Gerowitz hereby divests herself of all names imposed upon her through male social dominance and freely chooses her own name Judy Chicago."
CHICAGO, 1975; P. 63

An announcement for the exhibition, sent out by the Jack Glenn Gallery, offers a portrait of the artist in a boxing ring. Published in *Artforum*, then perhaps the most influential magazine devoted to contemporary art in North America, it had a greater impact across the United States than the exhibition itself.

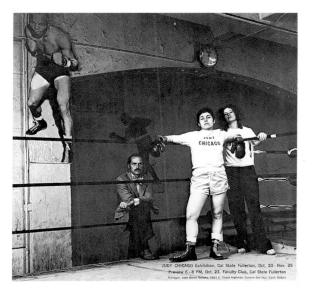

Announcement in *Artforum* for Jack Glenn Gallery
(Judy Chicago solo exhibition),
1971.
(above)

Sky Flesh
from Fleshgardens. *1971.*
Sprayed acrylic lacquer on acrylic;
8ft x 8ft (2.4m x 2.4m).
Collection: The artist.
(left)

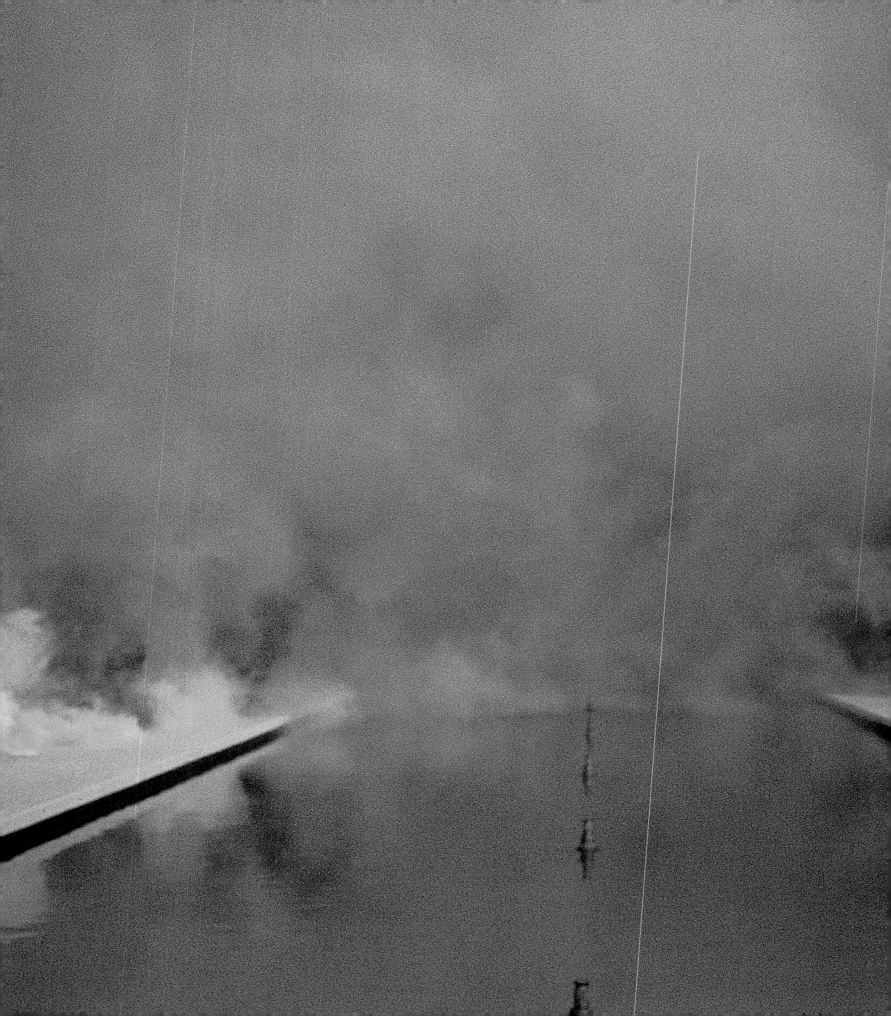

Chapter Two

Fireworks, Literal and Figurative

During the period when she was working on the *Domes* and the *Pasadena Lifesavers*, Judy Chicago became involved in a series of performance pieces called *Atmospheres*. They were not the first public events she had staged—an earlier example is the *Dry Ice Environment*, at Century City, Los Angeles, staged in collaboration with the sculptors Lloyd Hamrol and Eric Orr (1940–98). This was one of her earliest attempts to find public patronage—37 tons of dry ice was donated by the Union Carbide Company. It was also one of a number of endeavors undertaken with other artists during the 1960s, at a time when the cultural climate was perhaps uniquely favorable to enterprises of this sort. The *Atmospheres* had a more personal stamp. They were firework pieces in which, as Chicago saw it,

"The color inside the domes and the paintings was freed from the rigid structures in which it had been imprisoned and allowed to gush into the air."

CHICAGO, 1975; P. 57

As a result of her interest in making them, she decided to train as a licensed pyrotechnician with the only fireworks company on the West Coast that was capable of providing the devices she needed. However, the man who ran this company subjected her to increasingly severe sexual harassment, to the extent she was forced to give up her involvement with this form of expression, at least for a while.

Detail from
Multi-Colored Atmosphere
1970.
Fireworks;
Norton Simon Museum,
formerly the Pasadena Art
Museum, Pasadena, California.

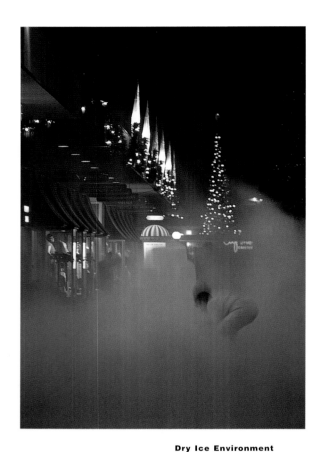

Dry Ice Environment
Judy Chicago, Lloyd Hamrol,
and Eric Orr, 1967.
Dry ice;
Century City Mall,
Los Angeles, California.
(above)

The Atmospheres

Like all events of their kind, the *Atmospheres* now exist only in photographs, but it is possible to trace a distinct progression in the way in which they evolved. A fairly late example of the first series, *Multi-Colored Atmosphere*, held in 1970 at what was then the Pasadena Art Museum (now the Norton Simon Museum), conforms closely enough, in its own way, to the color patterns already used in some of the *Domes*. The pool outside the museum building, used as an integral part of the event, emphasizes this cousinship, since its shiny reflective surface reacts with the intermingling hues in rather a similar fashion as the clear acrylic of the *Domes*. There is no specific feminist symbolism, though it was Chicago's intention, as she now describes it,

"to try to soften and feminize the environment."
INTERVIEW, MAY 1999

Later, when Chicago became publicly involved with the burgeoning feminist movement, the *Atmospheres* began to take on strongly feminist overtones. Examples are *Smoke Goddess V*, made on a beach near Los Angeles in 1972, and *Goddess with Flares II*, made at Fresno, California in the same year.

The last and most ambitious *Atmosphere* was *A Butterfly for Oakland*, performed at the Oakland Museum, as part of its "Sculpture in the City" show. While previous events of the same sort had been done on a shoestring budget, *A Butterfly for Oakland* required $2,500 worth of fireworks and the services of a large crew. It was performed on the shores of Lake Merritt at sundown and lasted for 17 minutes, during which time an enormous butterfly—an image Chicago had already turned into an emblem of the vagina and of female identity—came into being, erupted into brilliant color, and then died.

Compared with the sums required for some of the public art projects undertaken, then and later, by male artists, *A Butterfly for Oakland* was still a comparatively modest enterprise, despite its spectacular effect. Chicago says now that she would have been glad to continue with this aspect of her work had she been able to obtain the necessary commissions or the major financial backing that make such artworks possible. She was unable to do so, however, and had to enter the public sphere in a different and perhaps more lastingly effective fashion through *The Dinner Party* and the works that followed.

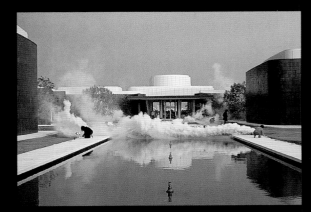

Smoke Goddess V
from Women and Smoke,
1972.
Flares;
outside Los Angeles,
California.
(below)

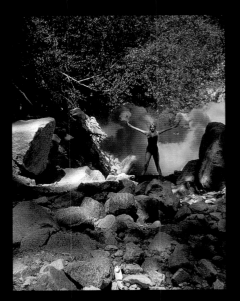

lti-Colored
nosphere
).
works;
ton Simon Museum,
erly the Pasadena Art
eum, Pasadena,
ifornia.
ove, right,
 below)

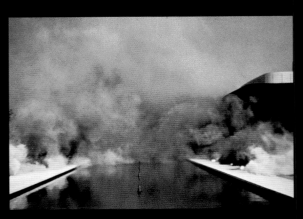

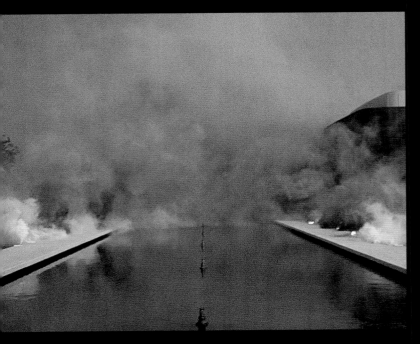

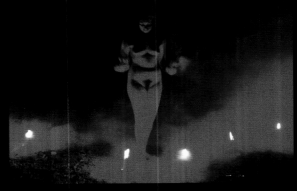

Goddess with Flares II
from Women and Smoke,
1972.
Flares;
Fresno, California.
(above)

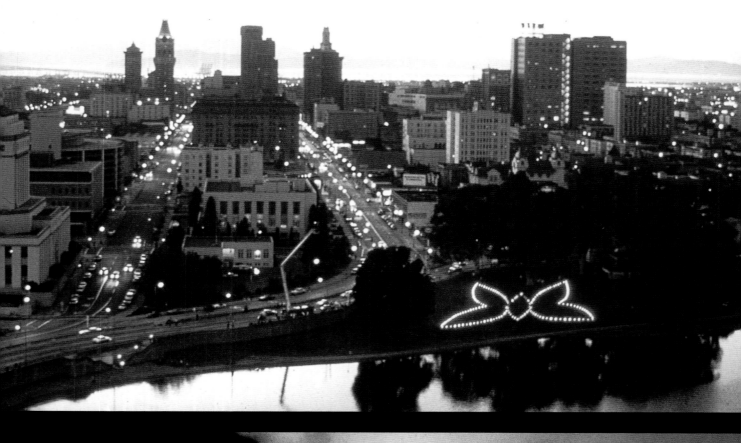
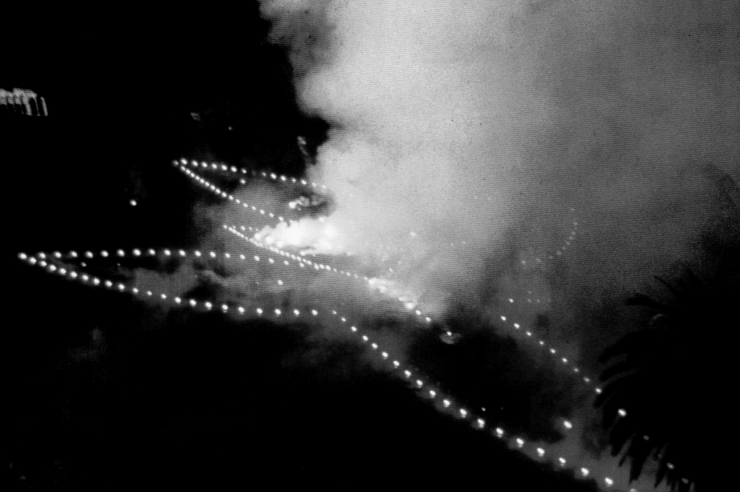

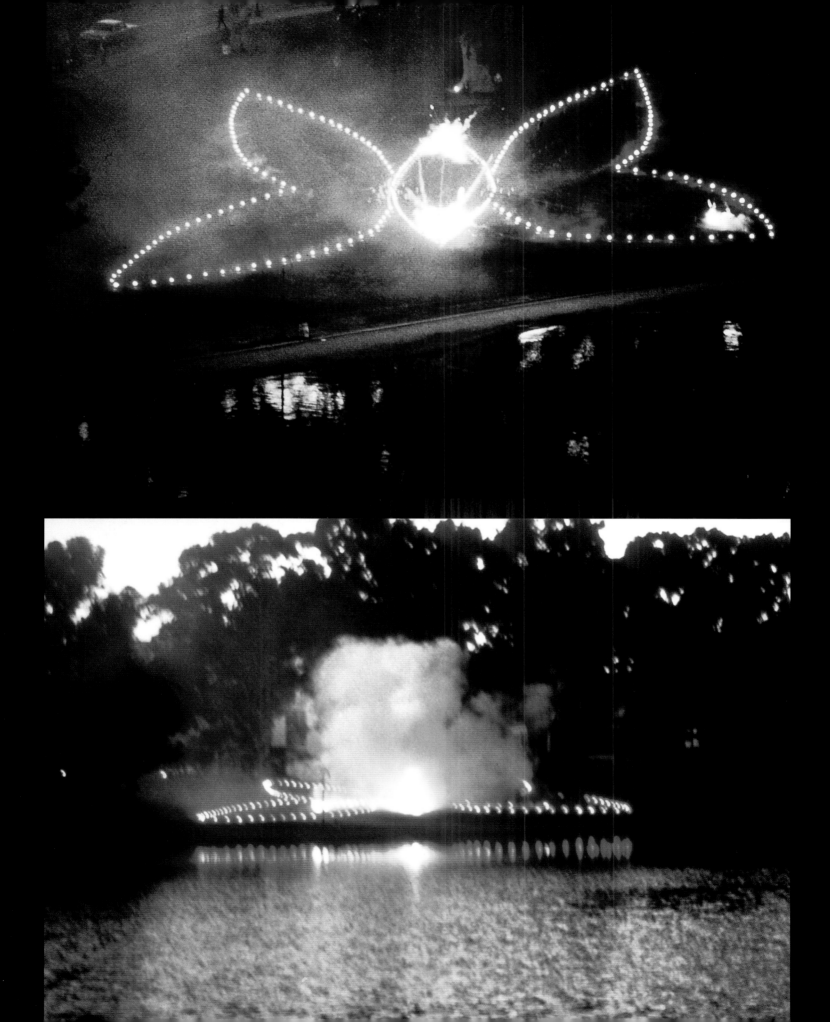

A Butterfly for Oakland
1974.
Fireworks, road flares,
and magnesium flares;
Oakland Museum of California,
Oakland, California.
(preceding pages)

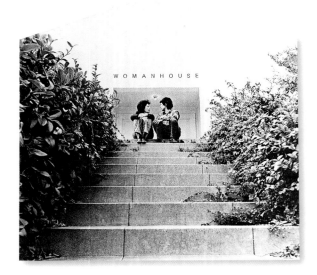

Judy Chicago with Miriam
Shapiro: catalog cover for
"Womanhouse," designed by
Sheila de Bretteville, 1972.
(above)

Cuntleaders
from the Feminist Art
Program, 1970–71.
Performance;
Fresno, California.
(right)

She had begun to read the literature created by the women's movement in the late 1960s. As she said later, she perused these writings

"with something akin to existential relief... [They] not only reinforced my belief that what I was facing amounted to blatant sexism, they also gave me the courage to speak out."
CHICAGO, 1996; P. 20

She gave her first public lecture about her "struggle as a woman artist" (the phrase is her own) at the home of Stanley and Elyse Grinstein, prominent Los Angeles collectors, cofounders of the print workshop Gemini G.E.L. and long-time patrons of her work. This took place in 1970, the year in which she began to teach the Feminist Art Program in Fresno, California. The experience in Fresno, and later at the California Institute of the Arts, working in collaboration with Miriam Shapiro, inevitably led her in the direction of performance and environmental works.

The function of these performance and environmental works was partly cathartic and therapeutic (that is, their importance lay in what they did for the performers and makers themselves) and partly didactic (that is, they spelled out aspects of the female experience for audiences who had never seen these issues raised in so clear and vehement a form). In addition, they marked a direction that feminist art in general was to take because of its dislike of traditional forms, such as painting and sculpture, which were perceived as patriarchal. It is interesting to note that, during her long career, Judy Chicago has on the whole tended to stand apart from this tendency—this period in the early 1970s was the only epoch when she was closely linked to it. She has preferred to create works that are not ephemeral and that have an independent, objective existence, apart from the artist herself. One reason for this is her concern about what she describes as the consistent "erasure" of women's work from the history of art (INTERVIEW, JANUARY 1999). However, she acknowledges the importance of performance as a means of unlocking feelings.

"One of the reasons that [it] proved to be so important in the [Fresno] program is that it provided a release for debilitating, unexpressed anger, thereby opening up a whole range of emotions for creative work."
CHICAGO, 1975; P. 126

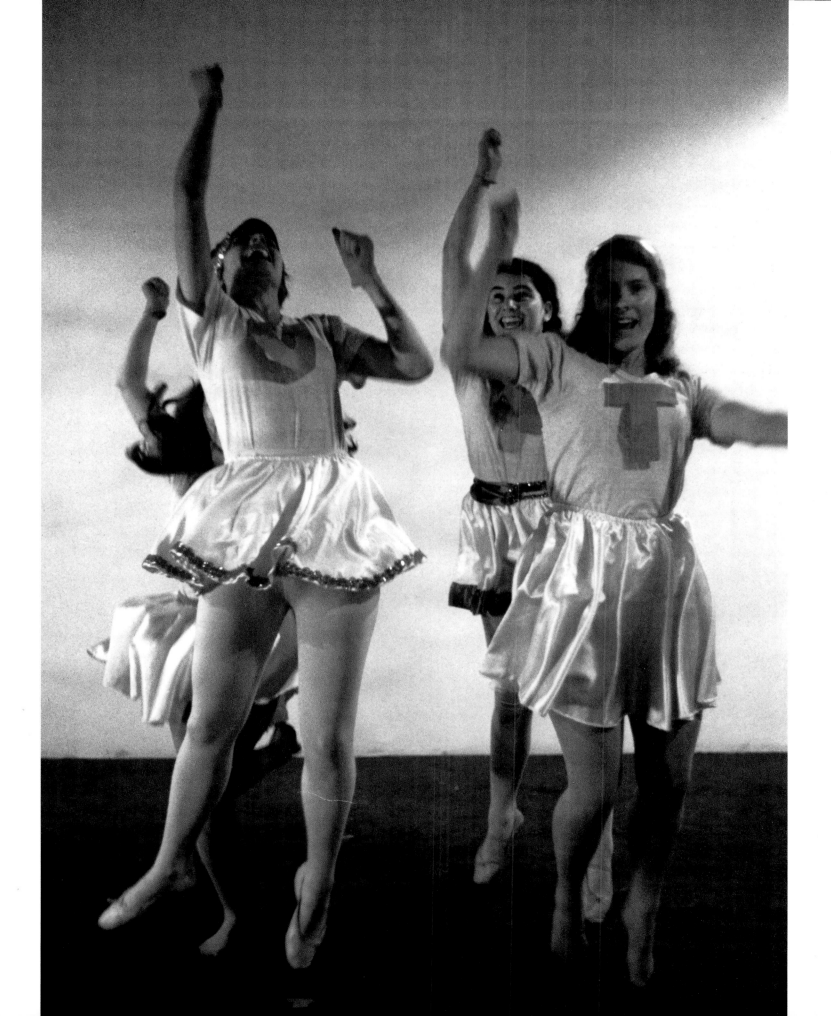

Essentially, Chicago's involvement in performance can be seen as being primarily an offshoot of her involvement with teaching. At Fresno work of this type arose directly from the desire to embody and make evident to all members of the group things that had hitherto remained undiscussable:

"One woman presented a performance that had to do with being asleep next to her boyfriend, dreaming that a man had come into the room and was stroking her leg slowly, panting with lust and excitement. She awoke, frightened, but as soon as she sat up, he disappeared. Was he real or was he an ever-present specter, whose need encroached upon her even while she was asleep? Again, she dozed, saw him, and woke up screaming. Again he disappeared. She became more and more confused and felt there was no safety, no escape from male presence, which surrounded her, consumed her, invaded her, even in sleep."
CHICAGO, 1975; P. 80

*Faith Wilding
(b. 1945)*
Crocheted Room
*1972.
Installation;
from "Womanhouse."*
(below)

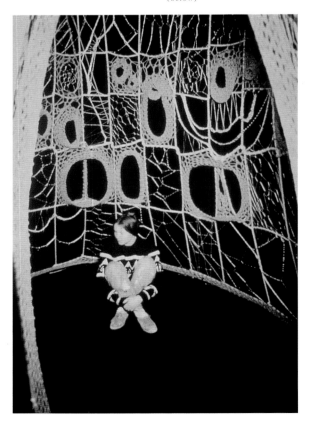

Yet there was also, in the Fresno program, an element of exuberant high spirits, which expressed the participants' feeling of liberation because of what they were doing in the program Chicago had designed. Examples were the Cuntleaders, four Fresno students in specially designed costumes doing a cheerleader routine that celebrated female power. Chicago records:

"The young women created this activity and the costumes themselves, sometimes greeting visitors to our program at the airport, much to my chagrin. Although I loved it, I also felt embarrassed at such overt expression of womanly pride."
CHICAGO, 1975; CAPTION BETWEEN PP. 106 & 107

One major result of the second phase of the Feminist Art Program, which was thriving under the leadership of Chicago and Shapiro, was the creation of "Womanhouse" in 1972. "Womanhouse," situated in the appropriately named Mariposa (Butterfly) Street in downtown Los Angeles, was a rundown mansion, unoccupied for 20 years, which was transformed into a series of art environments and was also used as a setting for performances. The environments were the work of various hands. *Nurturant Kitchen*, created by Vickie Hodgetts, Robin Weltsch, and Susan Frazier, offered a skin of neutral-colored paint covering walls,

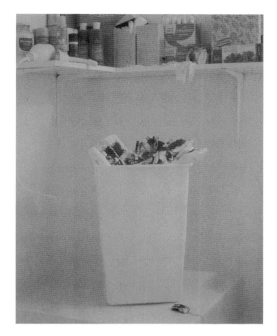

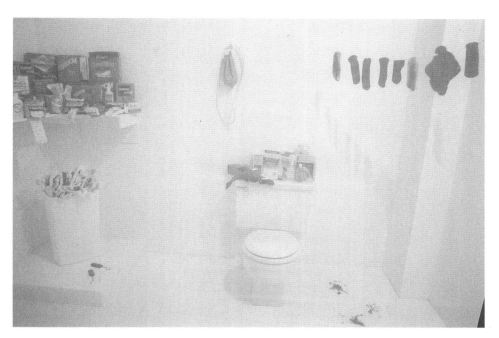

ceilings, and floors. Plastic fried eggs were transformed into breasts as they cascaded onto the walls. In another work, *Crocheted Room*, Faith Wilding created a complete crocheted environment, which enclosed the spectator like a spider's web. This was an example of the use of a specifically feminine skill to create a feminist artwork, foreshadowing attitudes that were to reappear in Chicago's *Birth Project*.

Chicago's personal contributions to "Womanhouse" included *Menstruation Bathroom* and a knockabout performance piece called *Cock and Cunt Play*. *Menstruation Bathroom* took up a theme that the artist had already tackled in her photolithograph *Red Flag*, which shows a woman's hand pulling a bloody tampon from her vagina. The subject is so much outside people's normal expectations of art that Chicago was sometimes accused of portraying not a tampon but a bloody penis. She comments that this is

"a testament to the damage done to our perceptual powers by the absence of images of female reality."
CHICAGO, 1975; P. 136

Menstruation Bathroom could not be entered but was seen through a thin veil of gauze, through which the viewer saw a white room, with a long shelf loaded with women's sanitary products and, beneath this, a garbage can full of bloody

Menstruation Bathroom
1995.
Exhibited in "Division of Labor" exhibition, Museum of Contemporary Art, Los Angeles, California;
Installation.
(above)

Menstruation Bathroom
1972.
Installation;
from "Womanhouse."
(above left)

tampons, with further traces of blood on the floor. Chicago reinstalled this piece in 1995 for an exhibition seen first at the Bronx Museum of the Arts and then at the Museum of Contemporary Art in Los Angeles.

"On this occasion I was struck by two things—first, that the range of sanitary products for women had grown enormously and, second, that the sense of shock elicited by the piece remained as potent as ever."
INTERVIEW, JANUARY 1999

The *Cock and Cunt Play* had in fact been written in 1970, before "Womanhouse" was conceived. It was a commedia dell'arte farce, in which the performers wore simple black costumes adorned with large, padded representations of male and female genitalia. The play was performed in a stylized manner, the words enunciated with a singsong rhythm. The theme was male and female stereotyping:

"SHE: Will you help me do the dishes?
HE: (Shocked) Help you do the dishes?
SHE: Well, they're your dishes as much as mine!
HE: But you don't have a cock!
(grasps cock and begins stroking it proudly)
SHE: What's that got to do with it?
HE: A cock means you don't wash dishes.
A cunt means you wash dishes."
CHICAGO, 1975; APPENDIX, P. 209

The conclusion of the play also touches on the theme of male violence to women. In the final scene, He beats She to death with his phallus, rather as Punch beats Judy with his truncheon in the traditional Punch and Judy puppet show.

Chicago was to return to this topic in a more serious fashion in *Ablutions*, a collaborative performance piece presented on only one occasion, in Venice, California in 1972. The sound track, played throughout the performance, consisted of a tape of women describing their real-life experiences of being raped. One performer, nude, was shown being bound, mummy-like, to a chair. Other women bathed in different tubs filled with eggs, blood, and clay. Yet other women nailed bloody kidneys to the wall or adorned themselves with chains. Finally, all the figures were bound together with rope:

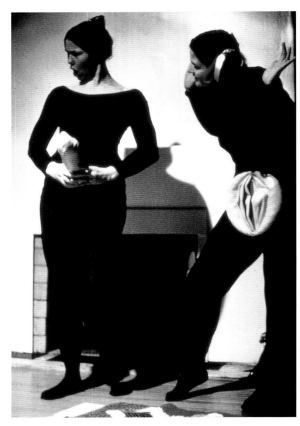

Cock and Cunt Play
1972.
Performance by Faith Wilding and Jan Lester;
from "Womanhouse."
(above)

Red Flag
1971.
Photolithograph;
20in x 24in (50cm x 61cm).
Collections: Various.
(right)

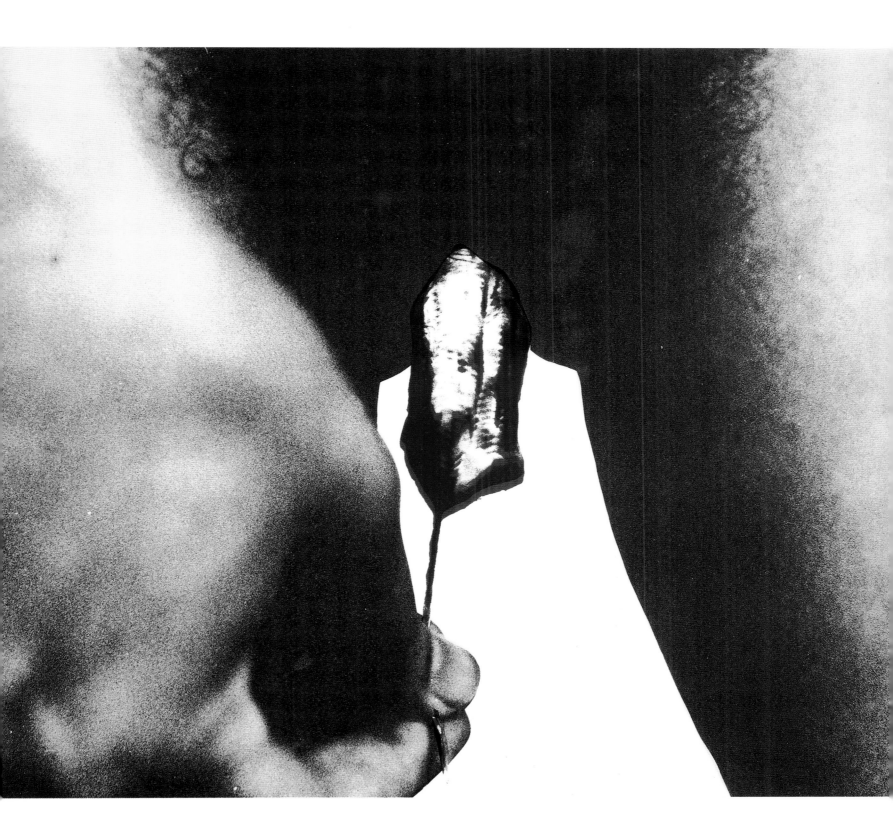

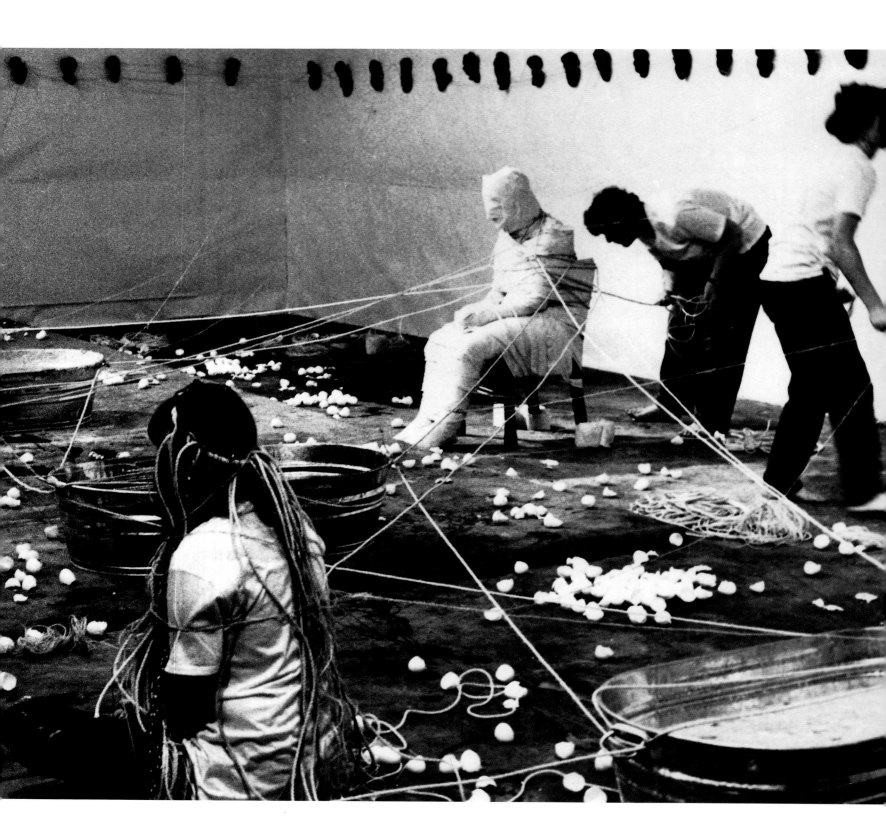

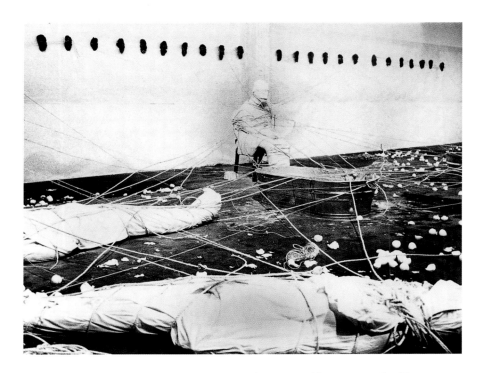

Ablutions

1972.

Collaborative performance;

Venice, California.

(left and above right)

Gunsmoke

1971.

Offset photolithograph;

17½in x 21½in (43cm x 55cm).

Collections: Various.

(below right)

"Round and round the women walked, tying everything up neatly, like some obsessive housekeeping duty, until the performance area was like a spider web and all the figures were caught, contained, bound by their circumstances and their own self-victimization."
CHICAGO, 1975; APPENDIX, P. 219

The theme of violence against women also surfaces in prints Chicago made at this time, such as *Love Story* and *Gunsmoke*. *Love Story* combines a photographic image of a nude, kneeling woman being threatened from behind with a gun that looks as if it is about to be thrust into her vagina, with a text borrowed from the celebrated French sadomasochistic novel *The Story of O*, now known to have been written by Jean Paulhan, editor (between 1925 and 1940) of the leading French literary periodical *La Nouvelle Revue Française*. The technique of combining image and text is borrowed from advertising and was to be much used in the 1980s by a new generation of

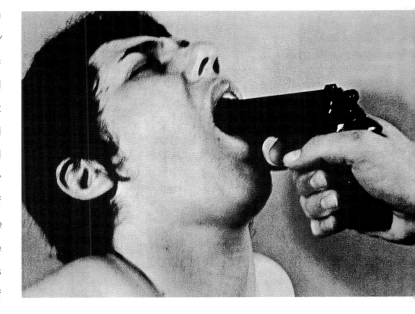

Butterfly Room
1976.
Installation;
And/Or Gallery,
Seattle, Washington.
(above and above right)

feminist artists. *Gunsmoke* may be seen as an even more brutal image than *Love Story* in some ways. It offers a closeup portrait of the artist's face, with a pistol thrust violently into her mouth.

Red Flag, *Love Story,* and *Gunsmoke* represent a direction not taken in Chicago's work. Though she was increasingly to turn toward figurative work from the time of *The Dinner Party* (1979) onward, she would make little use of photographic representation until the *Holocaust Project: From Darkness into Light* (1993), which was a collaboration with her husband, the photographer Donald Woodman, whom she married in 1986. Her experience with installation work in connection with "Womanhouse" was to have a more profound impact. She began exercising a much stricter control over the way in which her work was presented, often creating special settings for her paintings, such as the *Butterfly Room* created in 1976 for a show at the And/Or Gallery in Seattle. She also surrounded the paintings with inscriptions intended to reinforce their meaning. The feminist boldness reinforced by her experiences in Fresno, at the California Institute of the Arts program, and at "Womanhouse" was also reflected in ancillary materials, such as the announcements for her shows. Where she had once shown herself in quasi-masculine guise, as a boxer, she now offered her own likeness emerging from what was unmistakably a cunt.

Love Story
1971.
Offset photolithograph;
16⅛in x 12⅛in (41cm x 50cm).
Collection: The artist.
(right)

Study for gallery announcement
c. 1975.
Mixed media.
Collection: The artist.
(below)

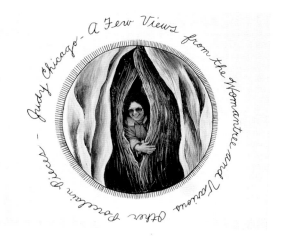

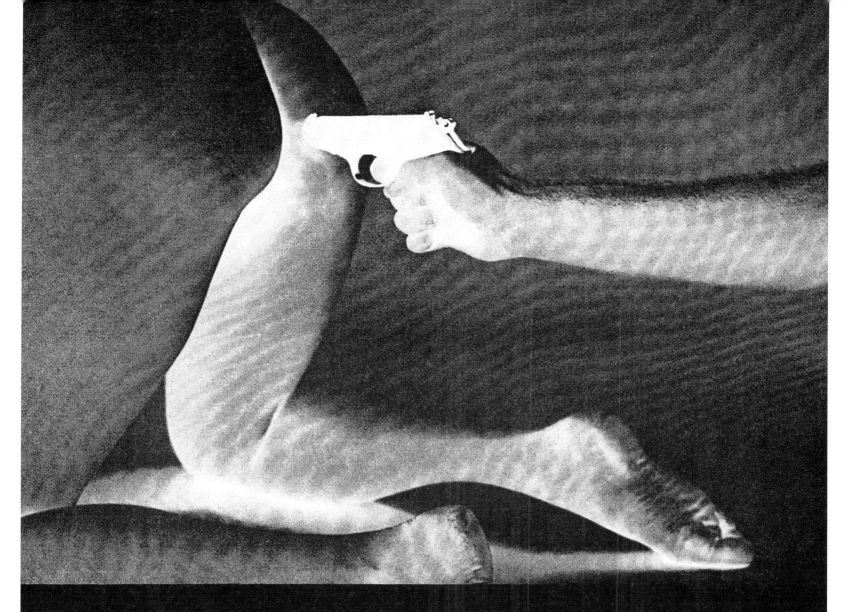

YOU ARE HERE TO SERVE YOUR MASTERS. YOUR MOUTH, YOUR BELLY AND YOUR BEHIND ARE CONSTANTLY AT OUR ENTIRE

DISPOSAL. YOUR HANDS ARE NOT YOUR OWN, NEITHER ARE YOUR BREASTS, NOR, ABOVE ALL, IS ANY ONE OF YOUR ORIFICES

OF YOUR BODY, WHICH WE ARE AT LIBERTY TO EXPLORE AND INTO WHICH WE MAY, WHENEVER WE SO PLEASE, INTRODUCE OUR-

SELVES. A HASSOCK WAS PLACED AS A SUPPORT UNDER HER CHEST; HER HANDS WERE FIXED BEHIND HER BACK, HER HAUNCHES

WERE HIGHER THAN HER TORSO. ONE OF THE MEN GRIPPED HER BUTTOCKS AND SANK HIMSELF INTO HER WOMB. WHEN HE WAS

DONE, HE CEDED HIS PLACE TO A SECOND. THE THIRD WANTED TO DRIVE HIS WAY INTO THE NARROWER PASSAGE, AND PUSHING

HARD, VIOLENTLY WRUNG A SCREAM FROM HER LIPS. WHEN AT LAST HE LET GO OF HER, MOANING AND TEARS STREAMING

DOWN UNDER HER BLINDFOLD, SHE SLIPPED SIDEWISE TO THE FLOOR ONLY TO DISCOVER BY THE PRESSURE OF TWO KNEES

AGAINST HER FACE THAT HER MOUTH WAS NOT TO BE SPARED EITHER. IT WAS WITH HER MOUTH STILL HALF-GAGGED BY THE

HARDENED FLESH FILLING IT THAT SHE BROUGHT OUT, THICKLY, THE WORDS: "I LOVE YOU." "SAY IT ONCE AGAIN. SAY I LOVE

YOU." O SAID: "I LOVE YOU."

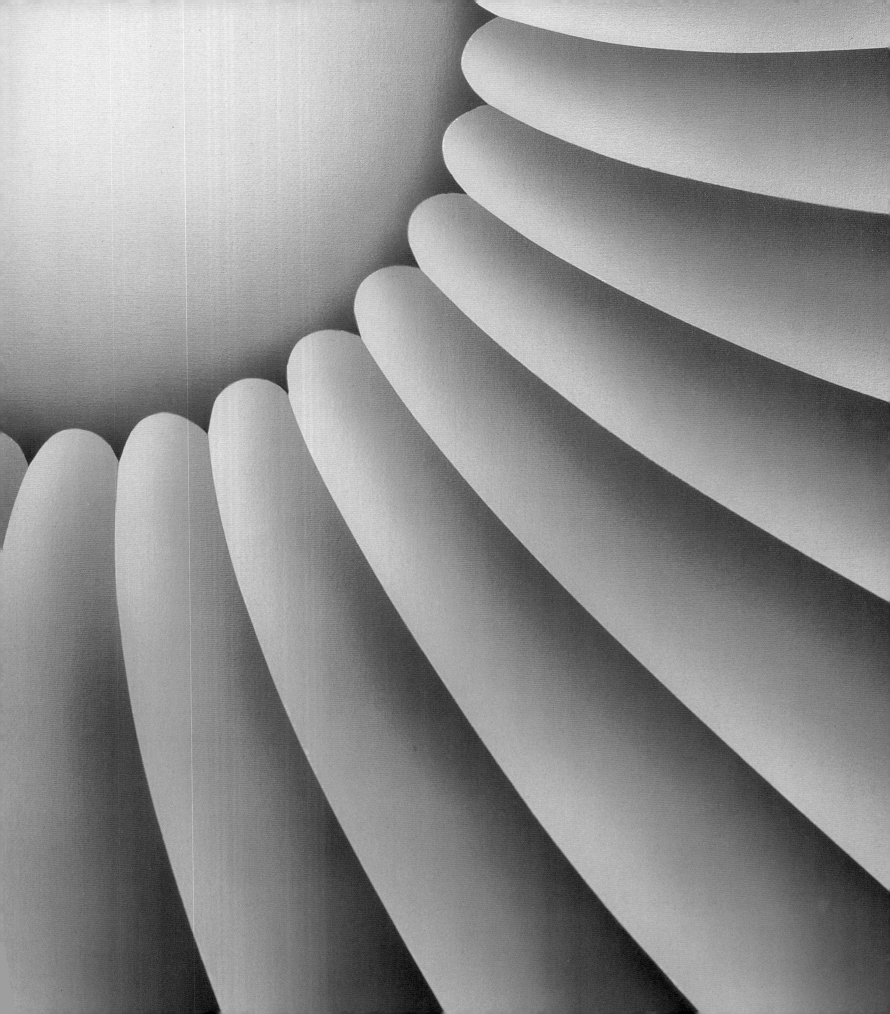

Through the Flower

In the early 1970s, Judy Chicago's personal work underwent a series of significant changes. "Womanhouse" had taught her a number of things—positive and negative—about her attitudes to art.

"I realized... that the reason I had thought about doing performance was that I wanted my work to have the same impact on values that performance seemed able to produce."

CHICAGO, 1975; P. 137

On the other hand, she did not want to give up all the artistic skills she had spent so much time developing:

"I didn't want to repudiate the aesthetic tradition in which I was raised, albeit male, or pretend that my skills and sophistication were something to be devalued and discarded as 'male,' 'elitist,' or 'bourgeois.' Rather, I wanted to wed my skills to my real ideas and to aspire to the making of art that could clearly reveal my values and point of view as a woman."

CHICAGO, 1975; PP. 137–38

Detail from
Through the Flower
1973.
Sprayed acrylic on canvas;
5ft x 5ft (1.5m x 1.5cm).
Collection: Elizabeth A. Sackler,
New York, New York.

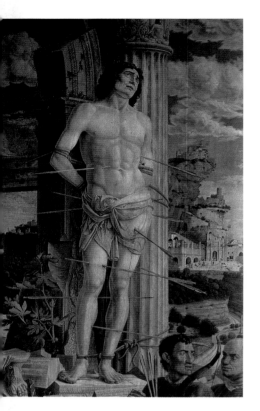

Andrea Mantegna
(1431–1506)
The Martyrdom of
Saint Sebastian
c. 1480.
Oil on canvas;
8ft 4in x 4ft 7in
(2.55m x 1.4m).
Collection: Louvre Museum,
Paris, France.
(above)

Heaven Is for
White Men Only
1973.
Sprayed acrylic on canvas;
6ft 8in x 6ft 8in (2m x 2m).
Collection: New Orleans Museum
of Art, New Orleans, Louisiana.
(right)

Gender Struggles

Other considerations also entered into the equation. One was the painful breakdown of her professional relationship with Miriam Shapiro, who had been her collaborator at the California Institute of the Arts:

"I made a series of drawings structured on a grid that Mimi had used. I guess that by adopting her format, I tried to hold onto her a little longer. Even while I was going through the feelings, I knew they were out of proportion to reality. All that had happened was that a friend of mine had, for her own reasons, decided to change certain aspects of her life. In so doing, she changed our relationship, which I didn't like."
CHICAGO, 1975; P. 139

The ultimate result of Chicago's struggle with grid imagery was the painting *Heaven Is for White Men Only*. But now the underlying subject matter had changed. She had seen Shapiro's images as being spaces that were inexorably closed, and the spaces inside her own grids as peaceful but still not to be entered. Now the metaphor was extended to embrace the situation of women in the art world. In *Heaven Is for White Men Only*, the "heavenly" space is barred by what the artist refers to as "flesh beams." The different colors assigned to the beams represent a first attempt to link gender and ethnicity. The ultimate source of the image is a painting by Andrea Mantegna of *The Martyrdom of Saint Sebastian*, which Judy Chicago saw in the Louvre when she and Lloyd Hamrol made a first trip to Europe in the summer of 1972.

An even more significant work of the same period is *Through the Flower*, which also supplied the title for an autobiographical book first published in 1975. Numerous studies led toward the creation of this work, in conformity with Chicago's now established creative practice. The image evolved both from earlier paintings, notably the *Pasadena Lifesavers*, which use a variant of the same pictorial organization—a motif with a female "core"—and from a study of the work of other female artists. The most obvious external influence is that of the flower paintings of Georgia O'Keeffe, although O'Keeffe herself always denied that her works of this type either contained a sexual significance or indeed had a merely feminist connotation. Chicago says:

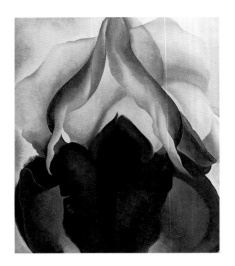

"I used the flower as the symbol of femininity, as O'Keeffe had done. But in my images the petals of the flower are parting, and one can see an inviting but undefined space, the spaces beyond the confines of our own femininity. These works speak of my longing for transcendence and the bitter hopes of all womankind. They are, in my estimation, my first steps in being able to make clear abstract images of my feelings as a woman."
CHICAGO, 1975; P. 141

At the same time she acknowledges that O'Keeffe steadfastly denied the sexual implications of her own works. Chicago adds,

"In my work, I felt a body identification with both the images I made and the surface on which they were painted. I felt myself to be both the image/surface and the artist working on that painting simultaneously. The canvas was like my own skin; I was the painting and the painting was me."
CHICAGO, 1975; P. 142

Closely related to the *Through the Flower* series of paintings, drawings, and prints was the *Great Ladies* series. *Christina of Sweden* is a typical example, using a new, softened and more fleshly version of the compositional formula that originated with *Pasadena Lifesavers*. The series was first exhibited at the Women's Building in Los Angeles, in the women's cooperative gallery Grandview, which shared the space with a number of other organizations.

Georgia O'Keeffe
(1887–1986)
Black Iris III
1926.
Oil on canvas;
36in x 30in
(91.4cm x 75.9cm).
Collection: Alfred Stieglitz
Collection, Metropolitan
Museum of Art, New York,
New York.
(above)

Through the Flower
1973.
Sprayed acrylic on canvas;
5ft x 5ft (1.5m x 1.5m).
Collection: Elizabeth A. Sackler,
New York, New York.
(far right)

Through the Flower 4
1973.
Prismacolor on rag paper;
24in x 24in (61cm x 61cm).
Collection: Unknown.
(right)

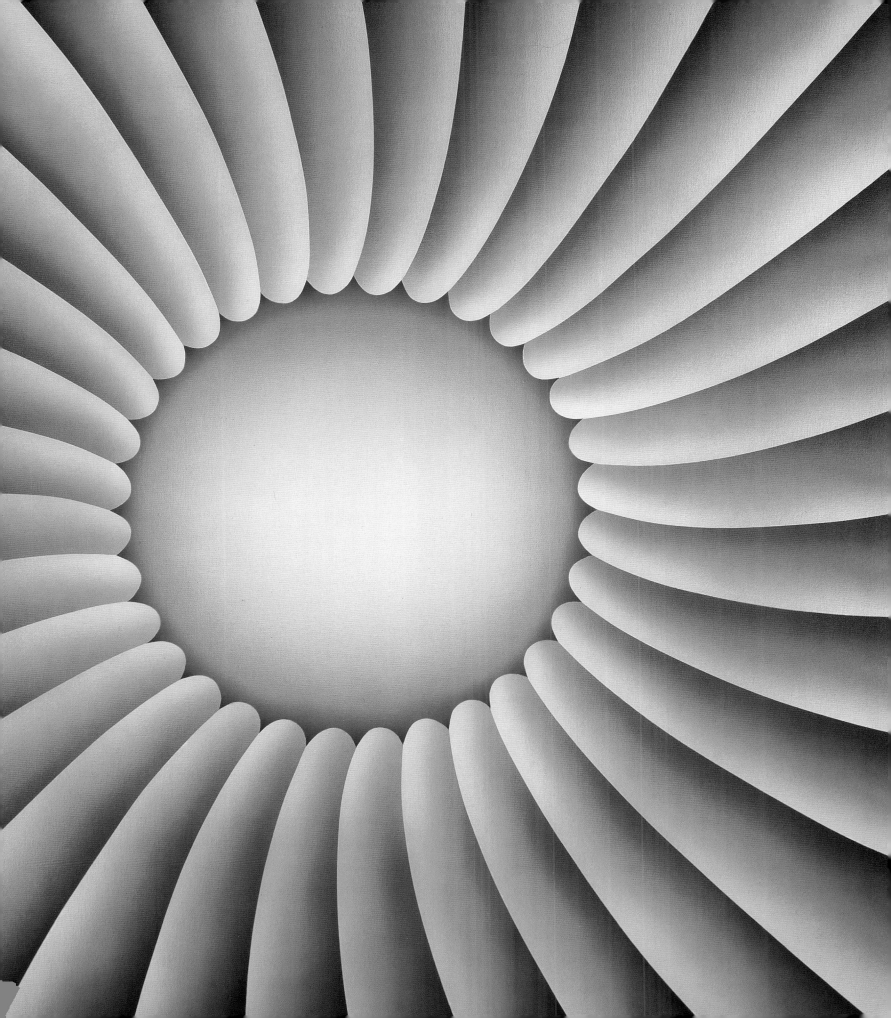

On the wall of the gallery Judy Chicago placed a long inscription:

"The *Great Ladies*—begun in the Fall of 1972, completed in the Summer of 1973—these women represent themselves, aspects of myself, and various ways in which women have accommodated themselves to the constraints of their circumstances. Some years ago I began to read women's literature, study women's art, and examine the lives of women who lived before me. I wanted to find role models, to discover how my predecessors had dealt with their oppression as women. I was also searching for clues in their work—clues that could aid me in my art. I wanted to speak out of my femaleness, to make art out of the very thing that made me the 'other' in male society."

CHICAGO, 1975; P. 203

It is obvious that this is the genesis of the thought process that led eventually to the creation of *The Dinner Party*, which is still Judy Chicago's most celebrated work. The *Great Ladies* paintings, in a quite specific fashion, can be thought of as direct precursors of the designs for the plates that form the central item in each *Dinner Party* place setting.

The *Reincarnation Triptych* marked a further step along the same road. In this piece of work, three paintings—homages to Mme de Staël (1766–1817), George Sand (1804–76), and Virginia Woolf (1882–1941), respectively—were conceived to be exhibited together. They were united thematically by the inscriptions that surrounded them. Once again, the paintings were meticulously prepared with a series of color studies. One can see from these how concerned the artist is with physical properties of color—she is determined to make it pulse and move in a quasi-kinetic way, so that the design, though abstract, becomes the mirror of a living being, which changes shape as we look.

Somewhat more explicit than any of these were other works of the same period, such as the multi-image *Transformation Painting: Great Ladies Transforming Themselves into Butterflies*, in which the butterfly shapes in the right-hand column of images more explicitly suggest vulvas, and the *Compressed Women Who Yearned to Be Butterflies*. Like the *Reincarnation Triptych*, *Transformation Painting* relies quite heavily on the inscriptions that surround the images; so does the *Compressed Women*. The drawing illustrated is dedicated to Elisabet Ney (1830–1907). Like all the dedicatees honored in the series, she is a

Installation view of the
Reincarnation Triptych
1973.
Three paintings, sprayed
acrylic on canvas;
5ft x 5ft (1.5m x 1.5m) each.
Private collections.
(above top)

Study for the
Reincarnation Triptych
1973.
Prismacolor on paper;
23in x 23in (58cm x 58cm).
Collection: The artist.
(above)

Christina of Sweden
from Great Ladies, *1973.*
Sprayed acrylic on canvas;
40in x 40in (102cm x 102cm).
Collection: Elizabeth A. Sackler,
New York, New York.
(left)

Transformation Painting:
Great Ladies
Transforming Themselves
into Butterflies
1973.
Prismacolor on paper;
23in x 23in (58cm x 58cm).
Collection: Deborah Marrow
and Michael McGuire,
Santa Monica, California.
(below)

Elisabet Ney
from Compressed
Women Who Yearned to
Be Butterflies, *1974.*
Prismacolor on rag paper;
24in x 24in (61cm x 61cm).
Collection: Arkansas Art Center,
Little Rock, Arkansas.
(below bottom)

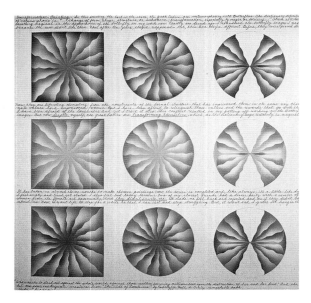

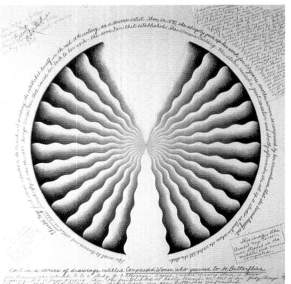

woman whose career in art was interrupted in some way. In her case, having pursued a successful career as a sculptor in Germany, she emigrated to the United States because of her marriage—a decision that entailed a 20-year hiatus in her artistic work. She was only able to resume work as a sculptor in the closing years of her life. Her studio, preserved in Austin, Texas, was, until the opening of the Georgia O'Keeffe Museum in Santa Fe in 1997, the only one-person museum in the United States dedicated to a woman artist.

For some of those interested in the development of Chicago's work at this time, for example the critic Lucy Lippard, a long-time friend and ally of the artist, she was still not pushing the matter far enough. The artist recalls the genesis of a series of five Prismacolor drawings called the *Rejection Quintet*:

Female Rejection
Drawing #3
(Peeling Back)
from Rejection Quintet,
1974.
Prismacolor on rag paper;
30in x 40in (76cm x 102cm).
Collection: San Francisco
Museum of Modern Art,
San Francisco, California.
(right)

"Here was where I was—involved with these abstract, flowerlike, controlled images—and they were still hiding my content... At that point in time, Lucy Lippard came to visit me, and she said 'Judy! Come out with it for God's sake!!'... So then I started. I peeled it right back. Let me tell you, I went through hell. I was terrified, because I got all this rejection from being out there. When Lucy said: 'Do it!' she didn't realize how hard it was going to be to come out there with that poor, strong, painful place. It's really an acknowledgement of what was there! From that point onward I began to deal with a transfigured image in which the vaginal form becomes butterfly... I took this vaginal form and I started to see what I could do with it."
BUTTERFIELD, 1984: P. 13

The *Rejection Quintet* images certainly possess a new kind of rawness. *Peeling Back* is unmistakably an image of a vulva. The work, moving back toward the figurative, begins to challenge the abstract and minimalist concerns that till then had dominated Chicago's work. The appearance of figuration, in however disguised a form, opened the door to a kind of art that would be able to confront social and moral issues in a direct, comprehensible fashion. The artist had started to address a different audience, not necessarily interested in art for its own sake.

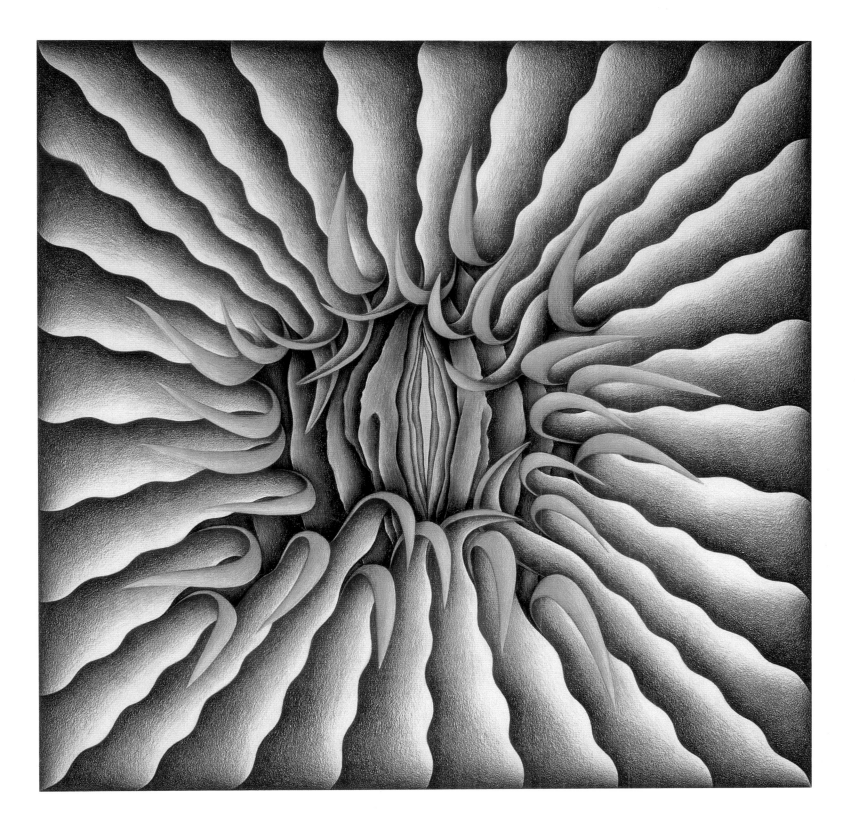

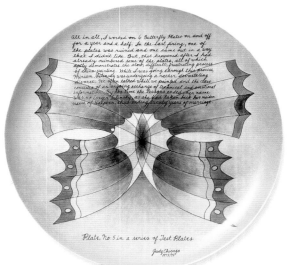

Rosemary Radmaker
(Dates unknown)
Painted plate
Date unknown.
China paint on porcelain;
14in (36cm) in diameter.
Collection: The artist.
(above top)

Test Plate #5
1973–74.
China paint on porcelain;
14in (36cm) in diameter.
Collection: The artist.
(above)

As her imagery developed, Chicago increasingly became involved in a new way of making art—china painting. She dates the first part of this interest to the discovery of a hand-painted plate in a country antique store:

"I was fascinated by how its effects had been achieved, presumably through a technique called china painting, which I knew absolutely nothing about. I would soon learn that this kind of painting involves the applying of specific paints onto a glazed ceramic surface, then firing it till the colors meld with the glazed surface. In addition to providing the kind of visual fusion I liked, china painting also seemed to offer exactly the precision of form that I thought my sprayed acrylic paintings were lacking."
CHICAGO, 1996: P. 3

In 1972, she joined a china painting class. She soon learned that painting in this medium was regarded as a hobby, one almost entirely confined to women, with no standing in the world of fine art. This affected the way in which the technique was taught. The aim was not to learn how to paint in general but to learn how to paint particular subjects in the approved way—for example, a rosebud or a whole bouquet of roses. This led her to think about the distinction between art and craft:

"One could say that the main distinction between art and craft is that in art, techniques are customarily put in the service of personal subject matter, whereas in craft they are generally employed for other purposes, including the simple demonstration of skill."
CHICAGO, 1996: PP. 37–38

Having found a teacher who was sympathetic to her aims, she gradually mastered the technique between 1972 and 1974, analyzing and sampling the range of colors available, noting their respective firing temperatures and examining the range of technical effects. She set up her own china-painting studio in Santa Monica and began producing test plates. Some of these feature the butterfly motif she was also using in her paintings in acrylic, such as Transformation Painting and Great Ladies Transforming Themselves into Butterflies. They clearly foreshadow the plates she was later to make for The Dinner Party.

Detail from
How Does It Feel to Stretch As Far As You Can?
from Six Views from the Womantree, 1975.
China paint on porcelain;
16in x 14in (41cm x 36cm).
Collection: The artist.
(right)

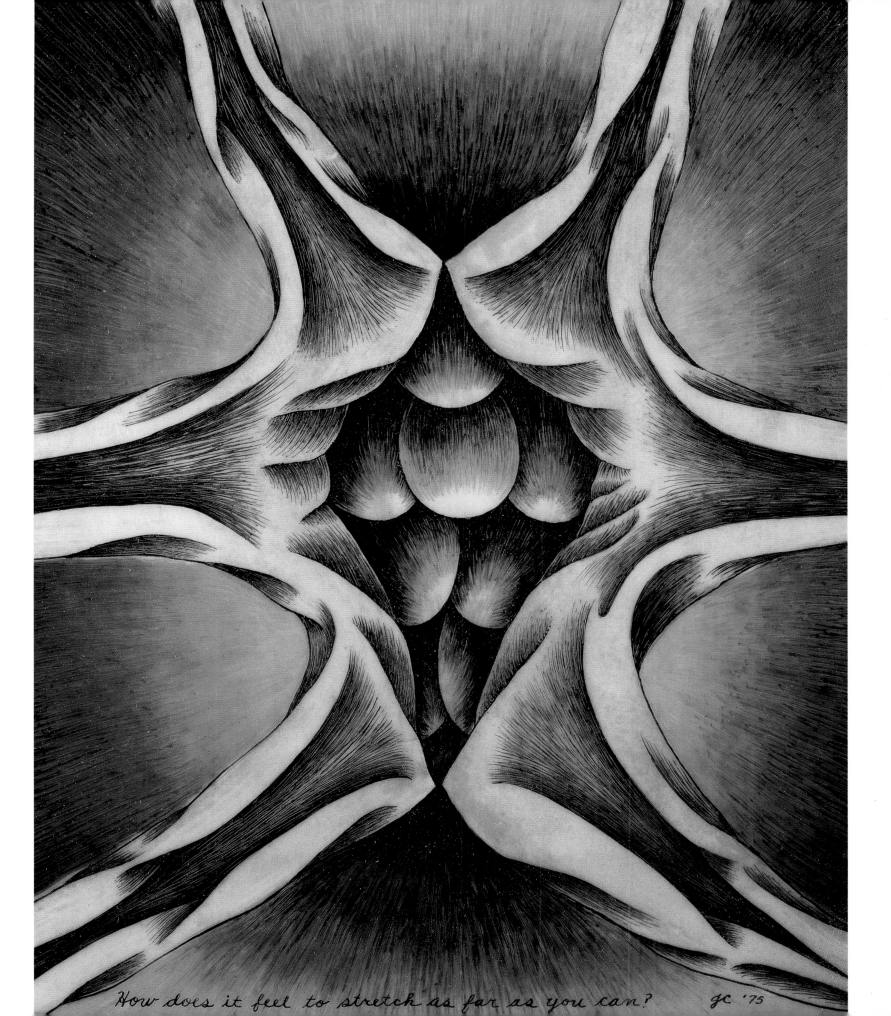

How does it feel to stretch as far as you can? JC '75

Sometimes Chicago used her new medium as if it were simply an alternative way of making paintings. This is the case with the series called *Six Views from the Womantree* (1975), in which the designs are painted on large porcelain plaques, using penwork as well as china paint. *How Does It Feel to Stretch As Far As You Can?* is a typical piece. Chicago relates that the inspiration for the series came from a large hollow tree she discovered in London, on Hampstead Heath. Fitting herself inside it, she felt as if she was within the sheltering body of a woman, looking outward from her cunt, like a child about to be born (INTERVIEW, JANUARY 1999). The *Womantree* pieces are of reasonably substantial size—16in x 14in (40cm x 36cm)—though small when compared with most contemporary paintings, including the paintings Judy Chicago herself had produced previously. In general, however, the use of porcelain as a base led to a considerable reduction in scale. This freed Chicago to be more candidly erotic in employing her new system of imagery. An example is the small plaque *The Cunt As Temple, Tomb, Cave or Flower*.

The new medium also encouraged Chicago to use different kinds of formal experimentation. Among the boldest of these experiments is the series *Broken Butterflies/ Shattered Dreams*, in which porcelain plaques delicately painted with butterfly-wing patterns have been deliberately broken and are presented in coffinlike boxes lined with satin. The pieces possess a double significance. Chicago's marriage to Hamrol was in trouble because he had suddenly confessed to a series of infidelities, some with his female students at the various schools where he had been teaching. Familiar with complaints from young women that "their male professors seemed more interested in seducing than educating them" (CHICAGO, 1996; P. 43), Chicago was particularly hard hit by this revelation. Secondly, she had already begun to dream of creating *The Dinner Party*, but had as yet no idea about how this mammoth task was to be accomplished and was rather overwhelmed at the thought.

Detail from
The Cunt As Temple, Tomb, Cave or Flower
from Butterfly Goddesses and Other Specimens, 1974.
China paint on porcelain in velvet-lined box;
6in x 6in x 2in
(15cm x 15cm x 5cm).
Collection: Unknown.
(above)

One feature of *Broken Butterflies/Shattered Dreams* is that the pieces in this series combine painted porcelain with fabric. A variant combination appears in a small erotic work, *Clitoral Secrets*, in which small ivory plaques painted with gouache are accompanied by an embroidered pouch. A more ambitious, much less deliberately private, example of the combination of porcelain and fabric is the altarlike *Did You Know Your Mother Had a Sacred Heart?* Here, a triptych of porcelain plaques is arranged on a table that is covered with an altar cloth. A significant feature of this cloth is the embroidery decorating the side panels.

The use of embroidery in this piece is the first notable appearance of the technique in Judy Chicago's work. It prefigures not only the major role it was to play in *The Dinner Party* but also many subsequent appearances, for example in the *Birth Project* and, later, in *Resolutions: A Stitch in Time*. Chicago recounts that her realization of the possibilities offered by needlework was something she owed to the publication of her first autobiographical volume, *Through the Flower*, in 1975. This brought her a letter from Susan Hill, who had been inspired by the book to offer help with her nascent *The Dinner Party* project, and who later became Head of Needlework in *The Dinner Party* studio. Hill, in turn, led her to an exhibition of ecclesiastical embroidery staged by an organization called the Episcopalian Embroidery Guild—an event that she might otherwise never had thought of attending, so far was it from her own cultural background.

"I can still remember entering the dim, slightly claustrophobic exhibition hall filled with displays of vestments and church furnishing. Although I had absolutely no idea of what most of these ecclesiastical objects were used for, I could see that the embroidery embellishing them was altogether superb. Many of the needlewomen were proudly standing by or demonstrating the techniques by which they had rendered these objects so exquisite, seemingly oblivious of the fact that their talents were being spent on a religious system that was essentially oppressive to the female sex. Even more unsettling was the fact that the women received absolutely no credit for their work; they were not even allowed to stitch their names on the pieces they had spent months and even years creating, As I commented to Susan, it was almost as if we were seeing women's overall historical and social circumstances being displayed right along with their splendid array of needle skills."

CHICAGO, 1996; P. 51

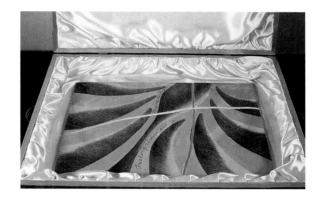

Broken Butterflies/
Shattered Dreams #4:
Pushing through and
Trying to Fly
1976.
China paint on porcelain, wood,
fabric, metal, and engraving;
17½in x 22¼in x 3¼ in
(43cm x 56cm x 8cm).
Collection: The artist.
(above top)

Clitoral Secrets
1975.
Gouache on ivory in
embroidered pouch;
12in x 18in x 12in
(30cm x 46cm x 30cm).
Collection: Zora and Ed Pinney,
Los Angeles, California.
(above)

Center panel from
**Did You Know Your Mother
Had a Sacred Heart?**
1976.
*China paint and pen
work on porcelain;
18in x 18in (46cm x 46cm).
Collection: Los Angeles County
Museum of Art, Los Angeles,
California.*
(far right)

Detail, embroidered panel from
**Did You Know Your Mother
Had a Sacred Heart?**
1976.
(right)

Installation view of
**Did You Know Your Mother
Had a Sacred Heart?**
1976.
*China paint and pen work on
porcelain, embroidery on
silk, and teakwood;
4ft 6in x 9ft x 2ft
(1.57m x 2.7m x 61cm).
Collection: Los Angeles
County Museum of Art,
Los Angeles, California.*
(below)

There is another element in *Did You Know Your Mother Had a Sacred Heart?* that is worthy of comment, and this is the way in which it "flirts with the issue of religious feeling" (BUTTERFIELD, 1984; P. 12). This flirtation is also evident in the painting *Heaven Is for White Men Only*, with its derivation from Mantegna.

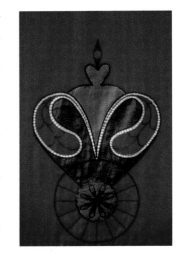

Although she was brought up in an eminently secular Jewish household, Judy Chicago in much of her work shows a longing for religious transcendence that, it seems to me, has been underestimated by her commentators and perhaps to some extent by herself. The ethical force for her work comes at least as much from emotion as it does from reason, and it has always tended to arouse equally strong emotions in people who disagree with her or who feel in some way threatened by what she does. She has a strongly prophetic side, and female prophets have, as a matter of historical record, tended to arouse even greater antagonism than male ones, in what is, in any case, a high-risk profession. This impulse becomes prominent in *The Dinner Party* and helps to explain why that work has been simultaneously so much lauded and so much execrated. In the next chapter, I will offer some—until now— unpublished evidence that will, I think, reinforce this view.

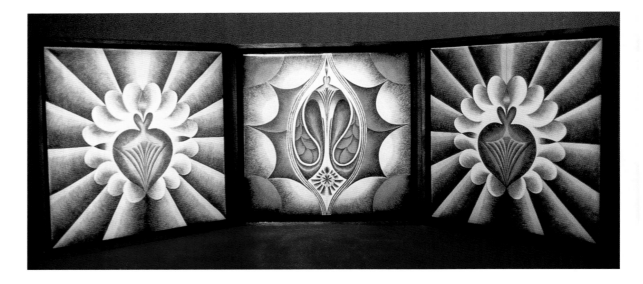

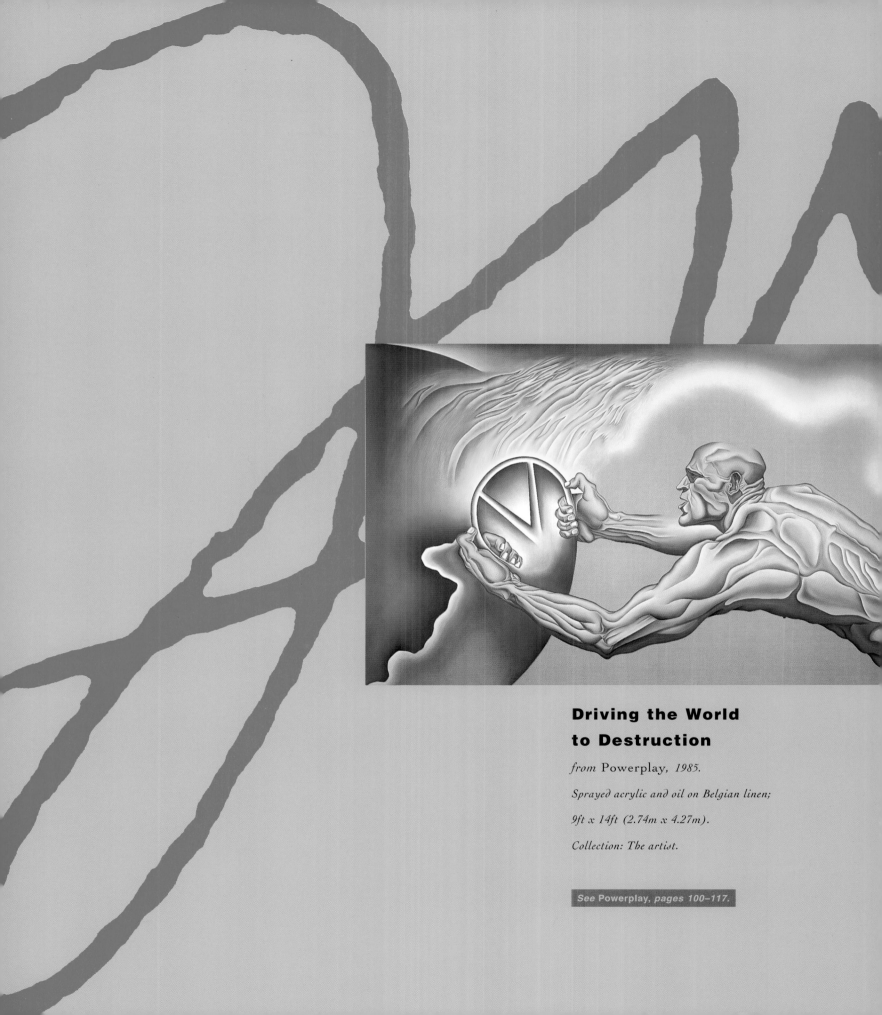

Driving the World
to Destruction

from Powerplay, *1985.*

Sprayed acrylic and oil on Belgian linen;

9ft x 14ft (2.74m x 4.27m).

Collection: The artist.

See **Powerplay,** *pages 100–117.*

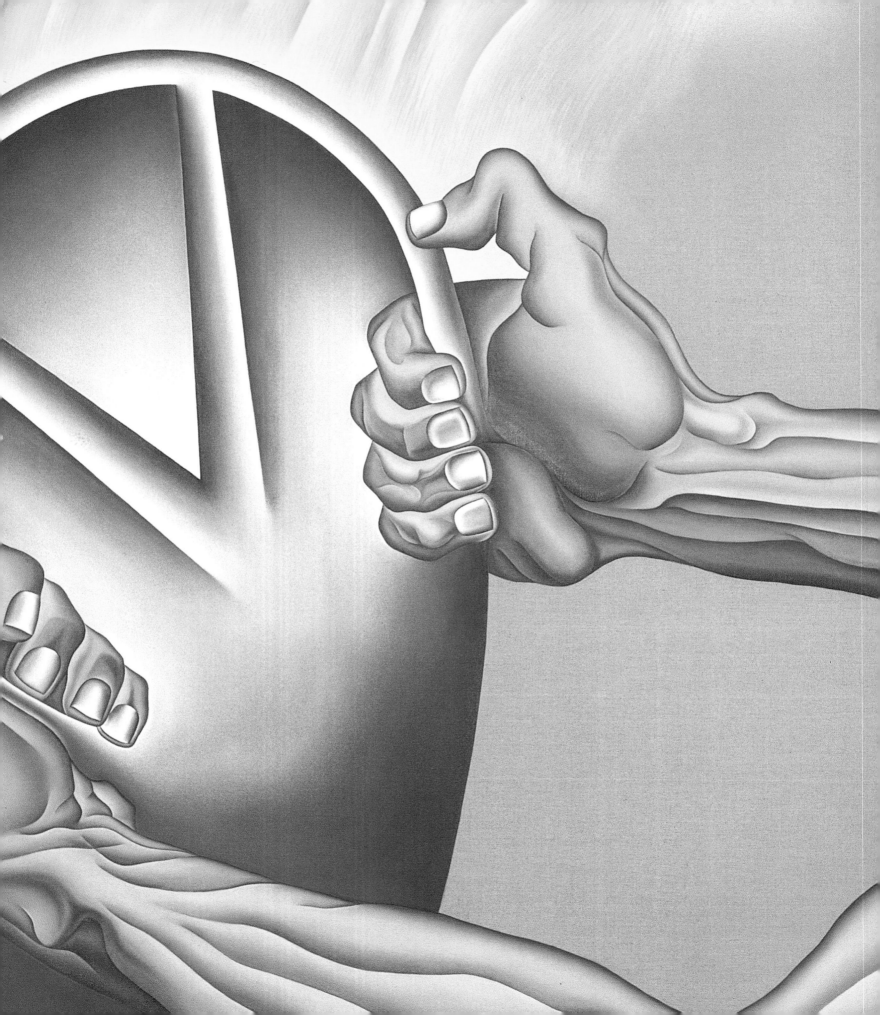

"I didn't want to keep perpetuating the use of the female body as the repository of so many emotions; it seemed as if everything was projected onto the female by both male and female artists. I wondered what feelings the male body might be made to express. Also, I wanted to understand why men acted so violently."

CHICAGO, 1996

Chapter Four

The Dinner Party

The Dinner Party is to date the most celebrated—some would say the most notorious—of all Judy Chicago's artistic enterprises. Over the years it has been praised and execrated in almost equal measures. Its opponents have included people who think of themselves as committed feminists as well as those who feel most threatened by feminism. Its historical importance cannot be denied—it is now mentioned, and usually illustrated, in almost all surveys of the development of the visual arts in the second half of the 20th century. Its legendary status is almost equally well established. Though it has been only intermittently on view since its creation (it remained in storage, for example, from its showing in Melbourne, Australia in 1988 until the "Sexual Politics" exhibition held in Los Angeles eight years later), few works of contemporary art have so completely penetrated the popular consciousness. In this sense, it is on the same footing as Jasper Johns' *Flags*, Andy Warhol's *Marilyn*s, Carl André's minimalist brick sculptures, Jeff Koons' giant *Puppy* made of flowers, and Damien Hirst's sliced up cows preserved in tanks of formaldehyde. The work can be looked at from a number of different points of view. The first and most obvious of these is the story of how it came to be created. Then there are the questions both of its intended meaning and of other meanings that have attached themselves to it—some beyond the control of the artist herself. This, in turn, leads to the violent reactions it aroused on its first showing, and that it still, if the press coverage of the 1996 showing in Los Angeles is anything to go by, continues to arouse.

Detail from
Eleanor of Aquitaine
place setting
from The Dinner Party, *1979.*
Mixed media;
5in x 5in (12.5cm x 7.5cm).
Collection: The Dinner
Party Trust.

Modernist Controversies

The early heroes of modernism took a long time to establish themselves. Despite the success of *Guernica* when it was shown at the Paris World Fair of 1937, Picasso remained a controversial figure until well after World War II. Since the appearance of pop art at the beginning of the 1960s, successful contemporary artists have been rapidly assimilated into the cultural establishment. This has been conspicuously the case in the United States, the nation that, for the past half century, has offered the warmest welcome to—and the greatest material rewards for—new artistic enterprises. It has also been the environment in which the new feminist consciousness has flourished most vigorously. Yet Judy Chicago remains to quite a substantial extent an "outsider," in the sense that she is an artist who finds no comfortable place within the now elaborate hierarchies of the world of art.

Like many ambitious works, *The Dinner Party* began modestly. Chicago's desire was to teach women's history through art. Her first idea was for a series of 25 plates, to be entitled *Twenty-five Women Who Were Eaten Alive*. Then she began to think on a more ambitious scale, planning 100 abstract portraits of women on plates. She looked for a model that might enable her to reach a wide audience—this led her to medieval and renaissance art, which she had always admired.

"I found it instructive that the Church had taught Christian doctrine to an illiterate population through understandable symbols, and I thought to make my own iconography clearer in order to accomplish a comparable goal."
CHICAGO, 1996; PP. 45–46

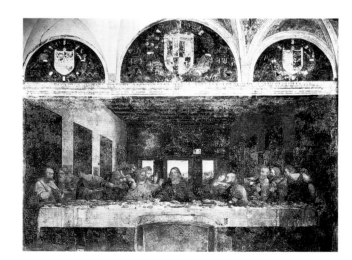

The Dinner Party
1979.
Mixed media;
3ft x 48ft x 42ft
(0.91m x 14.6m x 12.8m).
Collection: The Dinner
Party Trust.
(right)

Leonardo da Vinci
(1452–1519)
The Last Supper
1495–98.
Fresco;
Santa Maria delle
Grazie, Milan, Italy.
(left)

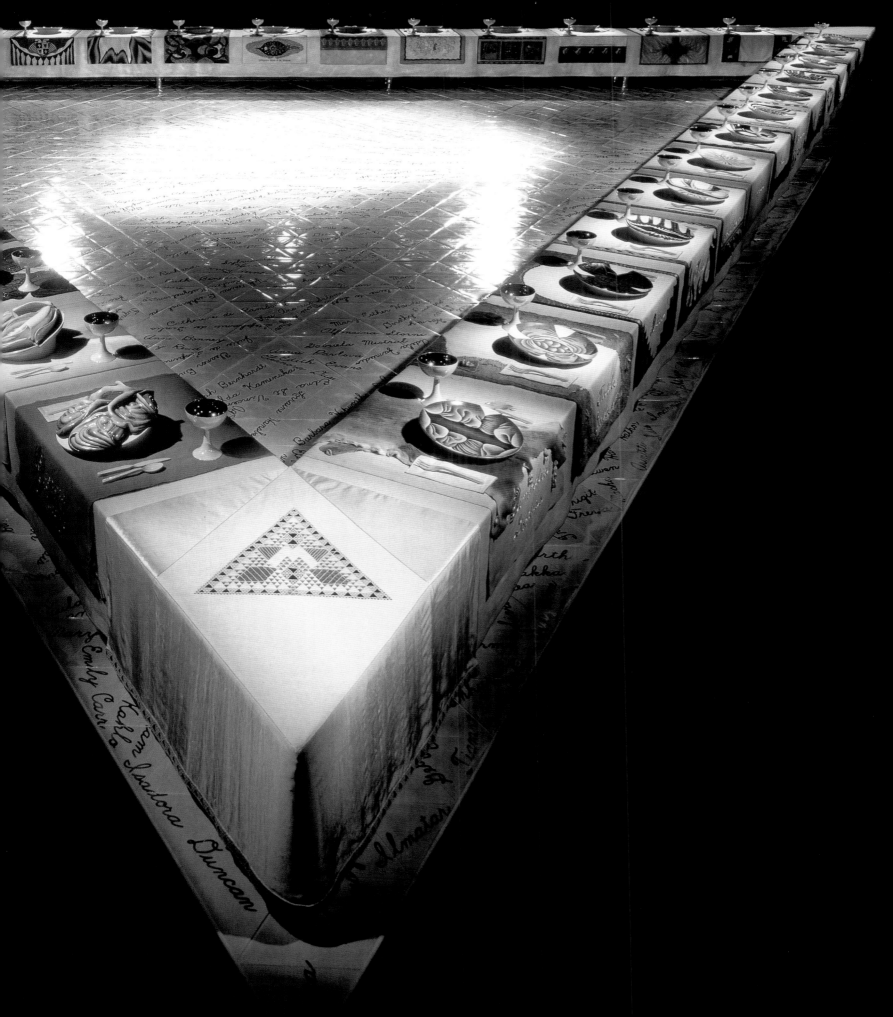

Conceptual drawing for
The Dinner Party
1975–76.
Ink on paper;
8¼in x 10¾in (21cm x 27cm).
Collection: The artist.
(above)

Conceptual drawing for
The Dinner Party
1975–76.
Ink on paper;
10¾in x 8¼in (27cm x 21cm).
Collection: The artist.
(above)

The idea coalesced when she visited a professional china painter who had spent three years making an elaborate dinner service for 16 people. The pieces were arranged in order on the painter's dining room table. Chicago decided that her abstract portraits of women had to be presented within the context of a table setting. Parallels with Christian representations of the Last Supper immediately sprang to mind.

"It seemed as though the female counterpart of this religious meal would have to be a dinner party, a title that seemed entirely appropriate to the way in which women's achievements—along with the endless meals they had prepared throughout history—had been 'consumed'."
CHICAGO, 1996; P. 46

What is apparently the earliest sketch in Judy Chicago's notebooks for the project shows that her first idea was to have a circular table with a hollow center—a variant of the "core" imagery she had already used for *Through the Flower* and other similar paintings. This was later modified to become a triangular table presenting a triple Eucharist. The triangle also became a symbol of the whole project and featured on the entry banners—made in a modified version of Aubusson tapestry—which greeted visitors at the entrance to the installation. At the table itself, 39 women would be honored, 13 to a side. As Chicago notes in her book documenting the project:

"There is a strong narrative aspect to the piece that grew out of the history uncovered in our research and underlying the entire conception of *The Dinner Party*. This historical narrative is divided into three parts, corresponding to the three wings of the table. The first table begins with pre-history and ends with the point in time when global history was diminishing. The second wing stretches from the beginning of Christianity to the Reformation, and the third table includes the 17th to the 20th centuries. Beginning with prepatriarchal society, *The Dinner Party* demonstrates the development of goddess worship, which represents a time when women had social and political control (clearly reflected in the goddess imagery common to the early stages of almost every society in the world). The piece then suggests the gradual destruction of these female oriented societies and the eventual domination of women by men, tracing the institutionalizing of that repression and women's response to it."
CHICAGO, 1979; P. 53

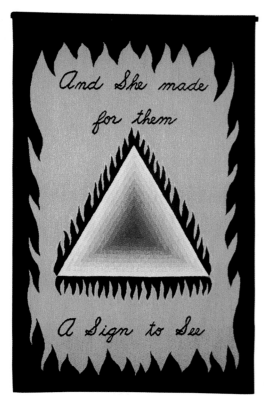

Wing One
featuring "Primordial Goddess"
and "Fertile Goddess," from
The Dinner Party, *1979.*
(above left, following pages)

Wing Two
featuring "Eleanor of Aquitaine,"
from The Dinner Party, *1979.*
(below left, following pages)

Wing Three
featuring "Virginia Woolf"
and "Georgia O'Keeffe," from
The Dinner Party, *1979.*
(far left, following pages)

Working on cartoon for
Entry Banner #2
from The Dinner Party, *1979.*
(left)

Entry Banner #2
(And She Made for Them
a Sign to See)
from The Dinner Party, *1979.*
Modified Aubusson tapestry
woven at the San Francisco
Tapestry Workshop;
5ft 6in x 3ft 6in (1.67m x 1.1m).
Collection: The Dinner
Party Trust.
(above)

Installation view of
Entry Banners
from The Dinner Party, *1979.*
Modified Aubusson tapestry
woven at the San Francisco
Tapestry Workshop;
5ft 6in x 3ft 6in
(1.67m x 1.1m) each.
Collection: The Dinner
Party Trust.
(right)

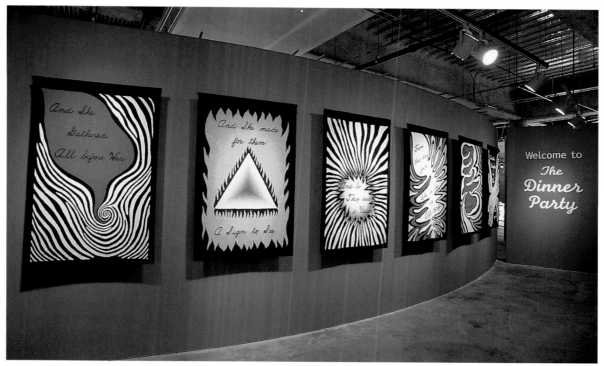

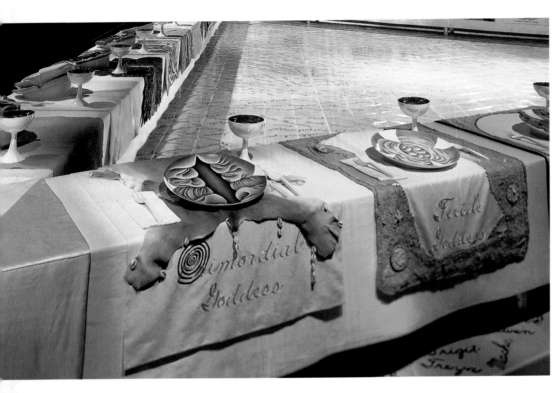

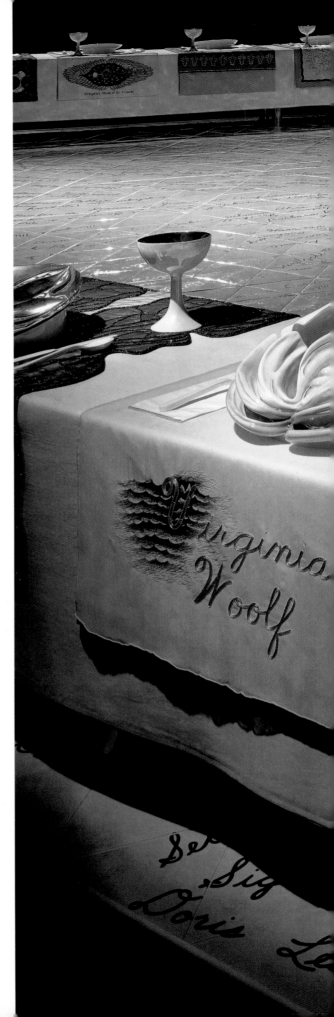

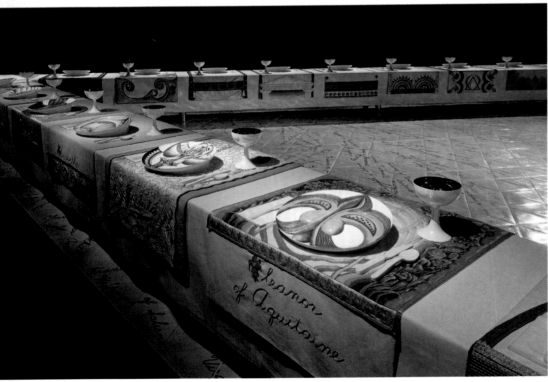

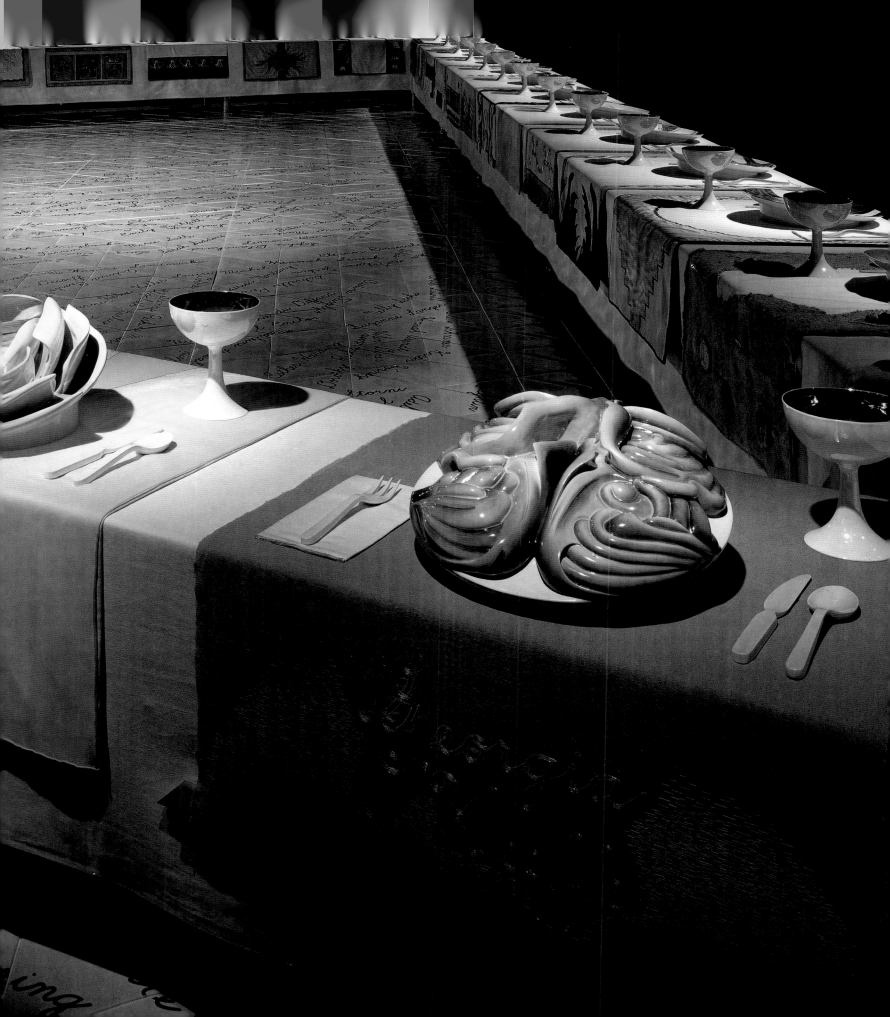

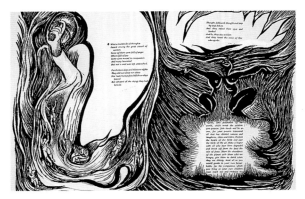

Surviving mock-ups for
Prophetic Book
Ink on paper;
8in x 11¼in (20cm x 28cm) each.
Collection: The artist.
(above and above top)

This account, with its emphasis on rational, didactic progression of argument, in my view downplays one of the most important aspects of *The Dinner Party*, which is that it is also a visionary work. The visionary quality it possesses is, I believe, the major reason for the durability of its appeal, and also, perhaps, for its frequently divisive effect. The installation was originally to have been accompanied by an elaborate illuminated book, which has remained in manuscript form, and which is unknown even to close students of Judy Chicago's work.

This text, in its present form, consists of three parts: "A ReCreation Myth," "History Tales," and "Silhouettes." The second and third of these consist chiefly of historical material, occasionally rising to flights of poetic prose. The first, in two sections, "Revelations of the Goddess" and "Visions of the Apocalypse," is a sustained prose poem. Though the material is not divided into lines of verse, the effect is, in many places, not unlike that produced by some of the prophetic books of William Blake (1757–1827):

"**And Woman was created holy for she was endowed with all the power of the Universe. Her faces were multiple like the phases of the moon; she was the black stone, reminder of the primary darkness from which all life springs. And she was the red crescent, whose blood would transform the soil and make the Earth a fertile place for all life's creatures. And she was the white egg, who would cherish the Earth and keep it pure. To her was entrusted the blessing to increase and multiply and to fill the Earth with her own kind. And Woman gave birth to the human race in pain and in struggle and she accepted it in joy because she knew that all life and all growth brings pain. And Woman brought forth the human race and female and male she birthed them.**"
REVELATIONS OF THE GODDESS, NO DATE

Surviving mock-ups for individual spreads in the book indicate that Chicago also envisaged it as being rather like one of Blake's illuminated prophetic books in appearance, with illustrations and text closely integrated.

The visionary element in *The Dinner Party,* furthermore, is relevant to a number of controversial aspects contained in the work. For example, there is the long-standing quarrel over its collaborative aspects. As the feminist art historian and curator Amelia Jones notes, in her essay *"The Sexual Politics of The Dinner Party: A Critical Context,"*

"The alternative mode of production Chicago practiced in *The Dinner Party* studio, for example, has been judged a success or failure according to certain ideas regarding what feminist collaboration was about during the first decade of feminist art practice."
JONES, 1996; PP. 103–104

Though all of Chicago's helpers and collaborators were fully acknowledged both in *The Dinner Party* exhibition and in the publication that accompanied it, many feminists would have liked such a conspicuous project to be completely non-hierarchical, a product of collective decision making. Clearly it was not that. Chicago compares the system she used to that of the Renaissance atelier—a master surrounded by helpers and apprentices. On occasion, she has gone so far as to suggest a comparison with Michelangelo (CHICAGO, 1979; P. 29).

There are several things to be said in response to this. The first is that Chicago's assistants seem to have been happy with the terms she set—the complaints about the way in which *The Dinner Party* studio was organized have come from outside the organization not from within it. It is as if the complainants feel that they have in some way been preempted by Chicago. Had *The Dinner Party* never existed, perhaps others could have carried through an equally ambitious project, but one organized on fully egalitarian principles. The fact is that no such project has ever come into being in a nonhierarchical feminist context, either in the 1970s or later. One is tempted to inquire: "Why not?"

Another thing worth considering in this context is the nature of contemporary studio practice in general. Abstract expressionism created a myth, which remains particularly potent in the United States, that the artist must be a solitary being, wrestling alone with his or her demons. In fact, the record shows that, since the 1960s, many of the most successful avant-garde artists have made lavish use of helpers and assistants of various kinds. This is true of Andy Warhol, for example, and it is equally true of the ongoing projects of Jeff Koons. The difference between their way of doing things

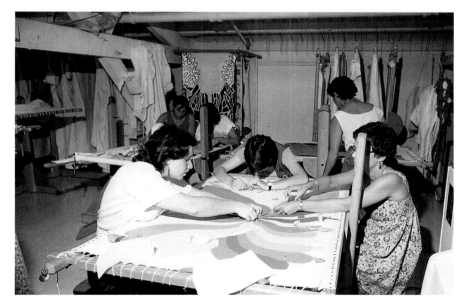

Needleworkers' loft in
The Dinner Party *studio,*
Santa Monica, California, 1977.
(below)

and that of *The Dinner Party* studio is that the names of these artistic helpers are seldom recorded, and their contribution is not mentioned when the finished product is put on show, yet male artists are never criticized for this omission.

Finally, however, I return to the underlying visionary impulse that informs the work and gives it so much of its power to move the imagination. Impulses of this kind are personal—they can be disseminated but not completely shared. The Sybil at Cumae did not, as far as we know, consult a committee. *The Dinner Party* is essentially the embodiment of a psychic event, or a series of psychic events, that happened to affect one particular individual. Egalitarian principles were irrelevant to its conception, though not to its physical implementation.

Looking at the different components of this physically very complex work, it is evident that they fall into a number of different categories: the banners, the china plates, the embroidered runners, the large, inscribed tiled floor on which the triangular table is placed. This "Heritage Floor" records the names of 999 women—and goddesses—whom Chicago wanted to honor. The reasons for the choice of these particular beings are given in the publication that accompanied *The Dinner Party* (CHICAGO, 1979). The information reflects a huge amount of historical research, but the floor is undoubtedly the most "conceptual" feature of the piece—its actual visual effect is subordinated to that of the plates and runners.

It seems natural that, of all the many components of *The Dinner Party*, the plates should have attracted by far the greatest share of public and critical attention. The sexual imagery, which was inherited from previous work by Judy Chicago, was bound to challenge many viewers. For example, it attracted much virulent comment during the abortive negotiations to have *The Dinner Party* housed permanently at the University of the District of Columbia in Washington. Jonetta Rose Barras, an African-American reporter for the *Washington Times*, described it as a "dramatic sexual sculpture," and various members of the Houses of Congress were quick to join in. Dana Rohrabacher, the Republican Representative for California, condemned it as "weird sexual art;" Stan Parris, the Republican Representative for Virginia, described it as "clearly pornographic" (LIPPARD, 1991; P. 41). The plates do indeed present striking images and are, in addition, a considerable technical achievement. Chicago gave a description of the difficulties she and her primary ceramics assistant, Leonard Skuro, endured:

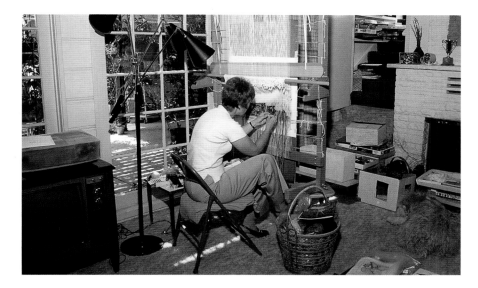

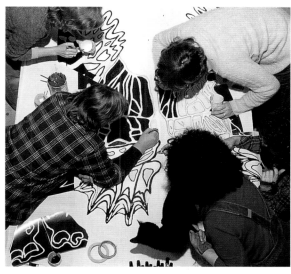

Audrey Cowan weaving the "Eleanor of Aquitaine" runner, from The Dinner Party, *1978.* (above left)

"It required three years to produce the plates, as the ceramic problems we encountered were incredibly difficult. First, there is no porcelain body in America which is comparable to that used for the Japanese plates [blank plates imported from Japan specifically for the use of china-painters]. Second, the stress placed on a plate which has different thicknesses is enormous and makes it liable to cracking. Carving into the plate or adding onto it creates great variations in thickness, and firing the plate repeatedly puts additional strain on it. In order to achieve a surface comparable to the surface of the already finished Japanese plates, the dimensional plates had to be fired at least five times. We had difficulty even making a perfect flat 14-inch plate and matching the beautiful glaze-quality of the plates from Japan. For months Leonard lost every plate he made, and he made hundreds."

CHICAGO, 1979; P.18

Working on the design for the "Natalie Barney" runner in The Dinner Party *studio, 1978.* (above right)

What matters most about *The Dinner Party*, however, is the integration of the various elements, in particular, the integration of the plates and the runners on which they stand. The runners had not been part of Chicago's original concept, though early drawings for some of them appear in the same sketchbook that contains the first scribbled idea for a large dinner table upon which to display the plates. Clearly a large table required a tablecloth, and Chicago's original idea had been to embroider circular phrases on the tablecloth itself, thus repeating the kind of design seen on the small plaque *The Cunt As Temple, Tomb, Cave or Flower*. She was soon persuaded, however, that it would be impossible to manipulate up to 30ft

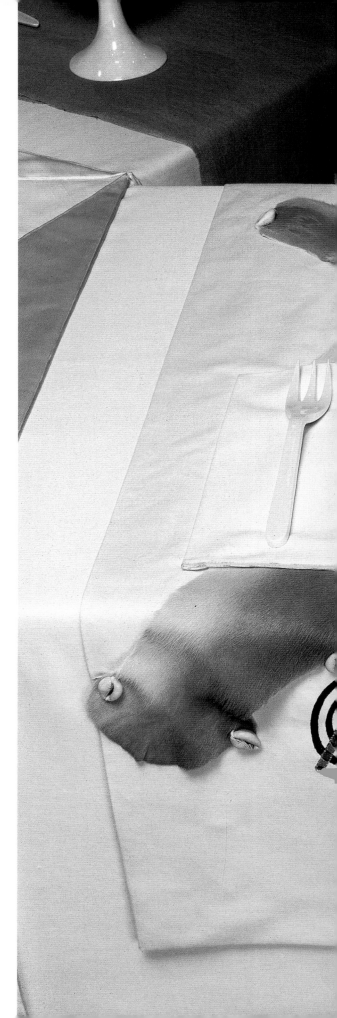

(about 10m) of fabric through a sewing machine in circles. Susan Hill, who had introduced Judy Chicago to ecclesiastical embroidery, suggested that an alternative would be embroidered runners modeled on the "fair linen" that covers the plate during the Eucharist. Each woman's name could then be embroidered on the front of her runner, which would drop over the viewer's side of the table.

"Instead of using a phrase to describe the woman's achievements, we would design needlework to visually express something about her and the time at which she lived. We also decided to let the runner extend over the back of the table and repeat or expand the imagery on the plate. Specific needlework techniques common to the woman's lifetime would be used, and, additionally, we would illuminate the first letter of her name."
CHICAGO, 1979; P. 18

With the addition of this element, the main parameters for the creation of *The Dinner Party* were set. The introduction of embroidery into the nexus of skills required for the creation of the complete work was significant in more than one way. Though Judy Chicago cannot, as she herself confesses, sew, she discovered that she had a talent for making designs for needlework, something that perhaps came from the methodical fashion in which she always prepared the creation of every new work—the numerous studies made for *Pasadena Lifesavers* are a case in point. Embroidery was another activity traditionally regarded as a hobby, and working with skilled embroiderers—"amateurs" operating in an area remote from the aesthetic concerns of contemporary art—led her to consider how these two apparently separate and even antagonistic worlds could be integrated. Finally,

"Primordial Goddess" place setting
from The Dinner Party, *1979.*
Collection: The Dinner Party Trust.
(right)

Working on the "Primordial Goddess" place setting, from The Dinner Party, *1979.*
(left)

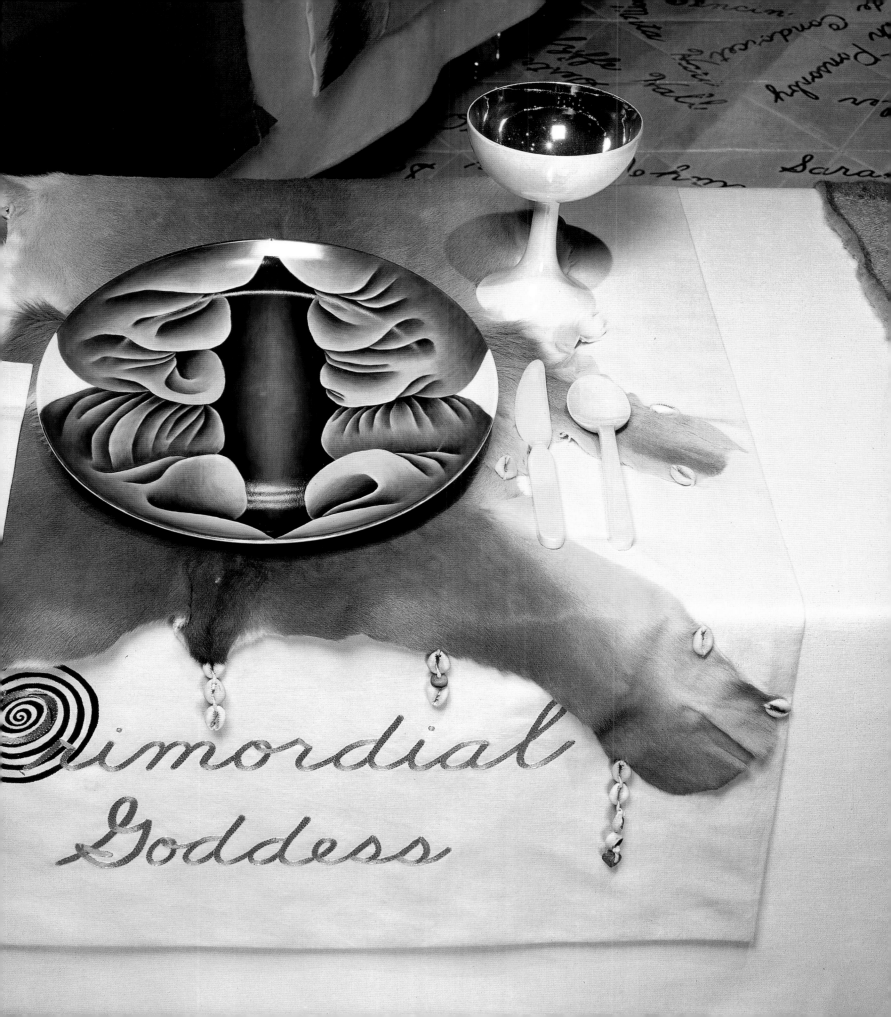

needlework was an activity identified with women, and it seemed only fitting that it should be prominently represented in the creation of the most ambitious feminist artwork that had so far been undertaken. Yet it was also, historically, an area fine artists had been willing to explore. One of the great Renaissance painters who made designs for needlework was Sandro Botticelli (1445–1510).

Perhaps the easiest way of comprehending how *The Dinner Party* works, or attempts to work, is to examine individual place settings. Four examples have been chosen here. The first is the first in the whole series—that for the Primordial Goddess. The plate itself is flat, in keeping with the idea that the plates were to become bolder and more complicated as the series progressed. Chicago says,

"At some point I decided that I would like the plate images to physically rise up as a symbol of women's struggle for freedom from containment."
CHICAGO, 1996; P. 47

The main aesthetic problem encountered by Chicago and her needleworkers was with the runner. This had to tread a delicate path between looking too slick and contrived, and appearing to be clumsy. The solution they settled upon was to

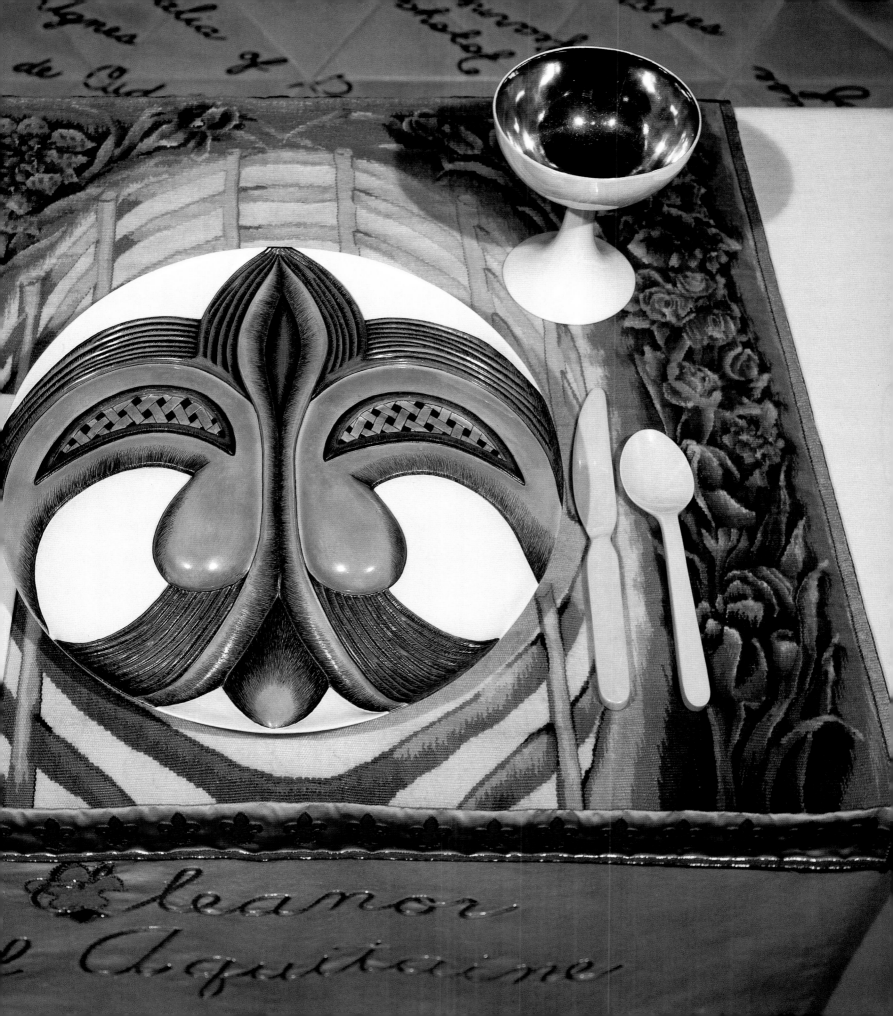

Unknown artist
(sixteenth century)
The Unicorn in Captivity
c. 1500.
From The Hunt of the
Unicorn *series.*
Silk, wool, silver, and
silver-gilt thread tapestry;
12 ft 1 in x 8 ft 5 in
(3.68m x 2.52m).
Collection: The Cloisters
Collection, Metropolitan
Museum of Art, New York,
New York.
(above)

Detail from a study for
"Eleanor of Aquitaine"
runner top
1977.
Graphite and Prismacolor
on rag paper;
29in x 23in (74cm x 59cm).
Collection: Audrey and
Bob Cowan, Santa Monica,
California.
(right)

overlap two complete skins taken from unborn calves and adorn them sparingly with cowry shells. The initial letter of the name is adorned with a spiral derived from the spirals often found in Paleolithic art.

The place setting for Eleanor of Aquitaine (1122–1204)—successively married to Louis VII of France and Henry II of England—emphasizes her royal status through the use of a fleur-de-lys motif on her plate and for her initial letter. It also emphasizes the fact that her second husband kept her in captivity for 16 years. The fleur-de-lys was not only the emblem of the French monarchy; it was the emblem of the Virgin Mary as queen of heaven. The cult of the Virgin reached a high point at this period and found a secular counterpart in the Courts of Love, which Eleanor of Aquitaine initiated, in which men—poets above all—were encouraged to place women on a pedestal. A source of inspiration for the runner was the series of late medieval millefleurs Unicorn tapestries in the Cloisters in New York, made for Anne of Brittany, queen of France, circa 1500, one of which shows the unicorn imprisoned by a picket fence. The runner occupies a particularly important place in the story of Judy Chicago's career since it was the first project she worked on with the tapestry-weaver Audrey Cowan (b. 1931).

The place settings for Emily Dickinson (1830–86) and Natalie Barney (1876–1972) are both from the third wing of *The Dinner Party*, and, in keeping with the principle of becoming more elaborate as time went on, their plates and runners are among the most elaborate in the entire work. The lacework design for the Dickinson plate proved to be especially controversial since the technique of making porcelain lace was associated with the worst excesses of late 19th-century design; the lace itself is dipped in porcelain slip and then fired. The embroidery for the matching runner makes use of the nearly forgotten late 19th-century technique of ribbon work, in which ribbons are folded and embroidered to make tiny flowers.

The Natalie Barney plate, one of the most luminously decorative in the series, uses a lusterware technique and required repeated firings. The matching runner has a butterfly image, constructed from layers of fabric:

Detail from
"Emily Dickinson" plate
from The Dinner Party, *1979.*
China paint on porcelain;
14in (36cm) in diameter.
Collection: The Dinner
Party Trust.
(right)

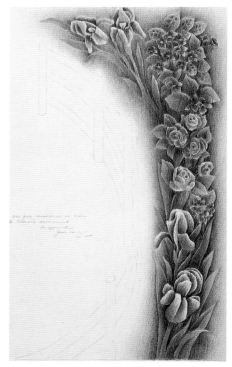

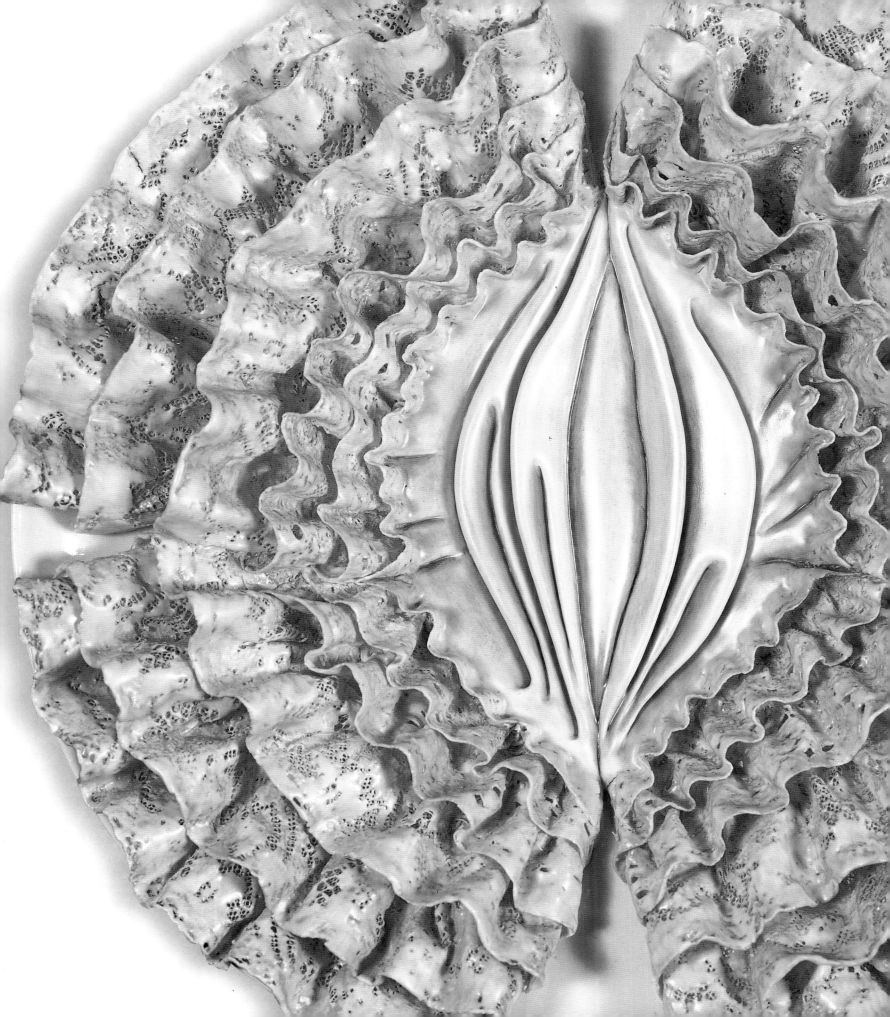

Building the "Emily Dickinson"
plate, 1979.
(above)

Study for
"Emily Dickinson" plate
1977.
Ink, photo, and collage
on rag paper;
24½in x 36½in (61cm x 91cm).
Collection: The artist.
(below)

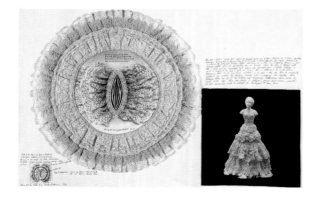

"Because of the repeated firings required to build up the deep iridescent tones, the lusters would unexpectedly change colors in the kiln. We kept having to take sections of the runner out; this meant not only cutting fabric without slitting the silk ground, but also spending hours matching colors and appliquéing the new overlays. When the color segments were finally completed, the runner was covered with fine black net, which both unified the hues and protected the raw edges of the silk."
CHICAGO, 1980; P. 250

The Dinner Party opened to the public at the San Francisco Museum of Modern Art on March 14, 1979. Five thousand people attended the opening and, during the three months it was on view in San Francisco, one hundred thousand people came to see it. This triumphant popular reception was not matched within the art world. Suzanne Muchnic, writing in the *Los Angeles Times*, spoke savagely of "An Intellectual Famine at Judy Chicago's Feast" (MUCHNIC, 1979). Later, the piece went to the Brooklyn Museum of Art in New York, where, as everywhere it traveled, it drew vast crowds. People lined up for as long as five hours to see the exhibition. This showing provided a platform for violent attacks from two influential New York critics. In the Friday "Arts and Leisure" section of the *New York Times*, Hilton Kramer described it as

"very bad art... failed art... art so mired in the pieties of political causes that it fails to acquire any independent life of its own."
KRAMER, 1980; SECTION C1, P. 16

The attack was repeated a few weeks later, in near identical form, by Robert Hughes, the chief writer on art for *Time* magazine (HUGHES, 1980; P. 85).

Several reasons can perhaps be adduced for this negative reaction. One was the fear of feminism itself; the rise of the movement made many people, women as well as men, feel deeply threatened. Another—valid in the case of critics based on the East Coast of North America—was the long-standing hostility between the art world of California and that of New York, which ever since the rise of abstract expressionism in the 1940s had liked to see itself as the only valid center of innovation. In 1980, that hegemony was being threatened by a whole series of events, notably the newfound independence of the European art world, which had recently fallen under the spell of Joseph Beuys (1921–86) and of the German and

Italian neoexpressionists. *The Dinner Party* was a lighted match dropped into an already volatile artistic situation. This may account for the unusually abusive tone of some of the reviews the work received, in a country where art reviewers are in general much more circumspect in what they say than they are in Europe.

Two of the striking characteristics of *The Dinner Party* are its continuing vitality and its undiminished power to offend. Shown in Los Angeles in 1996 as the main component of the "Sexual Politics" exhibition, it once again drew large crowds—and virulence. Christopher Knight, chief art critic of the *Los Angeles Times*, described the show as "the worst exhibition I've seen in a Los Angeles museum in many a moon" and revived the accusation that *The Dinner Party* was agitprop:

"Chicago's 'agit-prop monument' is a gross and self-important oxymoron, which partly explains the horrible divisiveness of its reception."
KNIGHT, 1996; CALENDAR

But does the case against it stand up? *The Dinner Party* does have a political and social agenda. This has been true of a number of major works of art created from about 1790 onward. The list includes Jacques-Louis David's *Death of Marat* (1793; Musées Royaux des Beaux-Arts, Brussels), Théodore Géricault's *The Raft of the Medusa* (1819; Louvre, Paris), Eugène Delacroix's *Liberty Leading the People* (1830; Louvre, Paris), and Pablo Picasso's *Guernica* (1937; Museo del Prado, Madrid). It is perfectly possible to admire some of these—the painting by David, for example—without in the least agreeing with the points of view they espouse.

The Dinner Party employs several varieties of visual rhetoric. It attempts to use not just specifically female imagery, but also artistic techniques that are more usually associated with women than with men. It is difficult to say which of these different visual strategies the critics of *The Dinner Party* find more upsetting. In recent years, spectators have become quite comfortable with the way in which representations of the penis have become emblems of artistic boldness. It is hardly possible to visit any large mixed exhibition of avant-garde art without being confronted by some representation of it. Spectators—and it seems male ones in particular—appear to be far more squeamish when they are confronted with something that even remotely resembles a vulva. The reaction to this discomfort, which is essentially rooted in the spectator's own psychology, is to blame the artist.

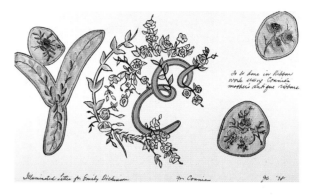

Study for
"Emily Dickinson"
capital letter
1978.
Prismacolor, ink, and
fabric collage on paper.
Collection: Mead Art Museum,
Amherst, Massachusetts.
(above top)

Detail from
"Emily Dickinson"
capital letter
from The Dinner Party, *1979.*
Collection: The Dinner
Party Trust.
(above)

Techniques such as china painting and stitchwork bring in their wake the accusation that the result is inevitably going to be kitsch. Here, one would do well to remember two things. The first is that the concept of kitsch has acquired a curious dynamic of its own. Referring to Jeff Koons' once-inflatable plastic *Rabbit* (1986), rendered in stainless steel, the respected art historian Irving Sandler remarked approvingly:

"Once cast, it also alluded to the polished sculptures of Brancusi and Arp. Kitsch and 'high' modernist art were wittily united."
SANDLER, 1996; P, 49

Secondly, in The Dinner Party, Judy Chicago anticipated Koons' characteristic technique of appropriation. Almost every image incorporated in the piece involves an element of quotation. This is a typically postmodern trait, as is the unabashed decorativeness of the total effect.

What most clearly distinguishes *The Dinner Party* from other postmodern works is the visionary element, and it is this that its detractors, both antifeminist and feminist, find offensive. How dare a woman try to set society to rights? How dare she claim that she knows truths that we don't? How dare she be so insistent about her right to tell them? These are hanging—or burning—offences well beyond the boundaries of the art world.

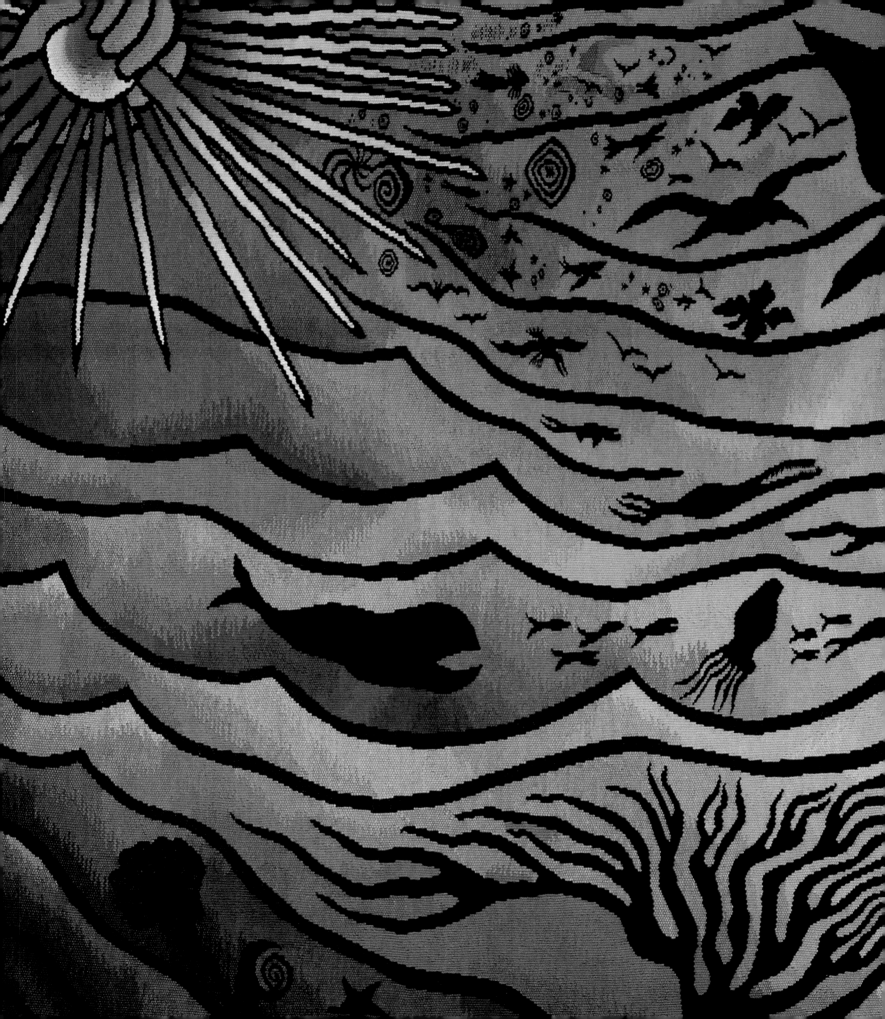

Birth Project

The Dinner Party turned Judy Chicago into a celebrity—but not one who enjoyed universal acceptance in the art world. While the piece would be shown a number of times between 1979 and 1988, only some of these showings took place in museums, where curators often remained obdurately opposed to Chicago's work. The rest of the showings were housed in temporary spaces organized by ad hoc groups. Some of these were necessarily rather stressful experiences because they meant working with people who were almost totally inexperienced in mounting large-scale projects, but the overall effect seems to have been to increase her inclination toward populism.

In Chicago's case, the populist impulse also incorporated a number of elements specifically linked to feminism. There was a long-held desire to outflank existing structures of cultural organization, and thus to undermine the assumption that museums had the absolute right to control what forms of art were offered to the public. There was also a wish to communicate directly through the creation of images that reflected hidden aspects of the female experience, and to cooperate with women in creating radically new work, building on ideas that had been incubated in *The Dinner Party* studio. The *Birth Project* (1981–87) was the result of this line of thinking.

Detail from
The Creation
1984.
Modified Aubusson tapestry,
needlework by Audrey Cowan;
3½ft x 14ft (0.91m x 4.27m).
Collection: Bob and Audrey
Cowan, Santa Monica,
California.

Bringing Birth to Art

Because it was decentralized, this new enterprise never achieved the impact made by *The Dinner Party*. Nor were its various components even in quality. One reason for this is that the concept changed as it went forward. Chicago began with the idea of simply creating needlework kits that would be the equivalent, though with designs of much greater aesthetic interest, of those found in needlework stores. She soon found a much greater degree of personal involvement and supervision would be required.

The idea of supervision raises, tangentially, the question of "exploitation"—an accusation that has haunted *The Dinner Party*, and that was also to attach itself to the *Birth Project*. The first thing to be noted is that needlework, though an immensely laborious and time-consuming activity when practiced at a high level of skill, is not usually something that is done commercially. Women do it for their own satisfaction, and the published evidence, presented in Chicago's book devoted to the *Birth Project*, shows that the needleworkers involved were on the whole extremely happy with the terms of their participation, though there were, inevitably, occasional moments of friction—also fully documented in the book. The terms were in any case regulated by a simple contract that both they and the artist signed.

The complaints about exploitation came not from within the enterprise but from outside it. The implication was that the needleworkers were ignorant people, who should have known better than to accept the terms they were offered. Underlying this, so it seems to me, there is a degree of intellectual snobbery. The proposition seems to be that while all feminists are equal, some are more equal than others. Audrey Cowan, Chicago's collaborator in tapestry, says that

"Collaboration is something that allows the collaborators to share their strengths. Judy has a vision—what I share is her vision, through skills which I possess and she doesn't. She wants to incorporate those skills into her work, and I am happy with that. When you work with Judy, you do more than you ever dreamed you could."
INTERVIEW, JANUARY 1999

Though the *Birth Project* was visibly imperfect in some aesthetic respects, it nevertheless represents a turning point in Chicago's development. In particular, it changed her from being an abstract artist into a figurative one. The figurative images incorporated into *The Dinner Party* had been largely appropriations. Like

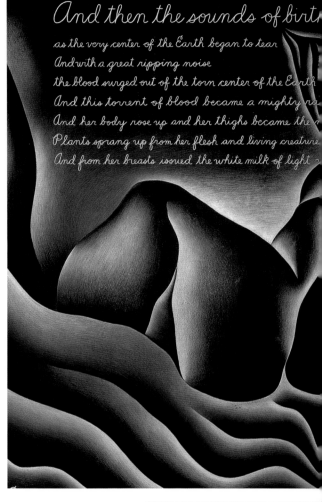

And then the sounds of birt
as the very center of the Earth began to tear
And with a great ripping noise
the blood surged out of the torn center of the Earth
And this torrent of blood became a mighty ri
And her body rose up and her thighs became the
Plants sprang up from her flesh and living creature
And from her breasts issued the white milk of light

Detail from
In the Beginning
1982.
Prismacolor on paper;
5ft x 32ft (1.5m x 9.75m).
Collection: The artist.
(above)

Unknown artist
Louis XIV's Visit to the Gobelin Factory, October 15, 1667
c. 1729–34.
Oil on canvas.
Collection: Châteaux de Versailles et Trianon, Paris, France.
(right)

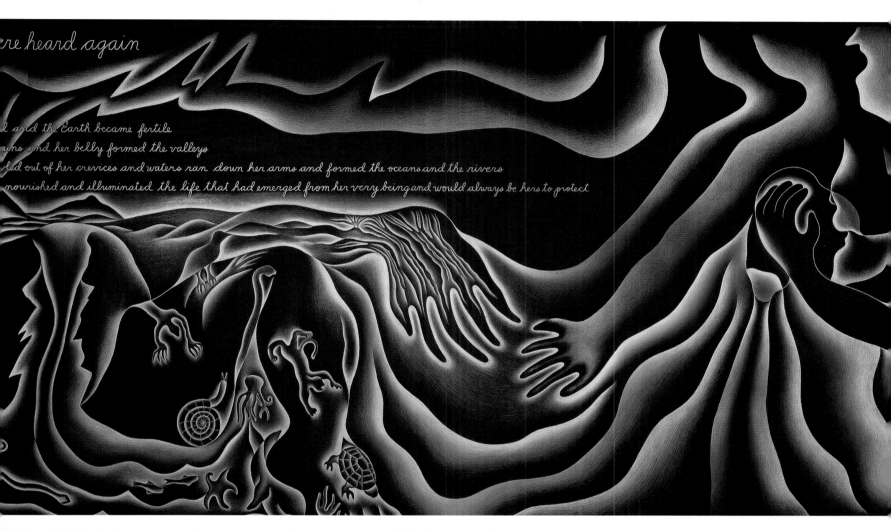

re heard again

l and the Earth became fertile
uns and her belly formed the valleys
led out of her crevices and waters ran down her arms and formed the oceans and the rivers
nourished and illuminated the life that had emerged from her very being and would always be hers to protect

all large-scale artistic enterprises, the *Birth Project* had its roots in more than one place. One starting point was Judy Chicago's friendship with Audrey Cowan. Cowan indicated to Chicago that she would like to work with her again after *The Dinner Party*, in a more ambitious way. Chicago had been playing with ideas about birth and creation, which in turn were linked to the visionary prose poem offering a new female-centered creation myth that she had written in connection with *The Dinner Party*. From this grew the design for a tapestry on the same theme.

The *Creation* takes some of its motifs from modern science—it looks for parallels between the human reproductive system and the solar system,

"Macrocosmic and microcosmic reflections of the creation and life process."
CHICAGO, 1986; P. 13

The Creation of the World
1981.
Stenciling by Eileen Gerstein,
embroidery by Pamella Nesbit;
15in x 22½in (38cm x 56cm).
Collection: Pennsylvania
Academy of the Fine Arts,
Philadelphia, Pennsylvania.
(following pages)

Birth Mouth
1982.
Ink on paper;
9in x 12in (23cm x 30cm).
Collection: The artist.
(above top)

Untitled
1980–81.
Ink on paper;
9in x 12in (23cm x 30cm).
Collection: The artist.
(above)

There are also many figurative elements: the human leg that dominates the design, and small images of birds, animals, and fish. The overall style is much more expressionist than anything Judy Chicago had created previously. The crisp symmetry of her earlier compositions has been banished in favor of the swirling patterns that stretch across the entire width of the composition. It is possible to see links with the work of the Norwegian painter Edvard Munch (1863–1944), whose intense treatment of emotional states was a major influence on the development of the German expressionist movement in the first years of the 20th century. By moving in this direction, Chicago was of course developing in step with the neoexpressionist current that began to be felt in European art at the same moment. While working on the tapestry cartoon, Chicago began to research the subject of birth:

"When I scrutinized the art-historical record, I was shocked to discover that there were almost no images of birth in Western art, at least not from a female point of view. I certainly understood what this iconographic void signified: The birth experience (with the exception of the birth of the male Christ) was not considered important subject matter, not even to women."
CHICAGO, 1996; P. 89

She decided she would have to turn to direct experience to fill the gap:

"While continuing to work in the studio daily, I began to seek out private photographs and descriptions from people who'd either given birth, witnessed, and/or participated in the birth process, or studied and documented it. It was an advantage to be in the Bay Area, where there was an active natural childbirth movement. As a result many people seemed eager to share their birth stories and pictures with me."
CHICAGO, 1996; P. 90

Eventually she was able to witness her first birth:

"I had the opportunity to see a well-prepared natural childbirth in a hospital with a cozy birthing room, attended by a doctor and a resident who were not only women but feminists, and, hence, sensitive to a birthing mother's needs. I can only imagine my reaction to less empowering birth experiences, like those suffered by too many women in the world."
CHICAGO, 1996; P. 92

In fact, the physical violence of the experience does seem to have had a profound effect, as indicated by a number of simple outline sketches made at this time. They are even more expressionist in style than the design made for *The Creation*.

Chicago was now keenly interested in continuing to work with Audrey Cowan and also to reach out to some of the many women who had written to her about their responses to *The Dinner Party*, offering their services if she did another large-scale project. Her idea for the *Birth Project*, as it was now officially called, involved people working in their own homes, rather than setting up a new, centralized studio. The often hostile response to *The Dinner Party* had also placed in her mind the thought that one of the things she most wanted to do was to break through what she calls

"coded language forms of contemporary art."
CHICAGO, 1996; P. 119

This may have accelerated the movement toward expressionism in her new work, since expressionism is really a kind of "antistyle"—it involves the rejection of formulas in favor of the open, unabashed venting of subjective emotion. However, she also began to think of other goals:

"I realized that I definitely wished to avoid another head-on collision with the art world and was therefore determined to find a way to distribute the work so that it would not encounter the kind of institutional resistance that had met *The Dinner Party*. At the same time, I wanted the art to be seen by a wide range of viewers because I was intent upon trying to extend the process of democratization exemplified by the creation and, although I had not planned this, the distribution of *The Dinner Party*. In terms of the *Birth Project* I was accomplishing this goal in that the images were being executed through a national network of participants. As to exhibition, even though *The Dinner Party* was being successfully shown through community efforts, it was complex to install and expensive to display. I wondered if I could figure out a way for the *Birth Project* to be easier to set up and at the same time structured so as to allow the type of viewing I found most desirable."
CHICAGO, 1996; PP. 131–32

Quilts hanging on clotheslines in Hatch, New Mexico; reference for the Birth Project.

Her thoughts about display were shaped by an array of quilts she had seen some years previously, at the village of Hatch in New Mexico, which were simply hung on clotheslines.

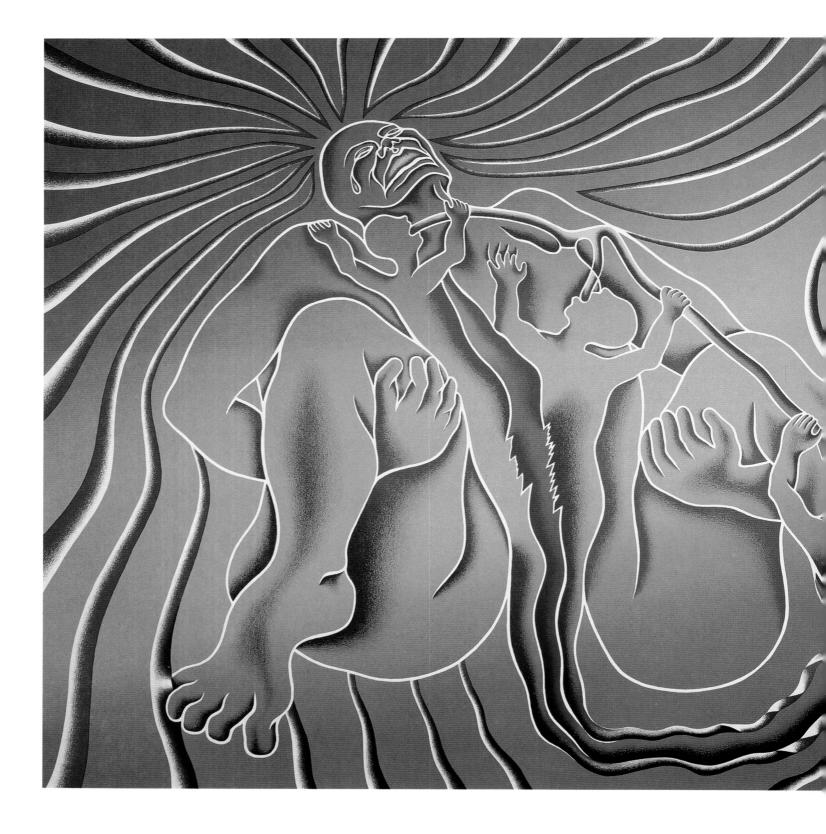

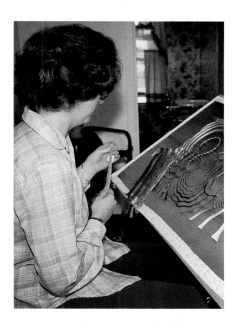

"I decided that one way of accomplishing some greater democratization while also meeting my own creative needs would be to offer the *Birth Project* art for exhibition in a variety of venues, depending on the nature of the work and the particular site. Instead of becoming a single mammoth work, the *Birth Project* might be better organized as a series of individual pieces of varying character that could be viewed one-on-one while also being monumental in overall concept."

CHICAGO, 1996; P. 133

While the *Birth Project* works have been widely exhibited in a number of venues ranging from the extremely prestigious to the extremely modest, they have never been seen all together. Between 1981, when the program was inaugurated, and 1987, when it ended, there were more than 100 exhibitions. During the height of its activity, between 1985 and 1987, there were as many as five shows a month. The viewing audience reached a total of 250,000.

*Judy Chicago and
Jane Thompson with
her daughter, Laura;
Jane Thompson working
on* Birth Tear/ Tear.
Houston, Texas, 1982.
(above and above right)

Birth Tear/Tear
from the Birth Project, 1985.
*Serigraph;
50in x 40in (76cm x 102cm).
Collections: Various.*
(left)

More concerted attention has been paid to the actual mechanics of the *Birth Project*, and to Judy Chicago's relationships with the team of needle-workers who collaborated with her, than to the appearance of the works themselves. It is time to try to say something about this.

François Boucher
(1703–70)
The Forge of Vulcan
1757.
Tapestry cartoon.
Collection: Louvre
Museum, Paris, France.
(above)

Some of the works, such as *The Creation*, are closely linked to a tapestry with the same theme and are attempts to simplify the original design and translate it into the idiom of North American craft. One point to reiterate here is that, from the late Middle Ages onward, tapestry-weavers have worked with fine artists. The tapestries produced in the French royal workshops of the 17th and 18th centuries were, for example, designed by leading painters, such as Charles Le Brun (1619–90), working for the Gobelins manufactory, and François Boucher (1703–70) at Beauvais. There is no such tradition in the "folk" crafts, so Chicago and her collaborators, in attempting to create serious artworks by using a variety of stitchwork techniques, were doing something entirely new.

To this was added the novelty, and often the violence, of the actual subject matter. Three versions of the same composition are illustrated. *Birth Tear/Tear* is a serigraph by Judy Chicago herself. At the time when the image evolved, the artist made the following note in her journal:

"[It] is very real and raw and powerful, and it brings up a certain amount of terror and discomfort in me... The power of the new images is incredible. I love them because they are an expression of who I am, and simultaneously I fear them because they result in so many personal dilemmas."
CHICAGO, 1986; P. 87

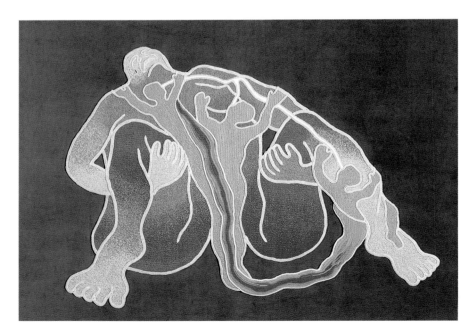

Birth Tear/Tear
from the Birth Project, *1982.*
Embroidery on silk by
Jane Thompson;
20½in x 27½in (50cm x 69cm).
Collection: Albuquerque Museum,
Albuquerque, New Mexico.
(right)

Birth Tear/Tear
from the Birth Project, *1985.*
Macramé over drawing by
Pat Rudy-Baese;
3ft 10in x 4ft 7½in
(1.17m x 1.4m).
Collection: Albuquerque Museum,
Albuquerque, New Mexico.
(left)

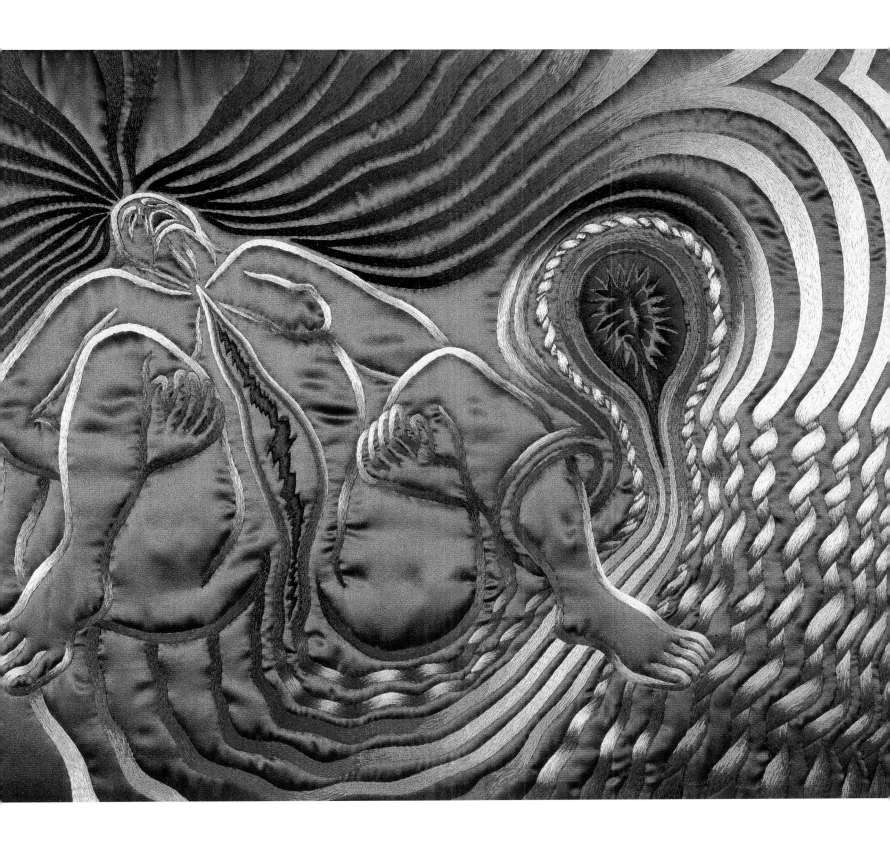

Study for
Birth Trinity
1982–83.
Ink on vellum;
9in x 12in (23cm x 30cm).
Private collection.
(right)

Birth Trinity
from the Birth Project, *1985.*
Reverse appliqué by Barbara
Velazquez, quilting by Jacquelyn
Moore and Ann Raschke;
3ft 11½in x 10ft 8in
(1.19m x 3.25m).
Collection: University of
Houston, Clear Lake, Texas.
(above right)

Birth Trinity
from the Birth Project, *1985.*
Needlepoint on 6-mesh canvas
by the Teaneck Group;
4ft 5in x 10ft 10in
(1.5m x 3.3m).
Collection: Albuquerque Museum,
Albuquerque, New Mexico.
(below right)

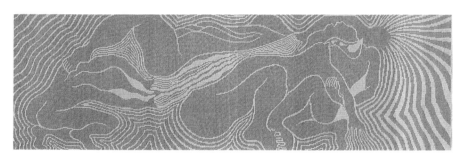

Detail from
Birth Trinity
from the Birth Project, *1984.*
(right)

Pattern for
Birth Trinity
1981.
Ink on rag paper;
3ft 6in x 10ft 6in (1m x 3.2m).
Private collection.
(above top)

Birth Trinity
from the Birth Project, *1984.*
Filet crochet by Martha Waterman;
3ft 6½in x 9ft 10in (1.07m x 3m).
Collection: Rose Art Museum,
Brandeis University, Waltham,
Massachusetts.
(above bottom)

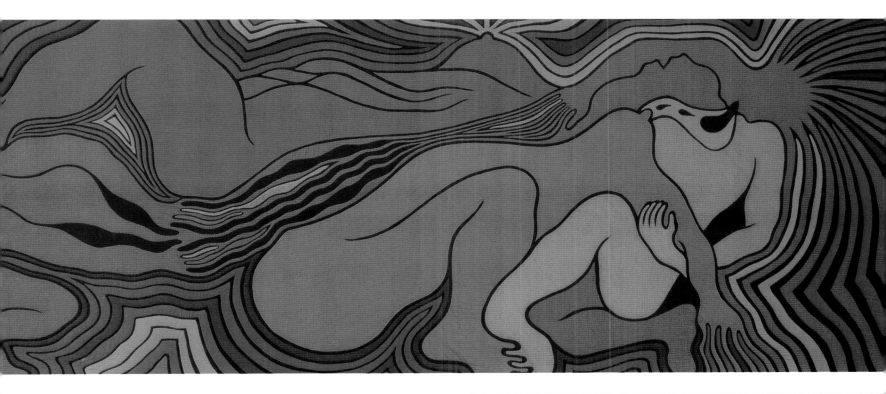

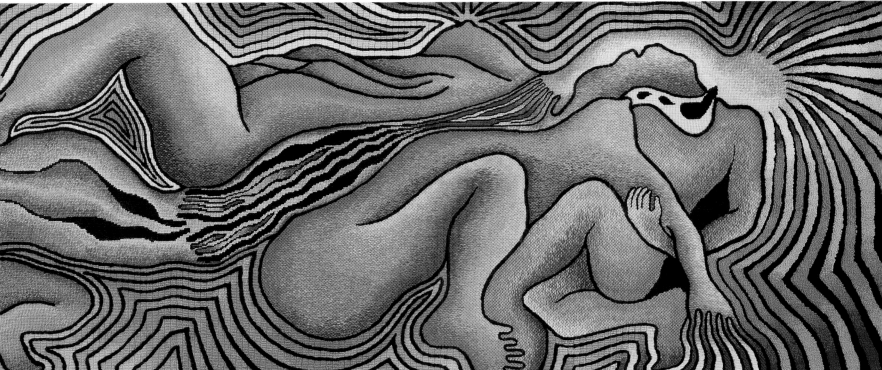

The serigraph closely resembles an embroidery of 1982. So close is the resemblance, in fact, that one gets the feeling that the artist is in some way trying to reclaim something she now almost regrets having put in the public domain. Interestingly enough, the addition of two child figures in the print makes it less, not more, violent than the embroidery that preceded it. One notes, in addition, the way in which the padded fabric makes the image more sensual, and therefore more disturbing. The third version is carried out in the wholly unexpected medium of macramé, a humble craft usually associated with objects like lamp shades and plant hangers. Here the composition is monumentalized and reduced to its essentials by the knotted cords used to create the outlines. The result achieved by using methods linked in people's minds with "hobbyist" craft possessing no aesthetic value offers an implied rebuke to conventional perceptions about women's roles in the world, and the impact of the image is thus actually strengthened. Chicago's willingness to experiment with this wholly unexpected technique is a good example of her "nonhierarchical" way of thinking about methods of image-making in general. What the technique will actually do, in terms of effectiveness and impact, is the thing that matters most, although she is not blind to social and cultural implications.

Birth Goddess
from the Birth Project, *1985.*
Embroidery on wool by
Candis Duncan Pomykala;
24⅛in x 28⅞in (61cm x 71cm).
Collection: Herbert F. Johnson
Museum, Cornell University,
Ithaca, New York.
(right)

Earth Birth
from the Birth Project, *1985.*
Sprayed acrylic on fabric,
quilting by Jacquelyn Moore;
5ft 3in x 11ft 4in (1.6m x 3.45m).
Collection: Through the Flower.
(below)

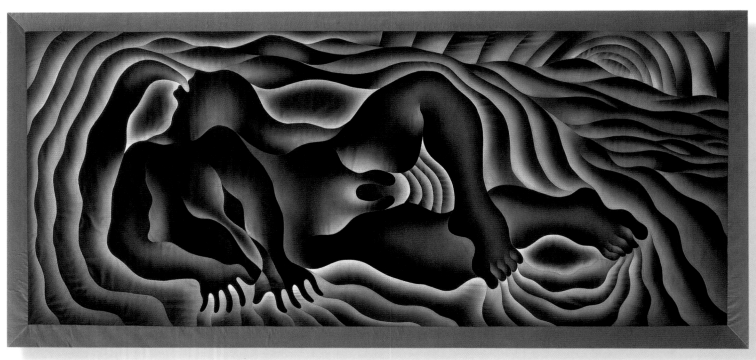

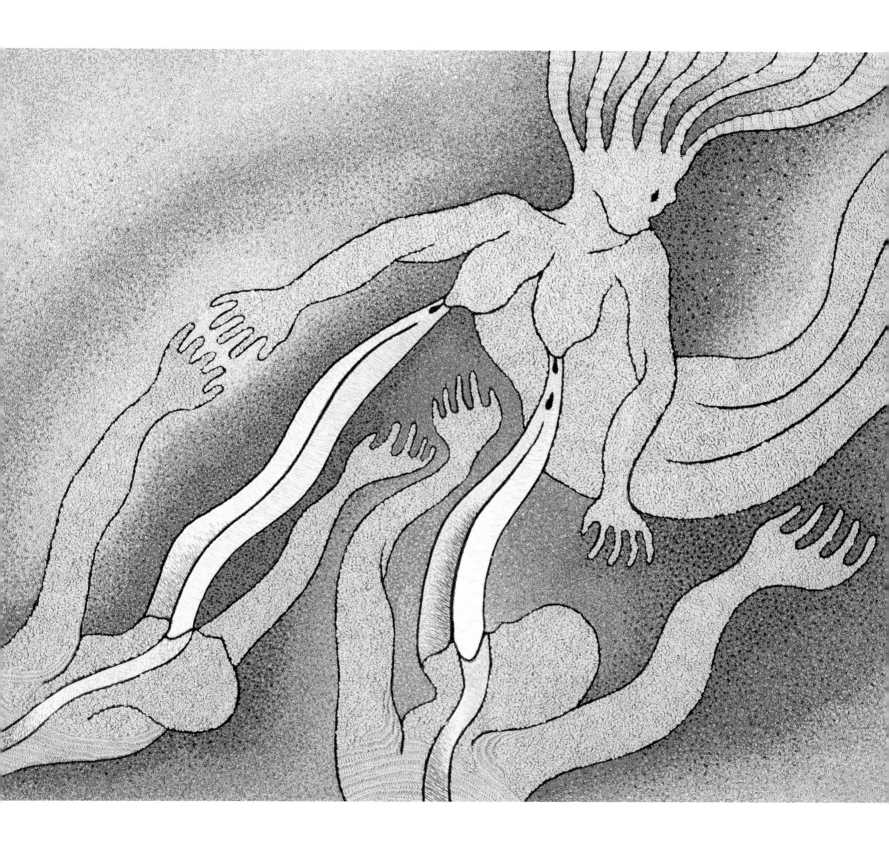

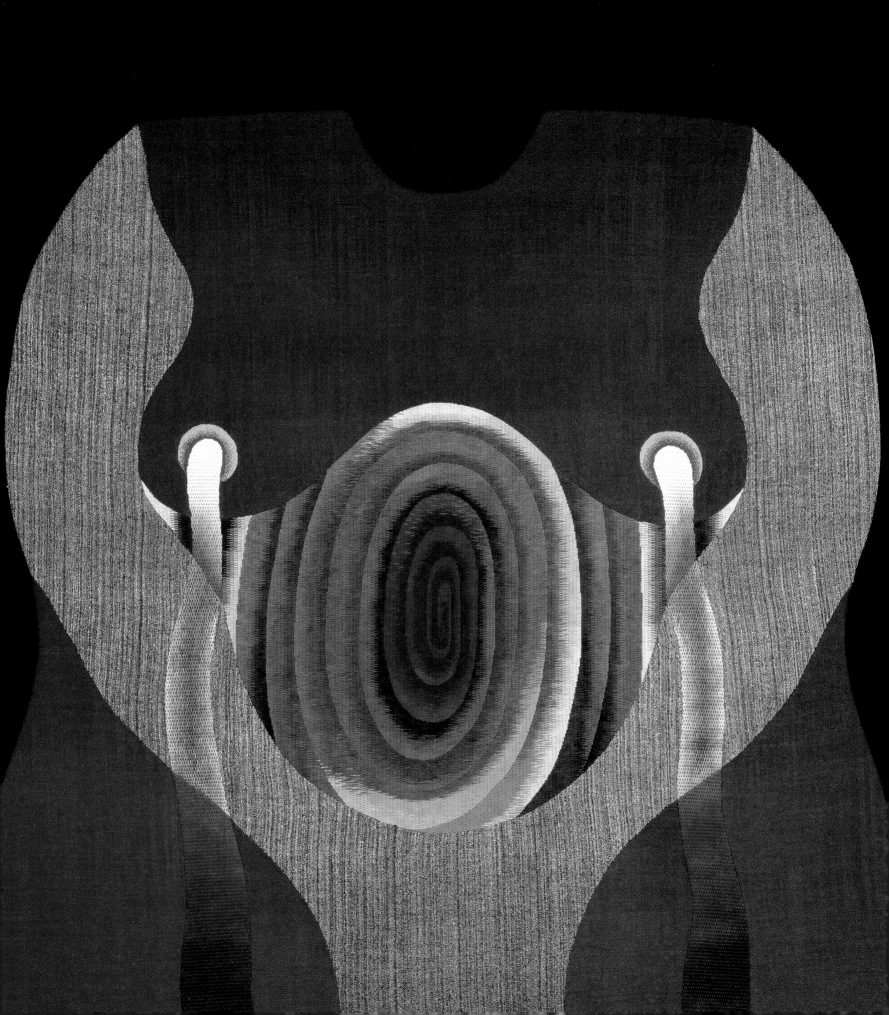

Birth Garment 1:
Pregnant Amazon
from the Birth Project, *1984.*
Dyeing, weaving, and needlepoint
by Helen Courvoisier, M.D.,
fabrication by Sally Babson;
5ft 8in x 5ft 7in
(1.12m x 1.09m).
Collection: Albuquerque Museum,
Albuquerque, New Mexico.
(left)

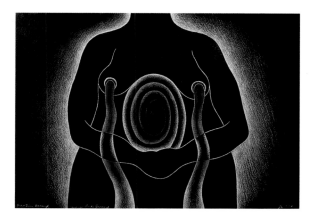

Macramé is not the only unexpected textile craft that finds a place in the *Birth Project*. *Birth Trinity*, for example, was executed in crochet, as well as in reverse appliqué (a technique in which successive layers of fabric are cut through and sewn back to reveal the fabric below), and in needlepoint. When one compares the original drawing for the composition, the pattern, and the finished piece in crochet, it becomes apparent how skillfully the needleworker has translated the artist's original idea, while a close-up view demonstrates that she has nevertheless remained completely faithful to traditional crocheting techniques.

Sometimes the discovery of a particular embroidery technique would influence the design. This is the case with *Birth Goddess*, the background of which consists entirely of French knots, made

following a laborious technique in which the thread is knotted with every stitch. The needleworker remarked that,

"The knots give depth to the piece by causing small shadows or 'ditches' to catch and reflect light."
CHICAGO, 1986; P. 174

Study for
Birth Garment
Prismacolor on black
Arches paper;
11in x 15in (28cm x 38cm).
Collection: The artist.
(above top)

Documentation panels for
What Did Women Wear?
from the Birth Project, *1984.*
Collection: Through the Flower.
(above)

There were also references to the part textiles themselves played in the birth process, and specifically to maternity garments—a source of grievance to many pregnant women. Despite the fact that the project was, so to speak, kick-started by *The Creation*, there are few weavings among the pieces. One reason for this, Chicago says, is that contemporary weaving, as opposed to the Aubusson technique used by Audrey Cowan, is not pictorial in nature. She did, however, feel that weaving could be used to represent garments, and this was the genesis of *Birth Garment 1: Pregnant Amazon*. Comparing this with Chicago's preparatory study, one can again see how faithfully her intentions were carried out. Pieces of this kind were exhibited with an explanatory panel, such as *What Did Women Wear?*—first to

contextualize the images, and second to make the work more accessible to a nonart-world audience. In some of the *Birth Project* panels, the stylistic vocabulary was adapted to a particular ethnic group. The most conspicuous instance of this is the large panel *Mother India*, which is composed in the manner of Indian folk-art hangings, with a central panel showing a pregnant Shiva, surrounded by subsidiary scenes. While this uses appliqué, including traditional Indian mirror appliqué, and embroidery, large areas are spray painted. The piece, through its appropriation of motifs, reverts to some of the approaches used in *The Dinner Party*. It is also rather ploddingly didactic in its subsidiary scenes. While Judy Chicago herself sets great store by it, it is not, in my view, one of the most successful pieces in the collection.

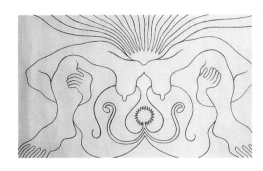

The compositions that seem to me to work best are those with the greatest universality—those that steer a path between the raw expressionist violence of *Birth Tear/Tear* and the resolute didacticism (and rather tame drawing) of *Mother India*. One of the strongest designs is *The Crowning*, whose versatility is shown in the group of illustrations: A fine Prismacolor drawing, an outline pattern, a version in needlepoint, and finally, a quilt in which the image is repeated four times. One of the reasons it works so unexpectedly well on the quilt is that the image is bilaterally symmetrical—it therefore, in a sense, reverts to the butterfly images Chicago used in the 1970s and gives them a new form. The outline pattern, which reduces the image to its simplest guise shows how powerful it is, regarded simply as a new visual invention, without reference to its meaning.

Earth Birth is another powerful image, of a more complex kind. By equating the female form with a landscape, it takes up an idea already used by the British sculptor Henry Moore (1898–1986). It also has a more distant relation in Michelangelo's figure of *Night* (1520–34; New Sacristy, San Lorenzo, Florence) and thus foreshadows the direction Judy Chicago's art was to take in her next large-scale enterprise, *Powerplay*.

Mother India

from the Birth Project, 1985.
Appliqué panels by Jacquelyn Moore, embroidered panels by Judith Kendall, and mirrored embroidery by Judith Meyers and Greeley, CO, Group; 11ft 2in x 8ft (3.4m x 2.4m). Collection: Through the Flower.
(below)

Pattern for
The Crowning
1980.
Ink on paper; 21¾in x 12¼in (55cm x 30cm). Collection: The artist.
(above top)

The Crowning
1982.
Prismacolor on black Arches paper; 30in x 40in (76cm x 101cm). Collection: Dr. Viki Thompson Wylder.
(above)

The Crowning
from the Birth Project, 1982.
Reverse appliqué and quilting by Jacquelyn Moore; 4ft 8½in x 7ft 5in (1.37m x 2.26m). Collection: Florida State University Museum of Fine Arts, Tallahassee, Florida.
(above right)

The Crowning
from the Birth Project, 1984.
Needlepoint by Fran Yablonsky; 5ft 1in x 3ft 4in (1.55m x 1m). Collection: Albuquerque Museum, Albuquerque, New Mexico.
(right)

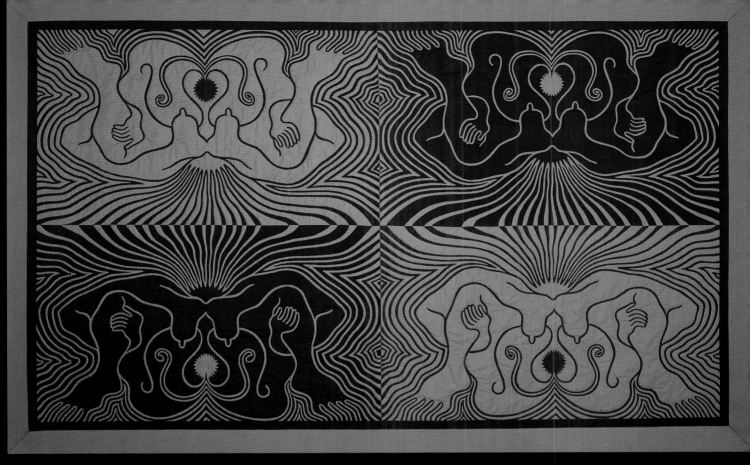

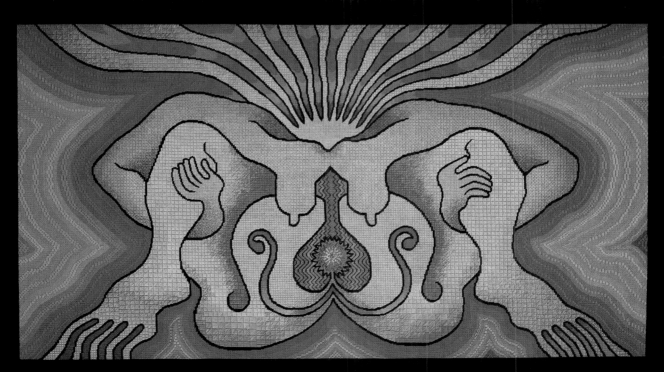

Salley, 11 births:1849, '51 '53, '55 '58 '59 '61 '64 '66, 1869, 1874 Magdelana, born 1833, 6 children

Malkah, born mid 1800's, 5 children

Miriam Ida, born 1837, 4 children

Lucinda born 1834 6 children Lydia Ann 12 births: 1859, '63 '65 '66 '68 '70 '73 '75 '76 '79 '81 1883

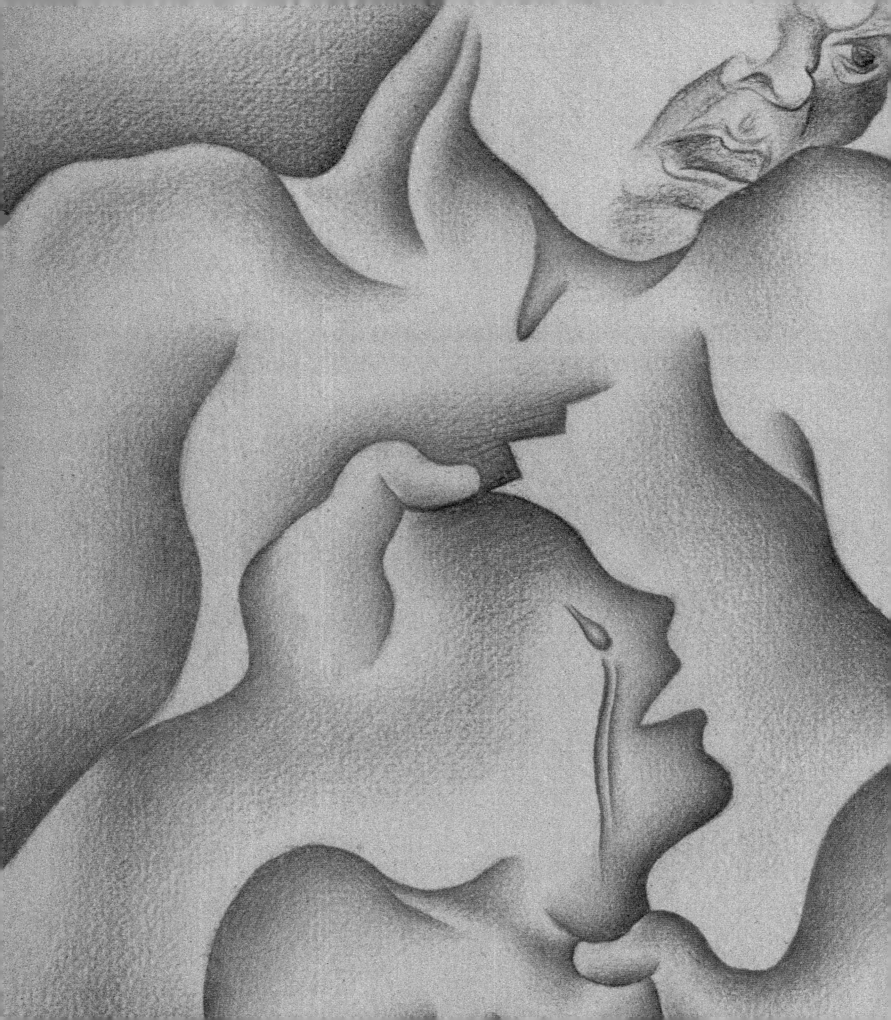

Chapter Six

Powerplay

Powerplay, begun in 1982, is an enterprise that overlapped with the *Birth Project*, but that could hardly be more different. In fact, almost the only thing the two series of images have in common is that they are both confrontational and deal with issues that have usually not made much of an appearance in Western art. Despite this fact, *Powerplay* is deeply rooted in the Western artistic tradition. Its beginnings stem from Judy Chicago's first visit to Italy in 1982. She went to Rome, Florence, Venice, Naples, and Ravenna and saw many of the Renaissance and earlier masterpieces she had hitherto known only from books. The works that made the greatest impact on her were in Rome—Michelangelo's Sistine Chapel ceiling and Raphael's *stanze* in the Vatican. These consolidated her desire to undertake something new:

"… an examination of the gender construct of masculinity [made] in much the same way as I'd been investigating what it means to be a woman. I was once again interested in dealing with ideas I had rarely seen represented in art—specifically how some women, myself included, perceived men. Over the years I had listened to women share their fears, rage, and frustration about how men acted both in private and in the world. Yet I knew that I didn't want to keep perpetuating the use of the female body as the repository of so many emotions; it seemed as if everything—love, dread, longing, loathing, desire, and terror—was projected onto the female by both male and female artists, albeit with often differing perspectives. I wondered what feelings the male body might be made to express. Also, I wanted to understand why men acted so violently."

CHICAGO, 1996; PP. 141–42

Detail from
Trying to Kill the Womanly Feelings in His Heart
from Powerplay, *1986.*
Prismacolor on handmade paper;
15in x 10in (38cm x 25cm).
Collection: Jeffrey Bergen,
ACA Galleries, New York, New York.

Study for
Powerplay
1985.
Prismacolor on parchment paper;
36in x 24in (91cm x 61cm).
Collection: Edward Lucie-Smith.
(right)

Andrea Mantegna
(1431–1508)
The Dead Christ
c. 1501.
Collection: Pinacoteca
di Brera, Milan, Italy.
(below)

A Return to Tradition

The masterpieces of the High Renaissance she saw in Rome brought her into direct contact with a tradition in which the male body, often nude, was the accepted vehicle for conveying emotion. Chicago seems to have been only partly aware of the precise historical context, but this partial awareness was clear enough:

"Looking at [the] monumental scale and clarity [of the major Renaissance paintings] led me to decide to cast my examination of masculinity in the classic tradition of the heroic nude and to do a series of large-scale oil paintings."
CHICAGO, 1996; PP. 143–44

According to her now long-established way of working, Chicago prepared for the finished works by making a large number of preparatory studies. These studies are

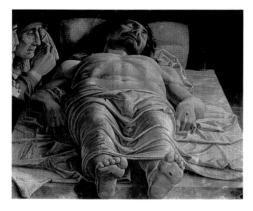

of great interest, not only in themselves but also when looked at in the context of the long-standing accusation that Chicago "can't draw." Because of the subject matter, she was here measuring herself directly against some of the greatest masters of the past. She was also, after moving away, first into abstract then into appropriated images, rediscovering skills that had originally been taught to her when she was a youthful student at the Art Institute of Chicago. This deliberate attempt to recuperate not only the skills of the past, but some of the attitudes toward art-making that the modernists were inclined to discard, makes Chicago fairly typical of the postmodern impulse.

"I began to work with a male model, finding it absolutely fascinating. It was remarkably different from drawing from a woman, which is what I had done in most of my figure-drawing classes, where there had sometimes been male models, but they were always clothed. When men did model, they were required to wear jockstraps, justified by the fact that, if naked, they might get erections. At any rate there was a distinct energy, gesture, and attitude in the male body, and also a strange sense of personal power in that I could render the figure in any way I wished. At first this scared me, but then I thought: 'This is a power men have had for centuries—the power to represent women however they wish.' If they could handle this, I saw no reason that I could not learn to do the same."
CHICAGO, 1996; P. 144

Study for
Pissing on Nature
1982.
Prismacolor on rag paper;
22in x 30in (56cm x 76cm).
Collection: The artist.
(above)

Pissing on Nature
from Powerplay, 1983.
Sprayed acrylic and oil on
Belgian linen;
9ft x 6ft (2.74m x 1.82m).
Collection: The artist.
(right)

One of the early stages in the study process is represented by a powerful outline drawing of a male nude executed on parchment paper, and loosely based on Mantegna's famous painting of *The Dead Christ* (c. 1501), now in the Brera Gallery in Milan. Chicago's own drawing, with its exaggeratedly large hands and feet, has a lot in common with drawings by some of the first-generation masters of modernism—in this case a particularly strong resemblance to certain drawings by Fernand Léger (1881–1955). By anyone's standards, it is an impressive sheet. While Chicago expresses a characteristic confidence in her own powers in the passage just quoted from her second volume of autobiography, *Beyond the Flower*, there may also be an element of bravado there. Going through her personal archives in preparation for writing this book, I came upon the sheet illustrated here and asked, with some surprise, why it had never been exhibited. The reply was enlightening:

"I suppose I thought it was too bold for a woman."
CONVERSATION, 1997

This perhaps relates obliquely to another experience that she recounts in *Beyond the Flower*:

"Almost immediately after starting work on these images, I came up against what can only be described as an internalized taboo against depicting men critically, manifested in a ghastly nightmare. One night I woke up with a start, overwhelmed with terror. I was sure that someone was in the house and that I was going to be viciously brutalized or killed. This fear was so intense—and irrational—that I could only explain it as the result of making images about men. Throughout the years I worked on this series I would have the same nightmare again and again, always wakening in a cold sweat. Each time I would try to reassure myself that I would not be so punished; after all, I was only making art."
CHICAGO, 1996; P. 146

104

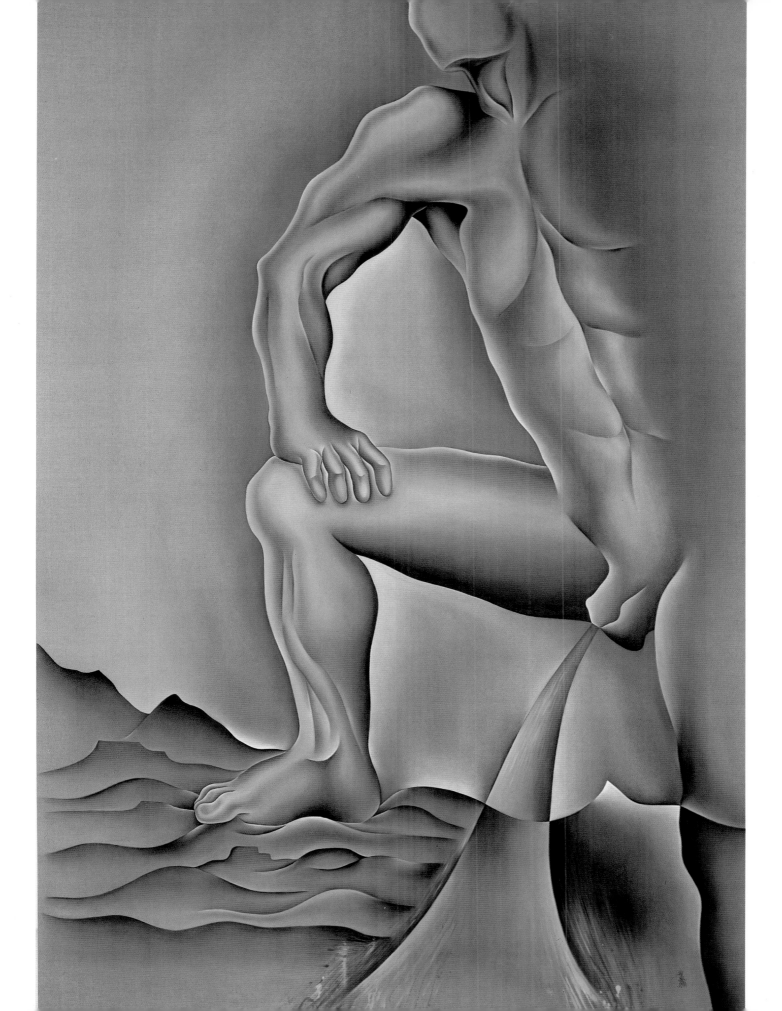

Study for
Rainbow Man, Attracting Her with His Light
1982.
Acrylic and Prismacolor on Stonehenge paper;
22in x 30in (56cm x 76cm).
Collection: The artist.
(above top)

Study for
Rainbow Man
1983.
Prismacolor on black Arches paper;
15in x 11in (38cm x 28cm).
Collection: The artist.
(above)

The studies for paintings in the series do exhibit a need to establish control over the forms to be used. Typical examples are preparatory drawings for *Pissing on Nature* and *Rainbow Man*. In these, both executed on parchment paper in black outline with a little color, one sees a need to make an elegant silhouette, almost in defiance of the declared subject matter. A second study for *Rainbow Man*, executed in white, plus color, against black, has an alluring, if rather mannered, art deco look. Other drawings are more complex, using the interlocking figures that also appear in some *Birth Project* compositions. Examples are *Struggling with those Womanly Feelings in His Heart* and *Trying to Kill the Womanly Feelings in His Heart*. They make one aware that the artist has been looking at some of the later developments in Cubism. Sources that suggest themselves are Picasso's *Three Musicians* (two versions, both 1921; Philadelphia Museum of Art, Philadelphia, and Museum of Modern Art, New York) and some of the paintings of figures made by Juan Gris (1887–1927). These resemblances make one aware that behind the avowed High Renaissance influence she is also influenced by the heroic masters of modernism, and she seems determined to challenge them on their own ground.

The finished works, the culmination of these drawings, were executed on a very large scale by the artist, working in a new studio she had set up for herself in a borrowed house in Santa Fe. *Pissing on Nature* is a 9ft x 6ft (2.74m x 1.82m) canvas; *Rainbow Man* is a triptych measuring 9ft x 22ft (2.74m x 6.7m). As usual, Chicago set herself—and others—a series of technical problems. The paintings are on Belgian linen, which is a traditional artists' material—but instead of the usual white gesso surface, Chicago wanted something that would show the natural warm beige of the cloth, yet still provide the sealed surface essential for oil paints. It took the technicians she contacted some time to accomplish this. The underpainting is in sprayed acrylic; the final top layer is in oil. Each stage offered its own particular series of difficulties. At the airbrushing stage, most of the image was covered and so could not be seen complete. Oil painting made the figures seem even more powerful and threatening.

"The oil painting took a long time, the process made even lengthier by the fact that I would paint and cover the same area repeatedly. If I let my brush freely express what I felt, I became scared of what I painted, thinking it ugly and obscuring it, only to paint exactly the same thing all over again."
CHICAGO, 1996; P. 15

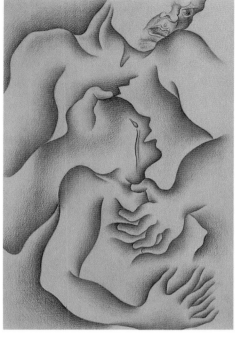

Struggling with those Womanly Feelings in His Heart

from Powerplay, 1986.
Prismacolor and pastel on handmade paper;
15in x 10in (38cm x 25cm).
Collection: Jeffrey Bergen, ACA Galleries, New York, New York.
(left)

Trying to Kill the Womanly Feelings in His Heart

from Powerplay, 1986.
Prismacolor on handmade paper;
15in x 10in (38cm x 25cm).
Collection: Jeffrey Bergen, ACA Galleries, New York, New York.
(above)

Rainbow Man

from Powerplay, 1984.
Sprayed acrylic and oil on Belgian linen in three panels;
9ft x 22ft (2.74m x 6.7m).
Collection: The artist.
(following pages)

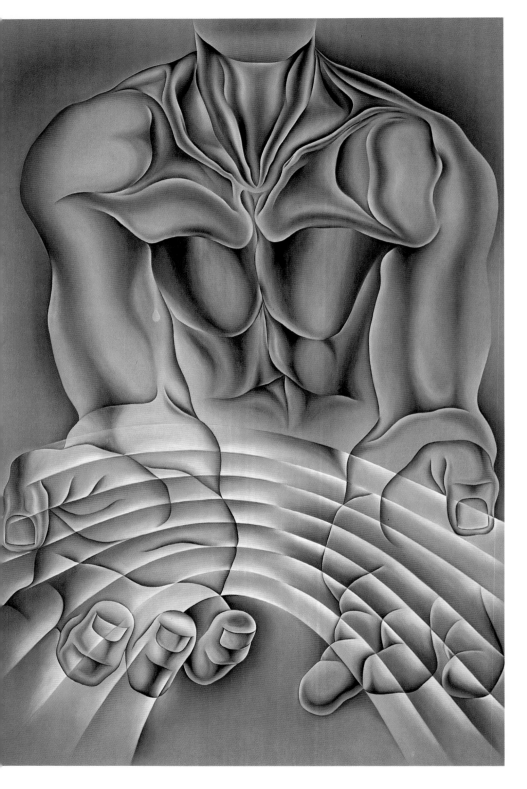

Michelangelo Buonarroti
(1475–1564)
Athlete
1509.
Fresco panel;
4ft 11in x 12ft 10in
(1.5m x 3.9m).
Sistine Chapel Ceiling,
The Vatican, Rome, Italy.
(above)

In the Shadow
of the Handgun
from Powerplay, *1983.*
Sprayed acrylic and oil
on Belgian linen;
9ft x 12ft (2.74m x 3.66m).
Collection: The artist.
(right)

The result is what Dr. Paula Harper, who wrote the catalog introduction for the first, and so far only complete, showing of *Powerplay*, describes as

"symbolic figures in a surreal, transparent, prismatically colored space."
HARPER, 1986; P. 7

This description is accurate as far as it goes, but several other factors have to be taken into account. Chicago has a peculiarly direct, and often rather brutal, way of using pictorial symbolism. This is the case with *Pissing on Nature*. The act of male urination can surely never before have been presented on such a heroic scale. *In the Shadow of the Handgun*—another enormous canvas (it measures 9ft x 12ft/2.74m x 3.66m), and one of the later paintings in the series—offers a curt visual pun. The male figure shoots a spray of blood from the tip of his extended forefinger. Chicago recalls:

"Again I had to overcome my fright at what was an extremely forceful image ... Almost as soon as I started this picture, I began having nightmares again. Then, almost as if my bad dreams were summoning terrible events into being, I began to be harassed by a man in the alley that ran along the side of the house, who would stand at my window and masturbate."
CHICAGO, 1996; P. 154

There was an ironic conclusion to this rather unpleasant episode. Someone lent Chicago a pistol and taught her the rudiments of using it. The exhibitionist reappeared when she had guests staying with her.

"Reaching into the drawer, I pulled out the gun and did just what Manuel Griego [her housekeeper's husband] had suggested some months before. I pointed the pistol at the guy and shrieked at the top of my lungs that I would blow his cock off if he didn't leave."
CHICAGO, 1996; P. 163

The unwelcome visitor never reappeared.

The image of *In the Shadow of the Handgun* may have been prompted, subliminally at least, by Chicago's long-standing antipathy toward one of the most famous images on the Sistine ceiling—the one that shows God giving life to Adam by extending his arm and pointing with his forefinger, as Adam's forefinger rises languidly to meet him. She feels that this version of the creation of humankind explicitly excludes the role of women. Converting the creative gesture into a destructive one is her revenge on Michelangelo.

What happens if one tries to place these huge, ambitious compositions in the general context of 20th-century art? Paula Harper suggests that they are "surreal," but this is true only if one defines the adjective in the loosest possible fashion. I have pointed to connections, especially among the preparatory drawings, with works by Picasso, Léger, and Gris—that is to say, with aspects of cubism. I think, however, that their most direct ancestry can be found in the work of the major Mexican and North American muralists of the 1920s, 1930s, and 1940s. In particular one thinks of aspects of Diego Rivera, José Clemente Orozco (1883–1949), and Thomas Hart Benton. All of these artists looked for ways in which to democratize modernism and make it accessible to large audiences. They were not afraid to look back to the 19th century for allegorizing and moralizing elements that the pioneering European modernists had been keen to discard (though in some cases—Picasso and Léger come to mind—they were later to return to them).

Orozco's powerful frescoes in the Hospicio Cabañas in Guadalajara (1936–39), his most celebrated works, have a distinct affinity with some of the large *Powerplay* compositions, both in their directness and in the confident way in which they use a system of self-invented symbolism—see, for example, the painting that is the conclusion of the whole series, *Driving the World to Destruction. Powerplay* seems to offer fragments of a mural cycle—bold public statements, not objects for private contemplation—and it would be interesting to see what Judy Chicago could do with the mural form. The history of the Mexican mural movement does not, however, offer encouraging precedents. Though there

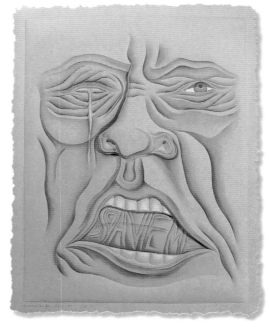

Doublehead/Save Me
from Powerplay, 1986.
Oil on hand-cast paper;
51in x 39½in x 5in
(130cm x 99cm x 8cm).
Collection: The artist.
(above)

Powerheadache
from Powerplay, 1986.
Modified Aubusson tapestry
woven by Audrey Cowan from
the artist's photo-cartoon;
24in x 20in (61cm x 50cm).
Collection: Camille and David
Lyons, Austin, Texas.
(right)

was a group of talented women painters working in Mexico during the 1930s and 1940s, almost none were commissioned to do murals. Leonora Carrington (b. 1917) made one for the National Museum of Anthropology in Mexico City. Frida Kahlo never made a mural and contrasted the private nature of her activity as a painter with the public gestures made by her husband, Diego Rivera. Maria Izquierdo (1902–55), arguably even more talented than Kahlo, was deprived of a major mural commission for the Palacio Nacional, already agreed, because Rivera and David Alfaro Siqueiros (1896–1974), the third member of the ruling male triumvirate of muralists, thought she was too inexperienced to handle the job. Izquierdo had, at that time, been working as a professional artist for more than 15 years. This brief account gives a glimpse of the strong prejudice that then existed—and that continues to exist—against women undertaking works of "public" art. It is felt in North America and Europe just as strongly as it is, and was, in Mexico.

Powerplay does not consist solely of allegorical compositions. A number of the works included in the series are of male heads seen close-up. They are executed in a variety of materials: there are paintings, often on a large scale, such as *Three Faces of Man*; finished drawings, such as *Weeping Maleheads*; bronze reliefs, such as *Malehead* and *Woe/Man*; cast paper reliefs, such as *Doublehead/Save Me*; and tapestries made from Judy Chicago's designs by Audrey Cowan, for example *Powerheadache*. They depict the faces members of the male sex present to the world, as well as the vulnerability that men will not or cannot allow themselves to show. Chicago locates the seat of vulnerability at the base of the throat, an observation supported by studies made by professional zoologists. When a male animal, wolf or dog, submits to a superior member of the pack, it

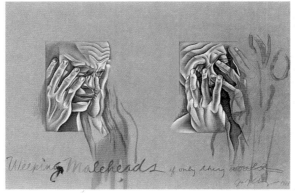

Weeping Maleheads:
If Only They Could/Would
from Powerplay. *1985.*
Prismacolor and ink on paper;
27½in x 36½in (69cm x 91 cm).
Collection: Unknown.
(left)

offers its throat as a token of submission. In *Woe/Man*, for which Donald Woodman, Chicago's new husband, posed, the head is lifted and the throat exposed in a gesture suggesting vulnerability. The piece was the outcome of Woodman's comment that he wished his new wife would offer a picture

"of men as women might wish them to be."

CHICAGO, 1996; P. 191

The heads were as meticulously prepared as the allegorical compositions. The preparatory material includes photographs taken using a model who was also an actor, and therefore able to assume the requisite expressions, and sketches exploring the same expressions. In creating these heads Judy Chicago was reverting to a well-established tradition. In the 18th century, for example, engraved drawing books reproduced sketches by well-known artists as a guide to students seeking the appropriate means of portraying various human emotions. These students were also encouraged to paint so-called *têtes d'expression*. On occasion these studies were pushed to extremes. Examples are the extraordinary grimacing heads sculpted by the Austrian artist Franz Xavier Messerschmidt (1736–83) and Géricault's portraits of madmen and madwomen, which attempt to classify different types of insanity through the study of facial expressions.

Rather than being an expressionist artist, Judy Chicago here shows herself to be a belated disciple of the 18th-century Enlightenment—someone who scrutinizes human behavior in a quasi-objective way. This shift in attitude was to stand her in good stead for her next major venture, the *Holocaust Project*.

Three Faces of Man
from Powerplay, 1985.
Sprayed acrylic and
oil on Belgian linen;
4ft 6in x 3ft
(1.37m x 0.91m) each.
Collection: Ruth Lambert and
Henry Harrison, New Haven,
Connecticut.
(previous pages)

Woe/Man
from Powerplay, 1986.
Bronze, multipatinated
by the artist;
48in x 36in x 5in
(122cm x 91cm x 12.5cm).
Collection: Elizabeth A. Sackler,
New York, New York.
(right)

Photo base for
Three Faces of Man
1985.
(left)

Malehead
from Powerplay, 1986–87.
Bronze, multipatinated
by the artist;
30in x 22in x 3in
(76cm x 56cm x 8cm).
Collection: Museum of Fine Arts,
Santa Fe, New Mexico.
(left)

Detail from study for
Malehead 3
1985.
Prismacolor and
graphite on paper;
14in x 10in (36cm x 25cm).
Collection: The artist.
(left)

Study for
Maleheads
1985.
Prismacolor on rag paper;
22in x 30in (56cm x 76cm).
Collection: The artist.
(below)

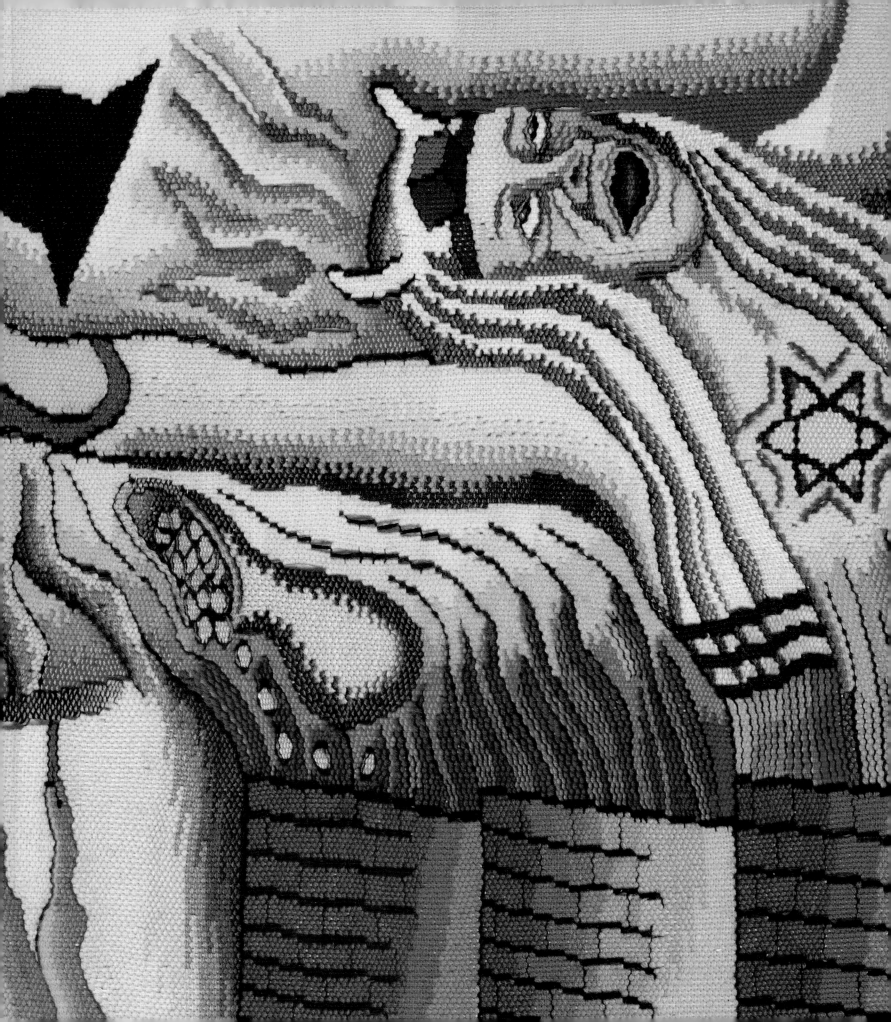

Holocaust

FROM DARKNESS I

The *Holocaust Project* was an u

in many respects, than *The Dinner Party*. Though t

it is still traveling. It is also still very difficult to e

course, is due to its subject matter. It has often b

subject too extreme for art to encompass. This ha

contemporary artists, in addition to Judy Chicago,

as subject matter. One instance is the work of

Boltanski's installation work *Memorial* (1985, Mus

widely from the *Holocaust Project* because it is ta

mugshots that Boltanski incorporates in this insta

schoolchildren taken in the interwar years. What w

of these children. Boltanski simply invites us to sp

Detail from
The Fall
from the Holocaust
Project, *1993.*
Modified Aubusson
tapestry, woven by Audrey
Cowan from Judy Chicago's
full-scale cartoon;
4ft 6in x 18ft (1.37m x 5.5m).
Collection: The artists.

remains within the accep

contemporary art and sh

and its taste for ambiguit

The German artist An

several paintings alludir

ambiguity about the su

the moral sphere. The

increased for many viewers by the fact that the

German rather than Jewish. Much of his referer

mythology, and it is never quite certain whether his

whether he accepts it at face value. Despite this

Jewish collectors in the United States. Their ch

linked to the fashion for German neoexpressionist

119

Jacques Callot
(1592–1655)
Miseries of War
Plate 14, 1652–55.
Engraving.
Collection: Bibliothèque
nationale de France,
Paris, France.
(above)

Artistic Responses to the Holocaust

George Segal's Holocaust memorial in San Francisco (1983) is a much more explicit work. When closely examined, it does contain symbolic elements—a woman lies against her male companion's rib, a half-eaten apple in her hand—but it is largely a literal transcription from the photographs and newsreels made at the time of the liberation of the concentration camps. It is actually based on one of the photographs taken by the leading news photographer Margaret Bourke-White (1906–71). The most striking deviation from the Bourke-White image is the apparently healthy condition of the victims and the sensuality of their poses. Criticized for this, Segal responded,

"That was also put there deliberately, so there would be overtones of the life force amid all the tragic (sic) and carnage."
BRENSON, 1983; SECTION C, P. 16

Like other attempts made in the United States to memorialize the Holocaust, it focuses on the American discovery of the full horror of the event and looks neither at the mechanics of genocide nor at its causes. Critics have also said that the monument is somehow diminished, and its meaning sanitized, by the beauty of its setting. This has not prevented vandalism. Four days after the dedication of the memorial, the faces of the figures were spray painted black and an inscription added on the wall behind: "Is this necessary?" Since then the sculptures have been sprayed with Nazi swastikas on a number of occasions.

The response to Segal's fairly literal representation of one aspect of the Holocaust indicates the explosive nature of the subject matter, even when it is presented in a form already made familiar to everyone through reports in the news media. As the first vandals at the site indicated, people know some of the facts, but often don't want to be forced to think about them. There is also the reaction pinpointed in *Maus*, Art Spiegelman's comic strip account of the Holocaust:

"Anyway the victims who died can never tell THEIR side of the story, so maybe it's better not to have any more stories."
SPIEGELMAN, 1991; P. 45

The Fall

from the Holocaust Project, *1993.*

Modified Aubusson tapestry, woven

by Audrey Cowan from Judy Chicago's

full-scale cartoon;

4ft 6in x 18ft (1.37m x 5.5m).

Collection: The artists.

See Holocaust Project: From
into Light, *pages 118–139.*

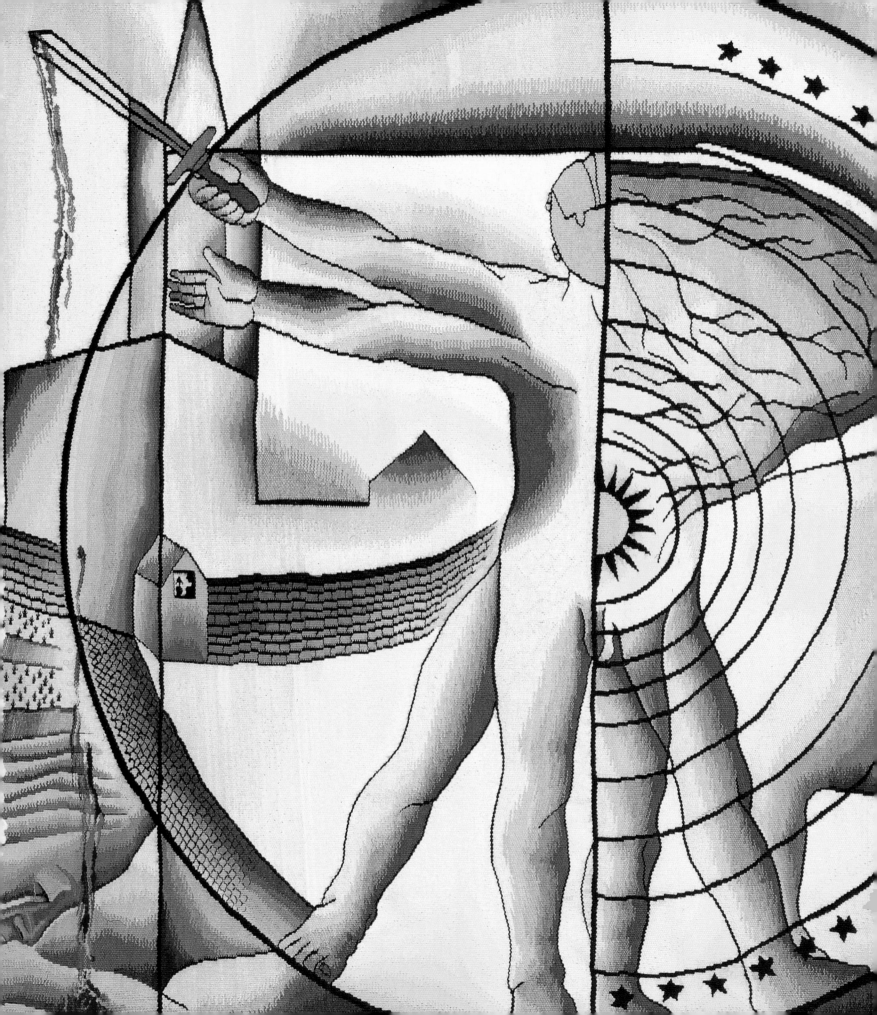

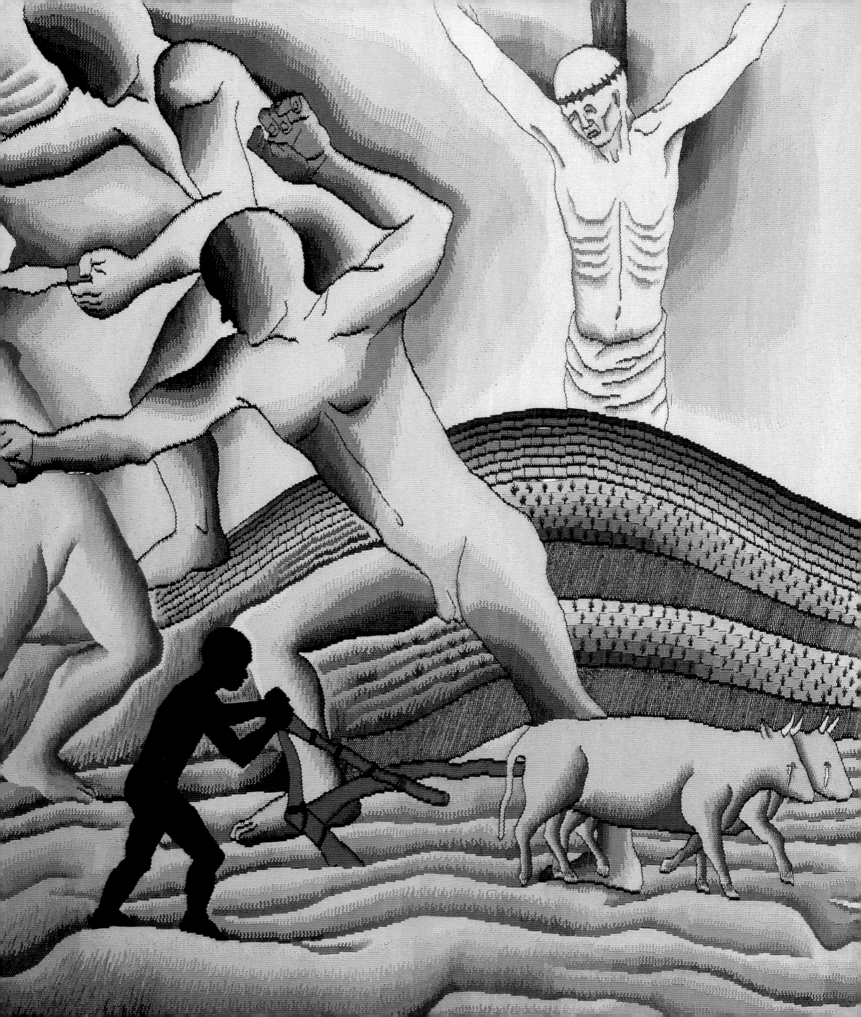

"I chose tapestry, which I believe is the perfect technique for this subject matter, because I want to emphasize how the Holocaust grew out of the very fabric of Western civilization."

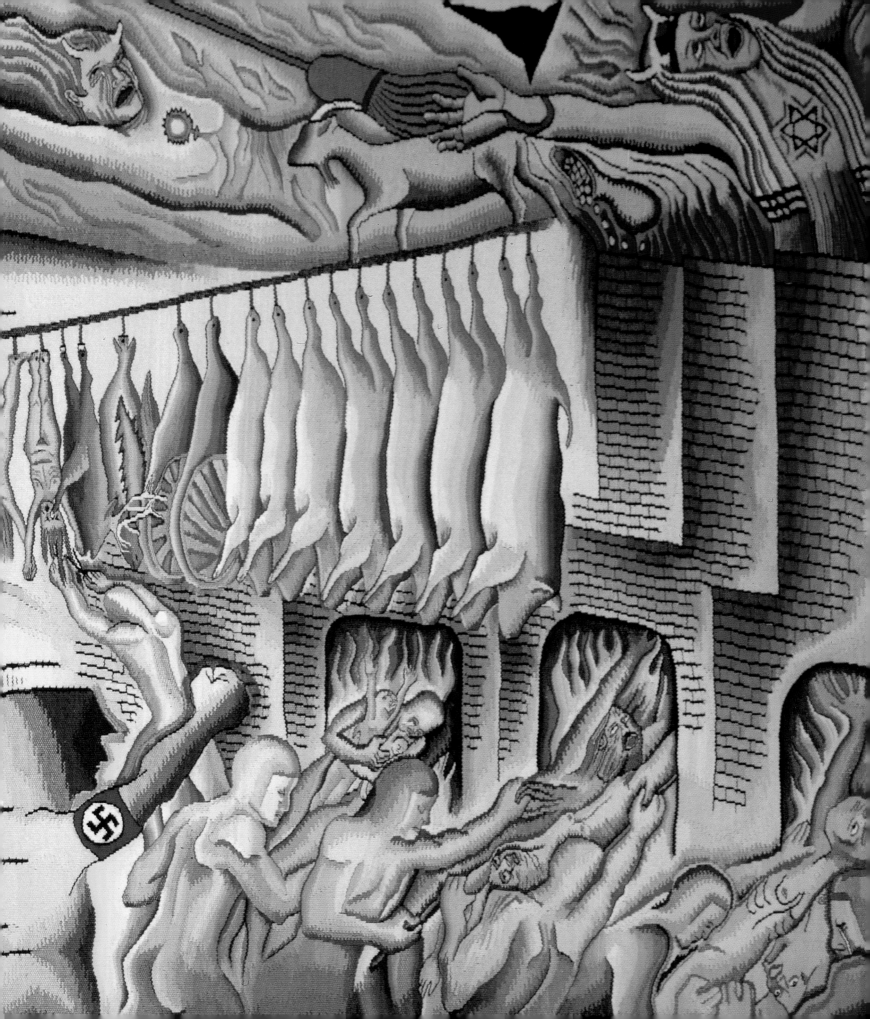

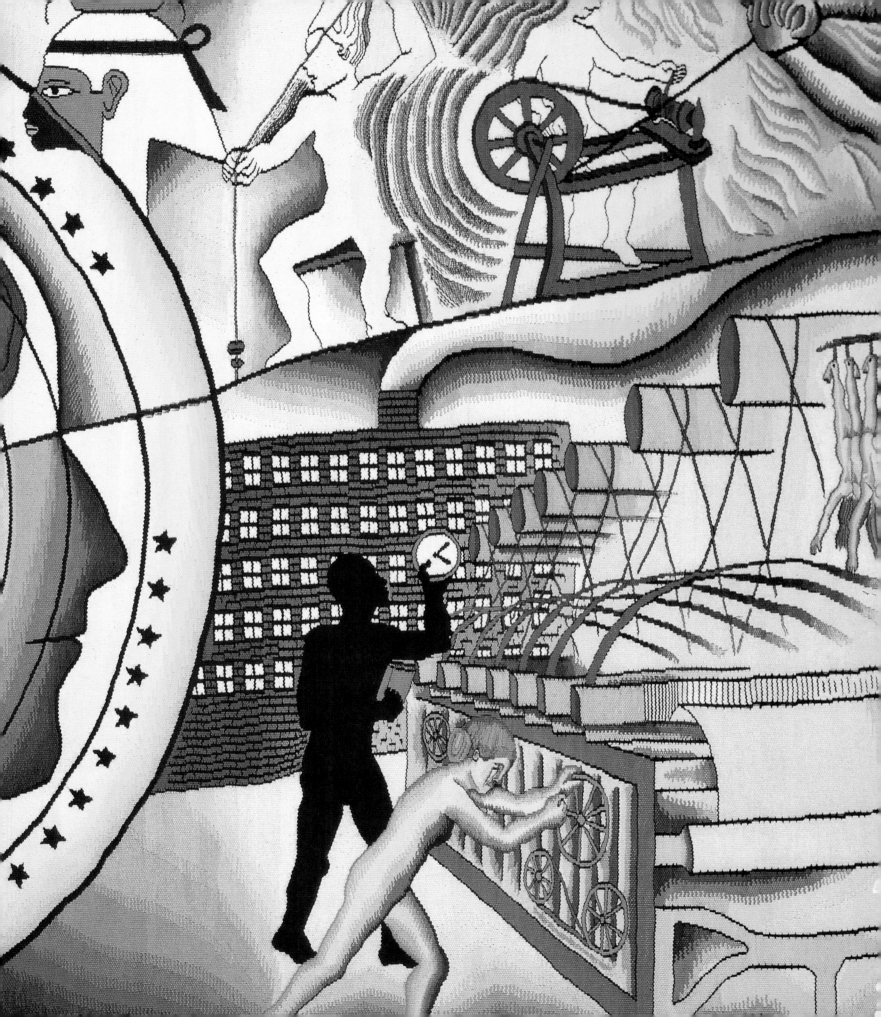

Maus has been an enormous success, largely because of the accessibility of the popular form it adopts, but has also been extremely controversial. As Stephen C. Feinstein, curator of the touring exhibition "Witness and Legacy: Contemporary Art about the Holocaust," remarked,

"Many survivors found [it] something that came close to blasphemy. The depiction of Jews as mice and Germans as cats seemed to be a somewhat unfitting reminder of German propaganda through films such as Hippler's *The Eternal Jew*."
FEINSTEIN, 1995, P. 18

Basically, most artistic responses to the Holocaust fall into one of two basic categories. Either they are heavily coded works, often environmental or conceptual in form, presented in ways that make them acceptable to the contemporary art community. They are made by people who may indeed be Jewish by birth but who are without direct experience of the subject. These works usually seem excessively distanced from their declared theme. Or there is what has been called "survivor art"—artworks, almost invariably small in scale, made by men and women who did experience the life of the concentration camps. By no means all of the artists themselves survived, and their works have depended on chance for their preservation. The extreme circumstances in which these images were made seem to render considerations of aesthetic quality irrelevant. The fact that they were created at all is a sufficient tribute to human spirit.

What can be said about the best of them is that they often bear a resemblance to three famous series of prints: the "small" (1632) and "large" (1633) *Miseries of War* by Jacques Callot (1592–1635), which document the atrocities of the Thirty Years' War; and *The Disasters of War* (1810–14) by Francisco Goya (1746–1828), which records the horrors of the Napoleonic invasion of Spain. It seems likely that both of these artists personally witnessed at least some of the events they recorded. However, neither of them suggests a systematic approach to the torture and extinction of others.

The unique characteristics of the Holocaust sprang from two things—that it took place within the framework of a highly industrialized society, and was carried out on a vast scale, using industrial means, within an elaborate bureaucratic

*Francisco Goya
(1746–1828)*
This Is Worse
Plate 37 from The Disasters
of War, *1810–1814.
Etching.
Private collection.*
(below)

Inside a tunnel at Ebensee, 1987.
(above top)
Dachau crematorium, 1987.
(above)

framework. As Isaiah Kupferstein, former Education Director of the US Holocaust Memorial Museum in Washington D.C., said in a paper on the *Holocaust Project*:

"The Holocaust was an unparalleled event in human and Jewish history. Within the broad United Nations' definition of genocide as 'acts committed with an intent to destroy, in whole or in part, a national, ethnic, racial, or religious group, as such,' the Holocaust was one of the most massive and extensive genocides ever executed. As an event it differed from other genocides in intentionality, planning, scope, and implementation. Never before did a modern state implement a plan to kill every last person of a particular group—in this case, a Jew wherever he or she might be—simply for the 'crime' of being a Jew."
KUPFERSTEIN, 1991; P. 2

There is the further consideration—a subjective one—that this series of events took place within a society that thought of itself as possessing a highly developed ethical sensibility. The unease that permeates discussions of the Holocaust is due to the way in which it holds a mirror up to every person—artists and historians alike—who attempts to get to grips with it. Pity and horror are mingled with guilt, fear, and an enormous amount of unresolved anger against perpetrators now forever out of reach. We would like to excoriate them but instead have to speak to one another.

Because of these considerations the *Holocaust Project* is a development from *The Dinner Party*. *The Dinner Party* is a very large environmental piece, but one that controls the viewer's response through the use of information panels. Information panels played an even more prominent part in the various presentations of the *Birth Project*. The *Holocaust Project* also takes the form of a structured exhibition, equipped with information panels that occupy a totally separate space. However, the viewer's response is to some extent controlled by the audiotape that accompanies the show, though he or she is of course free to switch this off and look at the works in a self-chosen order. Chicago herself says that the narrative structure of the exhibition was modeled on the displays presented by the US Holocaust Memorial Museum in Washington D.C. and the Simon Wiesenthal Center's Museum of Tolerance in Los Angeles, neither of which is an art museum. The artists, Judy Chicago and her collaborator and husband Donald Woodman, thus largely usurp the curatorial function. Critics—and museum visitors in general—are by this time used to works of art that pretend to be

something else—part of a shop window display, for example, like the sculptures of Haim Steinbach (b. 1944). What they are not, in most circumstances, used to is an artwork that simulates a didactic historical display, thus exchanging one kind of museum function for another, but that then reverses the exchange, reasserting its claim to be art. The anger and dismay of those commentators who are accustomed to art world norms is perhaps understandable from their own perspective, but it is also inappropriate in relation to the actual subject matter of the piece. In particular, professional commentators often found it hard to accept the idea that the *Holocaust Project* was both a narrative and an artistic expansion of, and commentary upon, the story that was being told. Ordinary viewers do not seem to have had the same difficulty. On a purely personal level, the *Holocaust Project* sprang from the artistic collaborators' exploration of their own Jewishness, and the urge to undertake this exploration came, in part, from a change of relationships— their marriage to each other in 1986. This statement is not simply an extrapolation made by an outside interpreter—myself—but has been explicitly stated by the artists themselves (CHICAGO, 1993; PP. 6–7).

This kind of personal motivation may, in some senses, seem hubristic; but it is actually a very characteristic one in the field of contemporary art, which has always been rooted in the individual—rather than the collective—experience. In the case of the *Holocaust Project*, Judy Chicago and Donald Woodman also chose to include representations of aspects of their own struggle to deal with the subject, as a bridge for viewers who might otherwise be reluctant to confront some of the issues raised by the exhibition.

To say that the personal aspect was the only motivation would not be true. Judy Chicago relates the complex genesis of the exhibition in her book *Holocaust Project: From Darkness into Light*, published in 1993. The first impulse came from a meeting, in 1984, with the poet Harvey Mudd (b. 1940), who had just completed a long poem about the Holocaust. Chicago first thought of illustrating his text, and this led her to begin immersing herself in the subject. Later, she read about Claude Lanzmann's nine-hour film *Shoah* (1985). In 1985, she and Woodman flew to New York to see it.

"It totally overwhelmed us."
CHICAGO, 1993; P. 6

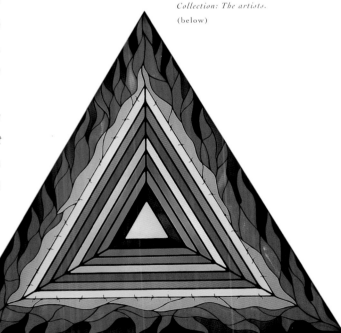

Logo
from the Holocaust Project, *1992.*
Stained glass, constructed by Bob Gomez, Michael Caudle, Flo Perkins, and Donald Woodman;
3ft 6in x 4ft 1in (1.07m x 1.24m).
Collection: The artists.
(below)

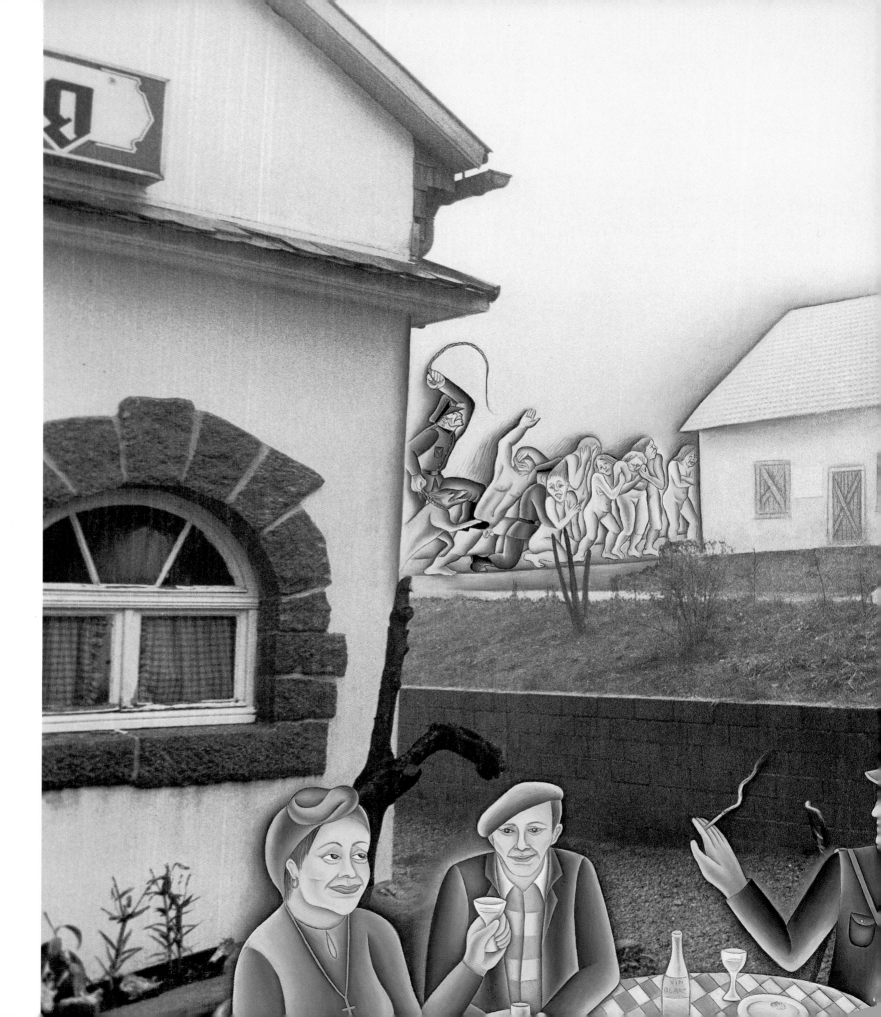

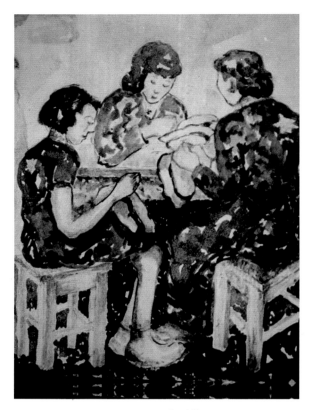

Jozef Kowner
(Dates unknown)
Drawing of women sewing
c. 1942.
Reference for the Holocaust
Project.
Collection: Warsaw Institute,
Warsaw, Poland.

Banality of Evil/Struthof
from the Holocaust Project,
1989.
Sprayed acrylic, oil, and
photography on photolinen,
30¹/₄in x 43¹/₄in (76cm x 109cm).
Collection: The artists.
(preceding pages)

Seeing the film triggered a long period of academic research—reading books, viewing films, traveling to UCLA and Yale to see taped survivor testimonies, and traveling around the United States to visit Holocaust exhibitions in order to see how the material was usually presented to the public. They also established contacts with leading Holocaust scholars. One of the things Chicago was searching for at this time was ways in which the Holocaust could be presented

"As a human event—done by people to people."
CHICAGO, 1993; P. 7

She and Woodman decided that, in order to do this, they would have to make a Holocaust pilgrimage themselves. In 1987, they traveled through France, Germany, Austria, what was then Czechoslovakia, Poland, and the then Soviet Union,

"Visiting concentration camps, extermination and massacre sites, and seeing what little remains of Eastern European Jewish culture."
CHICAGO, 1993; P. 8

Later, in 1988, they went to Israel, to see the country the survivors had built.

"What became clear as we traveled was that the Holocaust was much vaster in scale and more complex than we'd understood, and our ignorance was even greater than we'd imagined."
CHICAGO, 1993; P. 8

Everywhere they went, Woodman made documentary photographs, often in very difficult conditions. For example, the tunnels at Ebensee in Austria, used as a Nazi slave-labor factory, were now in total darkness and had to be lit by running through them with strobe lights. Woodman later said that the experience was totally exhausting, emotionally as well as physically (FROM DARKNESS INTO LIGHT, 1993). Many of the photographs Woodman took on the trip were first made as Polaroids, so that the collaborators could evaluate their reactions on the spot. Some of these survive as part of the notebooks Chicago kept to document the trip.

The completed *Holocaust Project* embraced many aspects of the subject and went well beyond the boundaries of a purely Jewish experience, though the Jewish experience did remain central to it. The emphasis on the human aspect of the

Holocaust involved a consideration of what seemed to be similar events and similar states of mind, and this in turn led to a broader philosophical meditation both about human capacity for evil and about the ways in which we all tend to disguise this potentiality from ourselves. This inclusiveness may supply an additional explanation for the hostility with which it was received in certain quarters.

The exhibition journey begins with a stained-glass logo, making use of the triangle motif the inhabitants of the camps were forced to wear, color-coded according to their category. This is followed by a large tapestry entitled *The Fall*, made in collaboration with Audrey Cowan, with whom Judy Chicago first worked on *The Dinner Party*. Chicago says,

"I chose tapestry, which I believe is the perfect technique for this subject matter, because I want to emphasize how the Holocaust grew out of the very fabric of Western civilization."
CHICAGO, 1993: P. 88

The composition is full of cultural references. The left-hand section—the composition reads from left to right—is based on the Hellenistic Altar of Zeus, Pergamon, in Berlin. The central image juxtaposes Leonardo da Vinci's famous image of *Vitruvian Man* (c. 1485–89; Accademia, Venice) with an emblematic representation of the "rational" Copernican universe. Chicago notes that she

"altered Leonardo's historic figure to show it for what I believe it truly embodies: That moment in human history when men consolidated patriarchal power through force and were able to represent themselves through art, literature, and history as the 'measure' of all reality."
CHICAGO, 1993: P. 90

The final scene shows victims being thrust into concentration camp ovens. Above them hangs a row of pig carcasses. The late 19th-century meat-packing plants in Chicago were the first examples of the modern industrial assembly line.

Detail from
Double Jeopardy
(panel 1) from the Holocaust Project, *1990.*
Sprayed acrylic, oil, and
photography on photolinen, silk
and embroidery on linen;
3ft 7in x 22ft 5in
(109cm x 6.83m).
Collection: The artists.
(below)

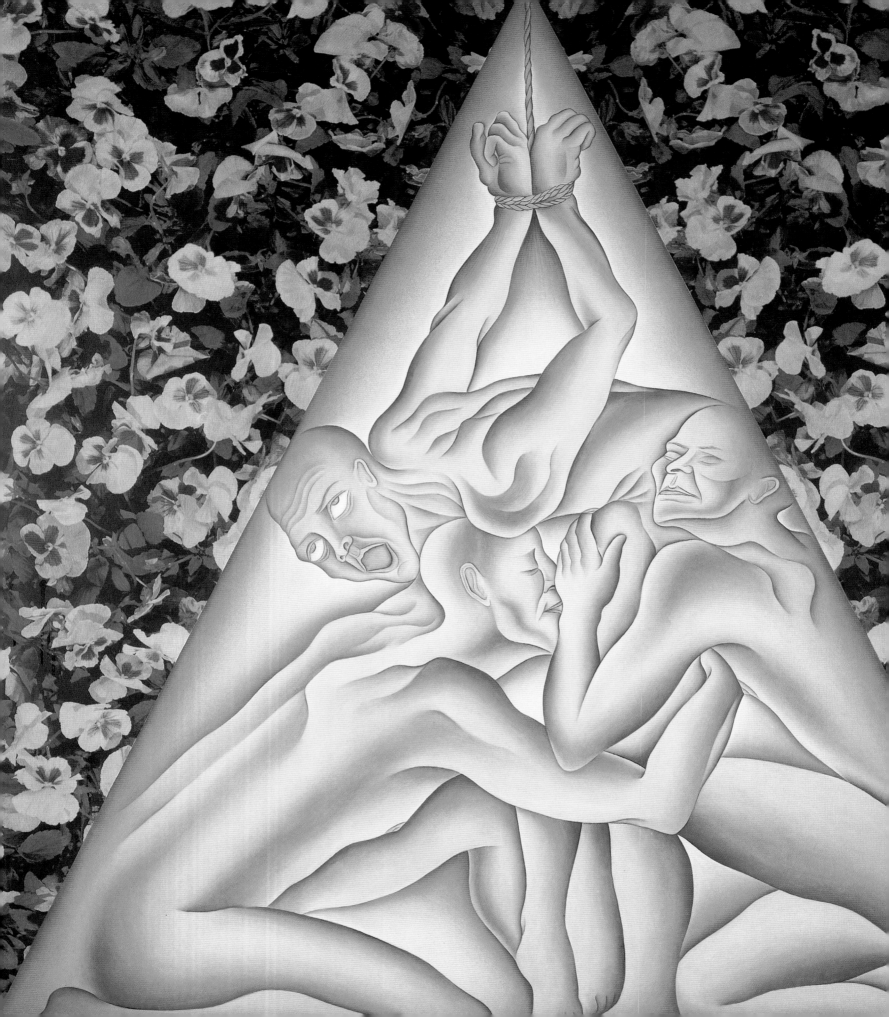

It is evident even from this brief description that representation and commentary are closely intertwined—there is, for example, a strongly feminist cast to the narrative Chicago has devised. What she wanted to do, she says, was to take the feminist perspectives developed by herself and others during the 1970s and 1980s beyond a focus purely on women. Her new allegiance to a Jewish identity was not, the tapestry declares, to exclude former loyalties. Indeed, in her commentary on the piece, the artist points to the similarity between antifeminist and anti-Jewish texts. She cites, in particular, texts connected with the witch-hunts of the 15th, 16th, and 17th centuries—specifically the *Malleus Maleficorum* of c. 1486, written by two German Dominicans and accepted for more than a century thereafter as the ultimate authority on the subject of witchcraft. There is an image of a witch surrounded by flames at the upper right of the tapestry.

Sometimes the narrative thread contained in the composition strains the established art historical facts. For example, Chicago reads the subject of the Altar of Zeus, Pergamon, as a battle between matriarchal culture and a newly emerging patriarchal society. Other feminists do the same. In this case the male Giants who appear in the frieze, since they are clearly defeated, would be the representatives of matriarchy—which seems strange, especially as many of their opponents are female. The more generally accepted reading is that the main frieze represents a battle of gods and goddesses against the Giants, heavenly powers opposed to subterranean or telluric ones—a much more appropriate subject for an open-air altar dedicated to Zeus, who was a sky-god in addition to being the chief father-god of the Greek pantheon. What matters, however, is not the mistaken interpretation but the vigor of the group of battling males and females that Chicago has created with this as her inspiration.

The general thesis offered by the tapestry is illustrated in more specific form by the images that follow. They employ a complex technique, which combines photography and painting, and which depends largely on the remarkable skills Donald Woodman was able to bring to the collaboration. Photography is used in a completely new way—not as the basis for painting, but as the equal partner of painting. Woodman described to me the intricacy of the techniques involved (INTERVIEW, MAY 1999), which he compared to some of the processes employed by the Victorian photographer Oscar G. Rejlander (1813–75) in creating

Detail from
Pink Triangle/Torture
(center panel) from the
Holocaust Project, *1989.*
Sprayed acrylic, oil, and
photo silkscreen on canvas;
48½in x 8ft 10½in
(1.2m x 2.69m).
Collection: The artists.
(left)

combination prints made up from multiple negatives. The most famous of these prints is *The Two Ways of Life*, in which more than 30 negatives were used. It was purchased by Queen Victoria from the Manchester Art Treasures Exhibition of 1857 as a present for Prince Albert. In a posthumous tribute to Rejlander, Henry Peach Robinson, a younger Victorian photographer, said that

"in clearness of story telling [this work] has never been surpassed in any art."
NEWHALL, 1980; P. 105

In fact, the photographic components of the *Holocaust Project* are even more complex than this comparison suggests. The images, which were either made by Woodman himself in the course of their travels or culled from documentary sources, were printed with superfluous elements removed by masking. Chicago worked on these prints, which were then rephotographed and transferred to photolinen, where Chicago worked on them again. Part of the problem lay in achieving precisely the right degree of contrast, so that painted and photographic elements would exist on equal terms.

With the Holocaust itself as a starting point, the images then progress in two simultaneous directions. In the first instance, they isolate and examine aspects of the event, or series of events, that seem to the collaborators to need more commentary than they have hitherto received. These aspects include the ease with which contemporaries of the Holocaust managed to ignore what was taking place and, linked to this, what the philosopher and Holocaust scholar Hannah Arendt described in an unforgettable phrase as "the banality of evil." They also include the fate of persecuted non-Jewish minorities such as gypsies, political prisoners, male homosexuals (wearers of the pink triangle, who were particularly badly treated), and lesbians. These groups of people have often been omitted or marginalized in standard accounts of the Holocaust. Chicago and Woodman also look at the fate of women in the world of the camps and ask themselves how this differed from that of members of the opposite gender.

The imagery deliberately combines the visionary and the mundane. The diptych *Bones of Treblinka*, for instance, invites a comparison with some of William Blake's illustrations to Dante's *Inferno* and honorably sustains this rather daunting

**Arbeit Macht Frei/
Work Makes Who Free?**
(center panel) from the
Holocaust Project, *1992.*
Sprayed acrylic, oil, welded
metal, wood, and photography on
photolinen and canvas;
5ft 7in x 11ft 11in
(1.7m x 3.63m).
Collection: The artists.
(right)

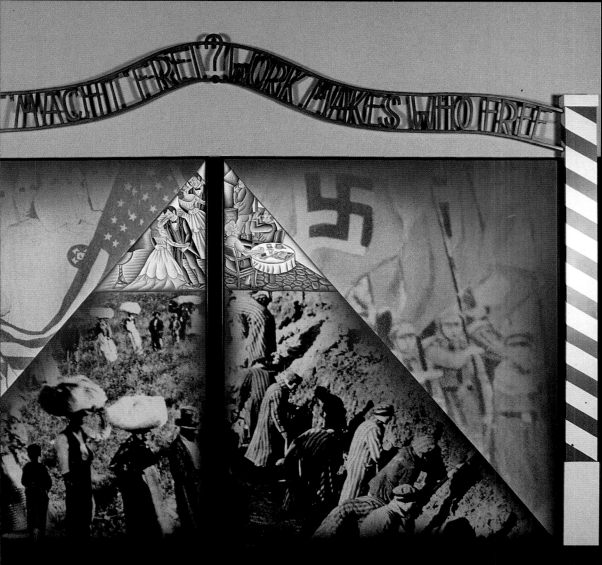

Details from

Arbeit Macht Frei/
Work Makes Who Free?

from the Holocaust Project,
1992.
(below)

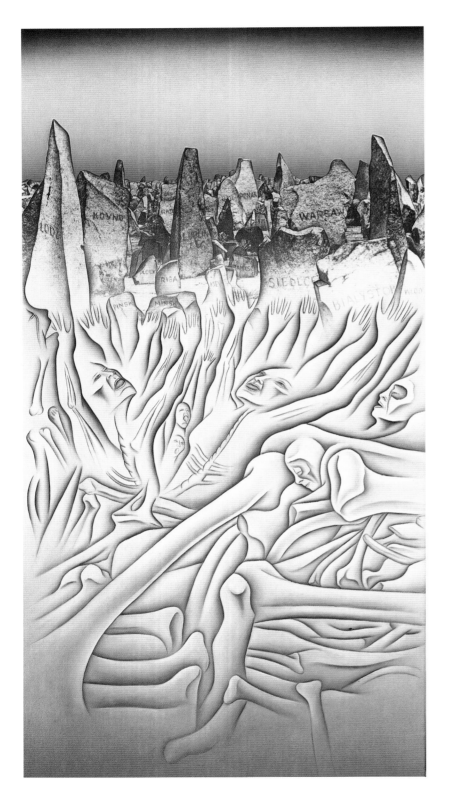
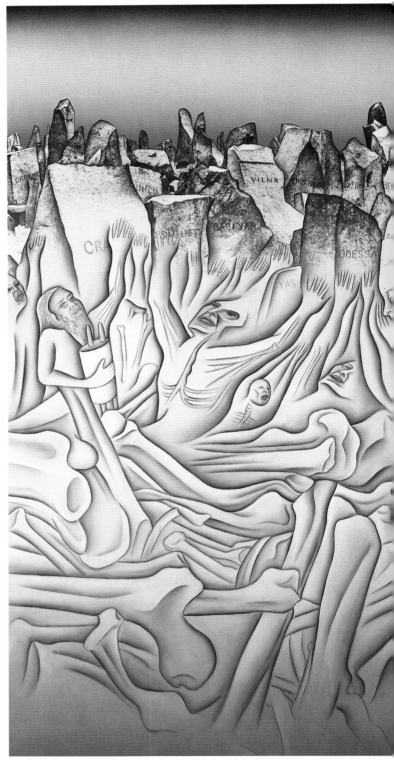

confrontation. It makes a jarring contrast with a piece like *Banality of Evil/Struthof*, which shows local inhabitants and Nazi soldiers enjoying the tranquillity of an inn garden while victims of the Holocaust are driven into a bathhouse, now a gas chamber, situated across the quiet country road that borders the garden itself.

Chicago says, in the audio guide that accompanies the show, that, while she and her husband set out for Europe in 1987 in order to gain a greater understanding of their shared Jewish heritage, one of the things that they realized during the course of their travels was that "the Jewish experience of the Holocaust... [also] provides a graphic demonstration of the vulnerability of all human beings, and, by extension, of all species on our planet" (*HOLOCAUST PROJECT* AUDIO GUIDE, 1993). This gradual expansion of the subject is represented by the works that appear in the second part of the exhibition. In these compositions there are references to the history of slavery in the United States, the war in Vietnam, the fate of endangered species, laboratory experiments on animals, nuclear testing, and the potentially dangerous transportation of nuclear waste. This last theme was of particular concern to the collaborators because of their own residence in New Mexico, which saw the explosion of the first atomic bomb at Los Alamos in 1945, and which is still a center of nuclear research.

The exhibition sequence culminates in a group of four panels entitled *Four Questions*. These confront pairs of images using a technique borrowed from the Israeli abstract artist Yaacov Agam (b. 1928) and, though the collaborators did not know it, also a technique used in Victorian art. The images chosen are shown on a ridged surface. When the work is looked at obliquely from one direction, a single, coherent image appears; when observed from the other direction, another, quite different, image can be seen. When it is looked at from directly in front of the panel, the two images are intermingled in a series of vertical stripes. This, however, is the only view that allows the titles themselves to be seen. They are: *Where Should the Line Be Drawn?*; *When Do Ends Justify the Means?*; *What Determines a Quality Life?*; and *Who Controls Our Human Destiny?* In the first panel, for instance, an image of a high-altitude experiment at Dachau is confronted with a terrifyingly similar image of a laboratory monkey bound to a piece of apparatus. The pieces that make up *Four Questions* are linked not only to Victorian art but also to contemporary advertising billboards, in which the image is silk-screened on to a

Bones of Treblinka

from the Holocaust Project, *1988.*
Sprayed acrylic, oil, and
photography on photolinen;
4ft ½in x 4ft 2½in
(1.2m x 1.27m).
Collection: The artists.
(left)

series of vertical blades and changes completely every few moments. The complex form involved making a whole series of photographic maquettes and blurring the boundaries between painting and photography.

Other compositions spring from a rather different, and much older, narrative tradition. The diptych, triptych, and multipanel formats used for the majority of the compositions included in the *Holocaust Project* are closely associated with sacred Christian art. A direct comparison can be made between *Im/Balance of Power*, which deals with the vulnerability of children in a nine-panel format, and something like Duccio's early 14th-century *Maestà* in Siena, in which the back of the panel is made up of 26 scenes. Another possible comparison is with Jan and Hubert van Eyck's *The Adoration of the Mystic Lamb*, which is part of *The Ghent Altarpiece* and which was completed in 1432. There seem to be two reasons for the choice of these formats. One is the lack, within the Jewish tradition itself, of a tradition of public, figurative art, due to the biblical prohibition in the Second Commandment of the making of graven images (Exodus 20:4; Deuteronomy 5:8). The other is that the Holocaust took place within an ostensibly "Christian" context.

The final piece in the *Holocaust Project*, *Rainbow Shabbat* also, thanks to its technique, carries strongly Christian and medieval overtones. The image is executed in stained glass and is in triptych format. To the left and right are panels bearing a prayer for a more peaceful world. The text appears against a yellow six-pointed star—the badge that Hitler forced the Jews to wear. The central and much larger panel shows a Shabbat service, with the wife blessing the candles while her husband, seated at the other end of the table, holds up his kiddush cup and sings her praises. Between them sit guests drawn from the chief races and religions of the world, hands upon one another's shoulders. Creating the stained-glass panel meant that Judy Chicago had to learn yet another new technique—the difficult art of painting on glass, as practiced in the Middle Ages and later by William Morris (1834–96) and other members of the Anglo-American Arts and Crafts movement.

Simply because of the horrific nature of its subject matter, it is difficult to evaluate the *Holocaust Project*, whether one sees it as a single, integral work of art or as a sequence of different but related works of art. Several considerations contribute to this difficulty. The Holocaust is perhaps the most difficult body of material that any artist could choose to tackle, because it is full of emotional and

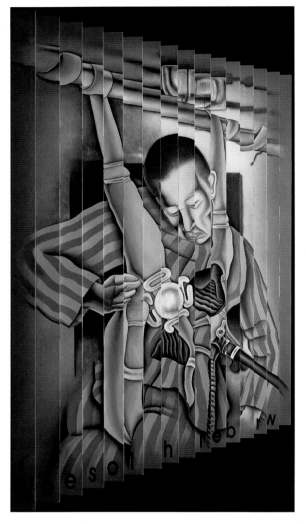

Details and full work
Four Questions
from the Holocaust Project,
1993.
Sprayed acrylic, oil, and Marshall photo oil on photolinen mounted on aluminum;
3ft 6in x 16ft 6in x 4in
(1.07m x 5m x 10cm).
Collection: The artists.
(details, above and above right; full work, right)

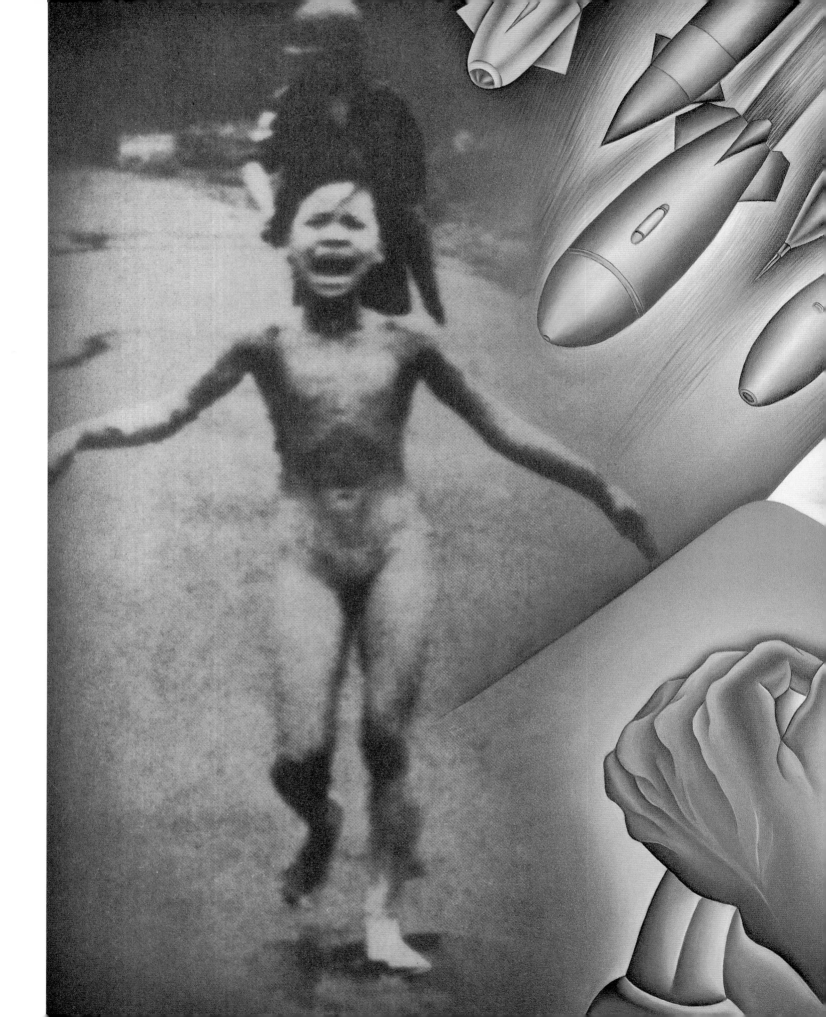

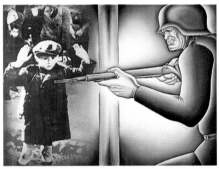

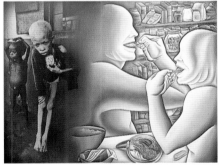

Panels from

Im/Balance of Power

from the Holocaust Project, 1991.
Sprayed acrylic, oil, and
photography on photolinen;
6ft 5¼in x 7ft 11¼in
(1.96m x 2.42m) each.
Collection: The artists.
(left and above)

Entry hall from the
Holocaust Project
1992.

practical trip wires of all kinds. As Judy Chicago and Donald Woodman discovered in the course of their travels and exhaustive researches, many groups lay claim to the Holocaust and try to insist on its being interpreted according to their own prescriptive views. For many Jews it is not only the defining event in the history of modern Judaism, but also something so unique in its horror that it is blasphemous to try to give artistic form to it. They believe that the documentary images that survive must be left in their unmediated state.

In contrast to this, the communist regimes of Eastern Europe tended to play down the Jewish experience. As Chicago noted in a journal entry describing their visit to Treblinka in Poland:

"Even though most of those killed at Treblinka were Jewish, there were no Stars of David or any reference whatsoever to the Jewish victims in any of the literature. Realizing that even in death Jewish identity was being destroyed, I burst into tears, and during our entire stay at Treblinka I just cried and cried."
CHICAGO, 1993; P. 68

Visiting Buchenwald, then in East Germany, she commented:

"The exhibits present a barrage of antifascist, anticapitalist propaganda, implying that all Germans were members of the resistance and that 'all the Nazis had emigrated to the West.' And of course they hardly mention the word 'Jew.'"
CHICAGO, 1993; P. 77

Other difficulties spring from choices made by the artists. They were determined, as has already been stated, to follow the didactic model offered by institutions like the US Holocaust Memorial Museum in Washington D.C. They saw this as opening a door to the North American Jewish community itself and also as the approach that would make the work most easily accessible to the wider audience, not necessarily Jewish, that they wanted to address.

This approach meant integrating the narrative, didactic element with the images themselves, rather than taking the much easier route of surrounding symbolic images with narrative explanation. All students of contemporary art will be aware of the fact that the narrative element was one of the chief victims of the modernist revolution. Here a specific comparison with Thomas Hart Benton is in order, since

he is one of Judy Chicago's very few predecessors in North American art who attempted to revitalize the vanishing narrative tradition. Like Chicago, Benton is frequently accused of abandoning aesthetic values in favor of crude, ego-driven populism. How seriously one takes this accusation depends, to some extent at least, on whether one thinks that 20th-century artists can in fact separate the aesthetic from the moral.

In a sense, the moral conscience of the *Holocaust Project* is supplied by its photographic base. Everyone knows that photographs can now be digitally manipulated, though this perception was less widespread in 1987, when the project began. Despite this, photography rather than painting has been the guardian of the conscience of our time, and it is photographers rather than painters who have usually been responsible for the most resonant and morally challenging images of the 20th century.

Some of these images have been taken with deliberate knowledge of their meaning. An example is the world-famous photograph of a little Vietnamese girl who had been set afire by napalm, used in the bottom right-hand panel of *Im/Balance of Power*. This image was one of the factors that helped to mobilize US public opinion against the Vietnam War. Others, like the pictures found in Nazi archives, are records made by the perpetrators of crimes, which speak eloquently against the criminals. These, too, found a place in the *Holocaust Project*. Donald Woodman points out that one of the difficulties the collaborators faced in using these documentary photographs was the need to avoid aestheticizing them, to the point where the unbearable nature of what they showed would in some way be veiled (INTERVIEW, MAY 1999).

The project itself nevertheless challenges the idea that these documentary images are sufficient in themselves—that nothing further could, or indeed should, be added. It combines them with the further images made by Donald Woodman, which treat the camps and other locations that are associated with the Holocaust as "places of memory," and with the painted images made by Judy Chicago.

The three different types of material are so intricately and skillfully bonded together that it is usually impossible to tell exactly where one ends and another begins. The final result transcends the boundaries of documentary realism and in so doing proposes a new kind of moral and idealistic art.

Installation view of the
Holocaust Project
featuring (from left)
"The Fall," "Banality of
Evil/Struthof," and "Wall of
Indifference." Spertus Museum,
Chicago, Illinois, 1993.

Drawing Is like Breathing

Making drawings has formed a large part of Judy Chicago's professional activity, which is why they are given separate treatment here. In particular, her commitment to drawing has intensified in the years since the making of *The Dinner Party*. Making drawings—drawings from the figure—formed an integral part of major enterprises such as the *Birth Project*, *Powerplay*, and the *Holocaust Project*. In addition, her drawings have an extremely personal aspect. They are often made as a way of recording emotional states, releasing feelings, and working out personal problems. This aspect seems to have intensified since her marriage to Donald Woodman in early 1986. The emotional openness of the later drawings makes them a remarkable confessional record, in some ways even more intimate and revealing that her two volumes of autobiography.

Together, her drawings and autobiographies offer a 20th-century equivalent of the collected autobiographical writings of Jean-Jacques Rousseau (1712–78). The comparison is applicable in more ways than one. The *Encyclopaedia Britannica*, for example, introduces its article on Rousseau with the following sentences:

"He furthered the expression of emotion rather than polite restraint in friendship and love. He introduced the cult of religious sentiment among people who had discarded religious dogma. He opened men's eyes to the beauties of nature, and he made liberty an object of almost universal aspiration."

Detail from
Rainbow Warrior
1980.
Prismacolor on rag paper;
23in x 29in (58cm x 74cm).
Collection: Rhonda and Paul
Gerson, Houston, Texas.

A Modern Rousseau

Granted the change in historical circumstances, and allowing for Rousseau's misogyny, one can still apply all of this to Chicago herself. She shares Rousseau's belief that progress has corrupted rather than improved people. She also shares his conviction that men and women are naturally good and that it is society that has corrupted them.

Her convictions about the importance of the natural world have been expressed both in her writings and in a number of special-occasion posters, such as *Rainbow Warrior*, commemorating the Greenpeace ship sunk by French secret agents in a New Zealand harbor, and *Would You Wear Your Dog?* PETA (People for the Ethical Treatment of Animals) used the latter for an advertisement that appeared on bus shelters in Washington D. C. It was also seen on billboards and in newspaper advertisements in the United States, Germany, and Switzerland. Chicago notes that this is a good example of the way in which her work often seems to overstep the boundaries normally observed by the world of "high art."

The style of Chicago's drawings tends to differ according to its origin and purpose. *Female Landscape 1* is part of a series connected in the artist's mind with the *Birth Project*. In the former, there are several images exploring the same theme. These *Female Landscape* scenes treat female flesh and landscape as being somehow equivalent, taking over an idea also used by the British sculptor Henry Moore. Students of 19th-century Romanticism will see an even closer resemblance to the Shoreham period landscapes of Samuel Palmer (1805–81), with their hushed, visionary intensity. A similar intensity informs an even more personal drawing, *Longing Landscape: Barred from a Natural Life* (1981), which comes from the same epoch. Though British and other feminists of the 1980s were highly critical of representations of women identified with nature, there is in Chicago's iconography an effort to transform some of these long-standing art historical associations and make them into empowering images for women. She realizes it is impossible to abolish the art of the past, or try to ignore its influence, as a number of other leading feminist artists have tried to do.

Samuel Palmer
(1805–81)
The Magic Apple Tree
1830.
Indian ink and watercolor.
Collection: Fitzwilliam Museum,
Cambridge, United Kingdom.
(above top)

Female Landscape 1
1981.
Oil, pastel, and white ink
on black Arches paper;
11in x 15in (28cm x 38cm).
Collection: The artist.
(above bottom)

**Would You
Wear Your Dog?**
*1991.
Polaroid photo-transfer,
acrylic, and ink on rag
paper;
15in x 22in (38cm x 56cm).
Collection: The artist.*
(left)

PETA installation of
**Would You
Wear Your Dog?**
*at bus shelters in
Washington, D.C., 1991.*
(right)

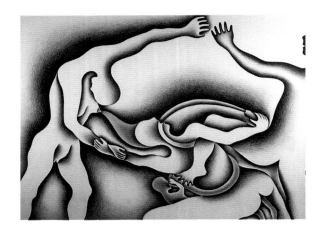

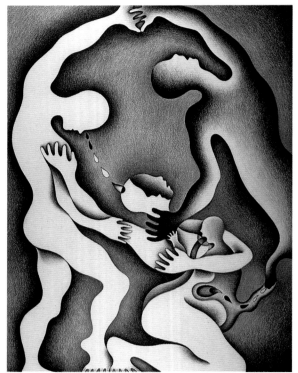

Holding on to the Shadow
1982.
Prismacolor on rag paper;
29½in x 36in (74cm x 91cm).
Collection: The artist.
(above top)

Wrestling with the Shadow for Her Life
1982.
Prismacolor on rag paper;
29in x 23in (74cm x 58cm).
Collection: The artist.
(above)

The much larger and more ambitious *And Then There Was Light* is related to *The Creation*, made in collaboration with Audrey Cowan, and to the restructured *Revelations of the Goddess*, originally written in connection with *The Dinner Party*. Here, once again, the Earth is compared to a female body:

"And then the sounds of birth were heard again
as the very center of the Earth began to tear
and with a great ripping noise
the blood surged out of the torn center of the Earth
and this torrent of blood became a mighty rain fall
and the Earth became fertile
and her body rose up and her thighs became the
mountains and her belly became the valleys
plants sprang up from her flesh and living creatures
crawled out of her crevices and waters ran
down her arms and formed the oceans and the rivers
and her breasts issued the white milk of light
which nourished and illuminated the life that
had emerged from her being and would always be hers to protect."
REVELATIONS OF THE GODDESS, NO DATE

More ambitious still is the immense scroll drawing *In the Beginning* (1982), which is 5ft (1.5m) high and 32ft (9.75m) long. Judy Chicago relates that she initially thought of it as a personal work, a space set aside from the collaborative effort of the *Birth Project*, which was going forward at the same time. She was also slightly astonished to find that she had made something that was so inconveniently large and fragile, and that needed to be expensively mounted. The theme is again the *Revelations of the Goddess*, passages from which are quoted within the field of the composition and along its borders, and the connection to *The Creation* is even closer.

Another group of drawings from the early 1980s—some of Chicago's most beautiful and original in their use of interlocking forms—are preliminaries to the *Powerplay* series. That series deals with male–female relationships from a relatively objective point of view. Drawings like *Holding on to the Shadow* and *Wrestling with the Shadow for Her Life* are anguished self-communings. The atmosphere of these drawings is well described in a note in the catalog to *Judy Chicago: Trials and*

**Accidents, Injuries
and Other Calamities**
from Accident Drawings,
1988.
Prismacolor on rag paper;
23in x 29in (58cm x 74cm).
Collection: Andrew Smith,
Santa Fe, New Mexico.
(left)

**Wondering if She
Should Try to Paint**
from Cast Drawings, *1985.*
Ink on paper;
14in x 11in (36cm x 28cm).
Collection: The artist.
(below left)

**She Kept Bumping,
Spilling, Trying to Connect**
from Cast Drawings, *1985.*
Ink on paper;
14in x 11in (36cm x 28cm).
Collection: The artist.
(below center)

**Feeling like She
Had a Claw for a Hand**
from Cast Drawings, *1985.*
Ink on paper;
14in x 11in (36cm x 28cm).
Collection: The artist.
(below)

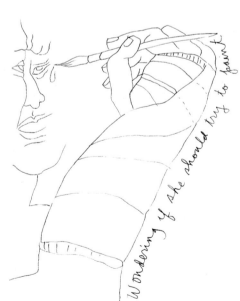

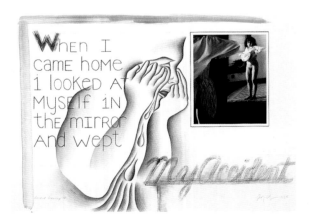

**Accident Drawings
#9, #10, and #18**
1986.
Prismacolor, graphite, and
photograph on rag paper;
22in x 30in (56cm x 76cm) each.
Collection: The artist.
(above)

Tributes, the touring drawing retrospective organized in 1999 by Dr. Viki Thompson Wylder for the Florida State University Museum of Fine Arts:

"The message is about family tension and a female's place among the shadowy outlines of the often unspoken family system, where the figures of mother, husband, daughter, and baby commingle with the concepts of nurturing, power, sexuality, and influence."
THOMPSON WYLDER, 1999: P. 63

Because of her sensitivity to psychic atmospheres, Judy Chicago has always been prone to psychosomatic illnesses and also to minor accidents related to emotional stress. She views these events with a mixture of objective interest, anxiety, and humorous resignation, and indeed in 1988 went so far as to hold an exhibition of drawings related to these crises under the title *Accidents, Injuries and Other Calamities*. Among the sheets included in the show were some of the *Cast Drawings* and *Accident Drawings*. The *Cast Drawings* were made after she broke her right wrist, slipping on the ice during a visit to her future husband's family in Boston. With her wrist immobilized, but still able to hold a pencil in her fingers, Chicago produced a series of very simple outline compositions. These expressive sheets show that she possesses in abundance two qualities she has often been accused of lacking—humility and a sense of humor. It is no disrespect to her general level of graphic skill to say that some of these sheets, such as *I'm Alright* (1985), could be described as Thurberesque.

Related to these *Cast Drawings*, but more fluent in outline, are a group of *Love Drawings* dedicated to her husband-to-be. The closest contemporary parallels to these are the drawings David Hockney (b. 1937) dedicated to his then boyfriend Peter Schlesinger. They are, in terms of Chicago's own output, the tip of an iceberg. She has made an enormous number of drawings for friends—ranging from simple sketches to elaborate greetings cards and whole notebooks—which remain a submerged part of her total work. These small works, made for particular people, are a tribute to the value she places on human relationships.

A more serious accident happened in 1986, when—three weeks after her marriage to Donald Woodman—Judy Chicago was hit by a truck when she was out running. She reacted with a series of *Accident Drawings*. These drawings,

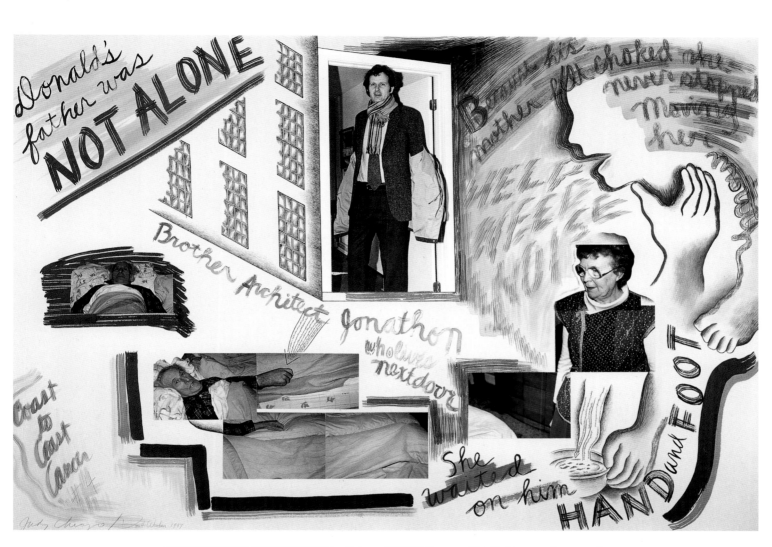

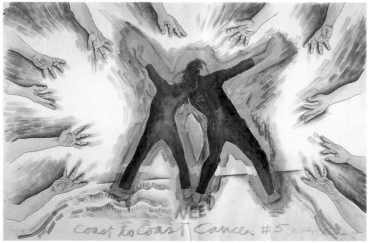

**Coast to Coast
Cancer #4**
1987.
Mixed media on rag paper;
2ft 6in x 3ft 8½in
(0.76m x 1.12m).
Collection: The Artists.
(above)

**Coast to Coast
Cancer #5**
1987.
Micrography and
mixed media on rag paper;
2ft 6in x 3ft 8½in
(76cm x 112cm).
Collection: The Artists.
(left)

candid emotional reactions to a traumatic emotional and physical event, often incorporate photographs made by Woodman. Chicago later said,

"I must admit it was difficult for me to have my new husband staring straight at my disfigured body through his camera lens, though I was glad of an opportunity to work together in an attempt to transform the raw emotions of the experience and painful photographs of my battered flesh into something resembling art."

CHICAGO, 1996; PP. 192–93

The *Coast to Coast Cancer* series involved a similar collaboration. It was inspired by the fact that Judy Chicago's mother, living in California, and Donald Woodman's father, living in Boston, were diagnosed with different forms of the disease at almost the same moment. One of the *Cancer* drawings shows Chicago's first use of micrography. In this specifically Jewish form of art, the outlines of people and objects are formed using written words. Chicago was later to employ this technique when making preliminary studies for the *Holocaust Project*. There was another, emotional link between the two series as well. Chicago described how she flew to California to see how her mother was doing after her operation:

Interrupted Joy
1995.
Mixed media and collage on bark paper;
30in x 22in (76cm x 56cm).
Collection: The artist.
(right)

And Yet There was Love Between Them
from Love Drawings, *1985.*
Ink on paper;
8½in x 5½in (20cm x 12.5cm).
Collection: The artist.
(far left)

And Long Afternoons Locked in Each Other's Arms Holding Hands
from Love Drawings, *1985.*
Ink on paper;
8½in x 5½in (20cm x 12.5cm).
Collection: The artist.
(left)

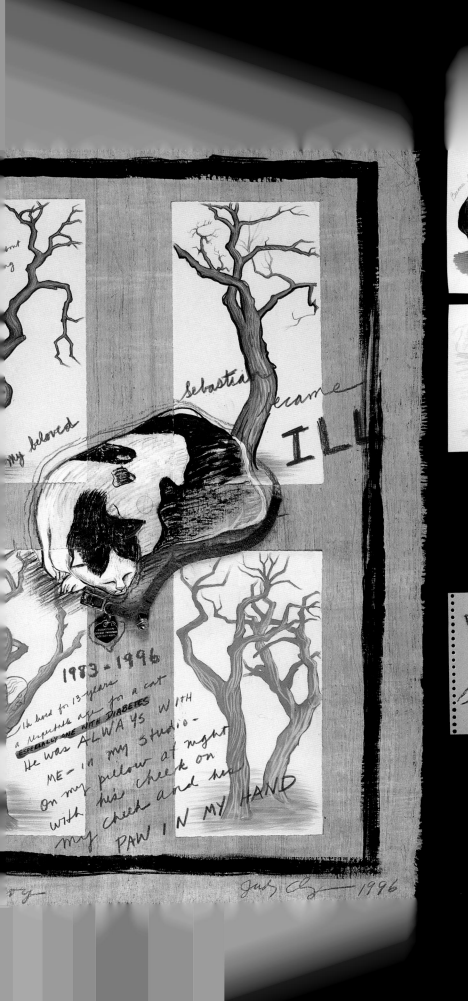

my beloved

Sebastian became

ILL

1983 - 1996

He lived for 13 years
a respectable age for a cat
ESPECIALLY ONE WITH DIABETES
He was ALWAYS WITH
ME - IN my studio -
On my pillow at night
with his cheek on
my cheek and his
PAW IN MY HAND

Judy Chicago 1996

Because I love to draw, I decided to draw my cats.

Sebastian at 10

But then

MULLY
IS THE SWEETEST AND THE
OLDEST AND SHE LOVES
TO HUNT

POPPY

mostly
loves laying around
waiting to have her
EARS SCRATCHED

Trio

Trio

BASICALLY
SHE
PREFERRED
HER
CATS TO
MOST
PEOPLE

ROMEO
LOVER

LITTLE
VER-
ONICA

who likes to curl up in the bed

Cat Family #1
1993.
Clockwise from top left:
Sebastian (deceased),
Mully (deceased), Inka,
and Poppy.
Mixed media on Magnani paper,
11in x 15in (28cm x 38cm).
Collection: The artist.
(above)

Cat Family #2
1993.
Clockwise from top left: Trio,
Romeo, Veronica, and Trio.
Mixed media on rag and
Magnani paper,
10in x 6in (25cm x 15cm),
15in x 11in (38cm x 28cm),
11in x 15in (28cm x 38cm),
and 10in x 6in (25cm x 15cm).
Collection: The artist.
(left)

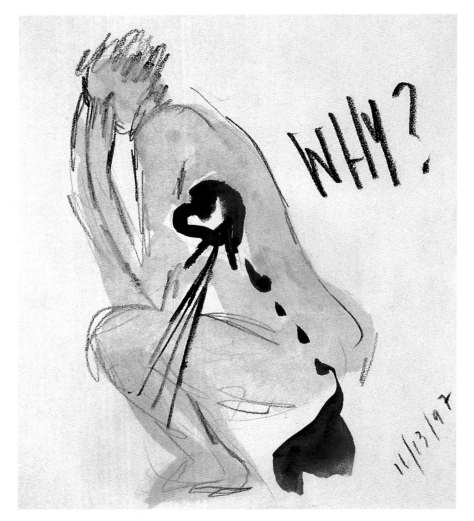

**The Path to the
Top of the West Mesa**
from More than 100
Drawings *sketchbook, 1997.*
Mixed media;
3¼in x 4in (8cm x 10cm).
Collection: The artist.
(right)

Helpless
from More than 100
Drawings *sketchbook, 1998.*
Graphite on paper;
3¼in x 4in (8cm x 10cm).
Collection: The artist.
(far right)

Why?
from More than 100
Drawings *sketchbook, 1997.*
Mixed media;
3¹⁄₄in x 4in (10cm x 9.5cm).
Collection: The artist.
(far left)

Peppers
from More than 100
Drawings *sketchbook, 1997.*
Mixed media on paper;
3¹⁄₄in x 4in (9.5cm x 10cm).
Collection: The artist.
(above left)

Ginger
from More than 100
Drawings *sketchbook, 1997.*
Mixed media on paper;
3¹⁄₄in x 4in (8cm x 10cm).
Collection: The artist.
(middle left)

Paula in the Leaves #1
from Reverence for Life, 1990.
Prismacolor and mixed
media on paper;
14¹⁄₄in x 10¹⁄₄in (37cm x 27cm).
Collection: The artist.
(below)

"When I saw her, I thought about the arrogance with which the Nazis deemed some people unworthy of life, because I realized that, given her age and infirmity, my mother would not have been allowed to survive."
CHICAGO, 1996; P. 199

The stress of the *Holocaust Project* and the pressure of family illnesses—she had now learned that her brother Ben, who worked as a potter in Japan, was suffering from a fatal disease that was slowly paralyzing him—affected Chicago's art in another and completely different way. It led her to start making drawings from life. One of these sheets is *Paula in the Leaves #1*, made in the small backyard of her then studio. Emotionally affirmative, this is also proof that Chicago is capable of making elegant, classical figure drawings whenever she chooses to do so.

These figure studies led to the beautiful *Reverence for Life* series. Two of the drawings in this sequence, *Loving Sebastian* and *Interrupted Joy*, express another enduring passion in Judy Chicago's life—her love of cats. Her household is overrun with them and they feature increasingly often in her art.

Drawing has, in fact, come to occupy a more and more central place in Judy Chicago's output. It has become the prime medium for an ongoing conversation with herself. A good example is a little sketchbook from 1997, entitled *More than 100 Drawings*. Chicago says she was inspired to begin this by seeing a similarly small sketchbook in the collection of the Vancouver Art Gallery, the work of the pioneer Canadian modernist painter Emily Carr (1871–1945). The drawings are extremely varied in scope. There are numerous landscape and tree studies, still-life studies (peppers and a piece of ginger root), pictures of cats, portraits of her husband, anatomical details, and occasional emotional outbursts. The notebook is a record of things seen, a kind of diary, and also an emotional safety valve. Few artists reveal themselves as intimately as Chicago does in these drawings of the 1990s.

Donald Has Deserted Me
from More than 100
Drawings *sketchbook, 1998.*
Mixed media;
3¹⁄₄in x 4in (9.5cm x 10cm).
Collection: The artist.
(above top)

**Donald Watching
Cars Go Around
on Sunday Afternoon**
from More than 100
Drawings *sketchbook, 1998.*
Graphite on paper;
3¹⁄₄in x 4in (9.5cm x 10cm).
Collection: The artist.
(above)

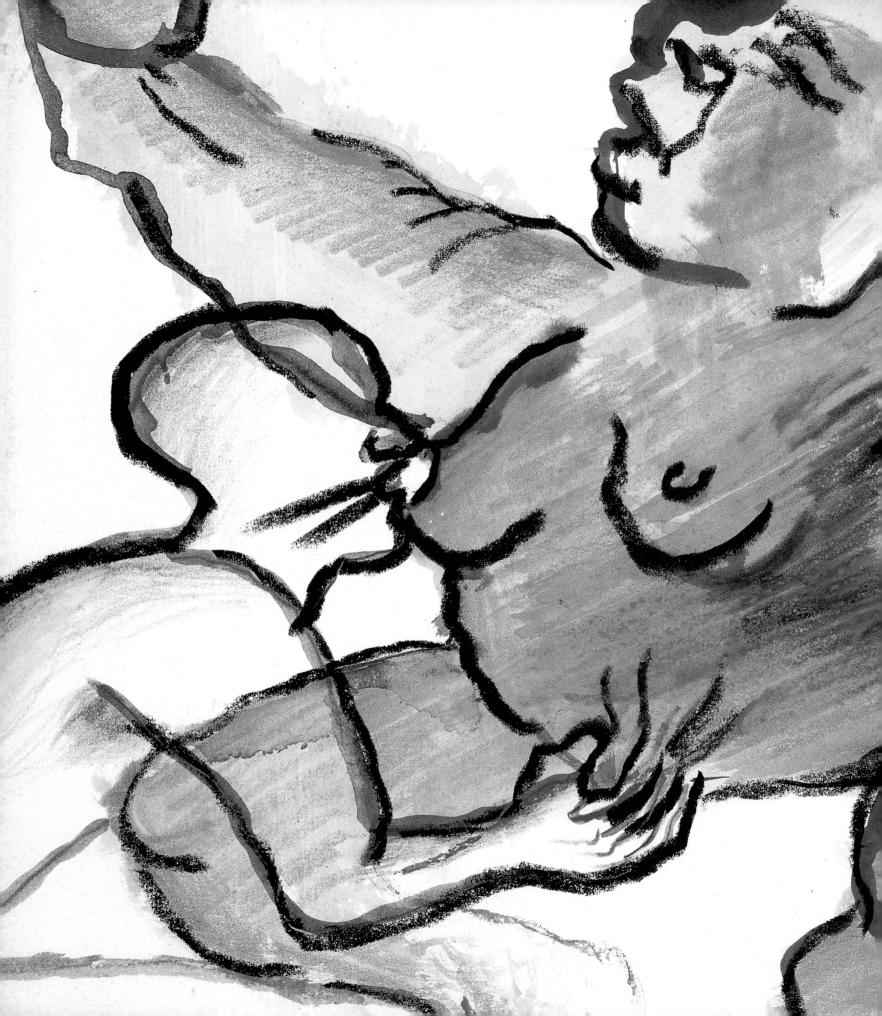

Four Series

ANALYSIS AND SYNTHESIS

Judy Chicago has always tended to make work in series. The series format enables her to deploy methods that have become characteristic of her art. These methods involve, first, periods of intense study and contemplation; next, an analysis of the appropriate technical means, and the mastery of new techniques if these seem necessary for the enterprise in hand; and finally a period of synthesis—bringing together all the elements already explored to create a final result that, as far as possible, seems both effortless and inevitable. Four series from the 1990s exemplify this approach, though the elements just enumerated exist in each in different proportions.

The most spontaneous of these series is a long suite of drawings, *Autobiography of a Year*. This was the first enterprise undertaken by Chicago after the completion of the *Holocaust Project*, which had required such a high degree of detailed rigor that she now felt the need to return to a more direct way of making art. She decided that the simplest way to do this would be to record the vicissitudes of a single year in autobiographical form.

"I wanted," [she says] "to locate an authentic emotional impulse, and I wanted it to come through my hand in unmediated form."

INTERVIEW, MAY 1999

Detail from
Definitely in the Orange Zone
from Autobiography of a Year,
1993–94.
Mixed media on Magnani paper;
11in x 15in (28cm x 38cm).
Collection: The artist.

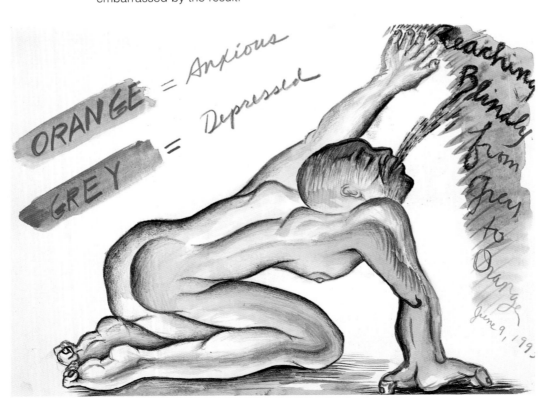

The Color of Emotion

There is, nevertheless, an underlying system that helps to structure the images. Before she embarked on the series, Chicago decided that each mood or emotional state should be designated by a color.

"The color gives the mind set."
INTERVIEW, MAY 1999

She was also willing to repeat any particular drawing until she felt she had got it right.

"I did some of them over and over, whenever I felt they were not 'pure,' not exactly what I wanted."
INTERVIEW, MAY 1999

And sometimes she found herself surprised, disconcerted, and even, occasionally, embarrassed by the result.

Definitely in the Orange Zone
from Autobiography of a Year, *1993–94.*
Mixed media on Magnani paper; 11in x 15in (28cm x 38cm).
Collection: The artist.
(right)

Reaching Blindly from Grey to Orange
from Autobiography of a Year, *1993–94.*
Mixed media on Magnani paper; 11in x 15in (28cm x 38cm).
Collection: The artist.
(left)

But Behind the Emptiness Was Rage II
from Autobiography of a Year, *1993–94.*
Mixed media on Magnani paper; 15in x 11in (38cm x 28cm).
Collection: The artist.
(right)

**My God Was
She Really 54?**
from Autobiography of a
Year, 1993–94.
*Mixed media on
Magnani paper;
15in x 11in (38cm x 28cm).
Collection: The artist.
(below)*

**She Wanted to Make
a Form with Her Hand
and Have It Be What
She Means**
from Autobiography of a
Year, 1993–94.
*Mixed media on
Magnani paper;
15in x 11in (38cm x 28cm).
Collection: The artist.
(above)*

She felt utterly drained

II November 16, 1993

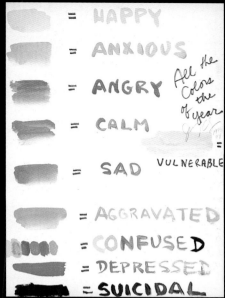

= HAPPY
= ANXIOUS
= ANGRY All the Colors of the year
= CALM
=
 VULNERABLE
= SAD
= AGGRAVATED
= CONFUSED
= DEPRESSED
= SUICIDAL

She Felt Utterly Drained II
from Autobiography of a Year,
1993–94.
Mixed media on Magnani paper;
15in x 11in (38cm x 28cm).
Collection: The artist.
(left)

All the Colors of the Year
from Autobiography of a Year,
1993–94.
Mixed media on Magnani paper;
15in x 11in (38cm x 28cm).
Collection: The artist.
(above)

Trees Twisting with Joy
from Thinking about Trees,
1996.
Mixed media on Magnani paper;
22in x 30in (56cm x 76cm).
Collection: The artist.
(right)

The general stylistic tone of the sequence is much more expressionist than anything Chicago had produced hitherto. It was primacy of feeling that counted, not polish. Some drawings are somberly introspective, including those that meditate on the inevitable inroads of age, for example *My God Was She Really 54?* Others are uncensored records of passing emotional states, for example, *She Felt Utterly Drained II* and *But Behind the Emptiness Was Rage II.* The sequence makes room for the visionary—*Everyone Was Going to See Who She Really Was*

Hopelessly Entwined
from Thinking
About Trees, 1996.
Mixed media on Magnani paper;
30in x 22in (76cm x 56cm).
Collection: The artist.
(above)

looks a little like an illustrated page from one of Blake's prophetic books, a comparison that occurs to me frequently when looking at Judy Chicago's art. It also has space for the purely domestic—for example, a sheet devoted to portraits of some of her beloved cats.

The emotional transparency of these drawings, their willingness to make everything visible, whether creditable or discreditable, is close to what one finds in Chicago's two best-selling autobiographies, *Though the Flower* and *Beyond the Flower*, but they operate with an even greater directness because here she is making use of what she regards as her primary, rather than her secondary, means of expression. Chicago has always been an artist first, and a writer only second. She would not care to be remembered, as the unfortunate Benjamin Robert Haydon (1786–1846) has been, chiefly for her written autobiography.

A second, very different drawing sequence, *Thinking about Trees*, evolved in a much more deliberately structured way. Chicago cannot quite recall how the idea of making such a sequence first entered her mind. She thinks part of the inspiration for it came from the magnificent tree that stood outside the little house she then occupied in Albuquerque. Once the idea had entered her head, however, she set about preparing for the project in her usual methodical way. She read about trees and examined the different ways in which they had been represented in art, by both Eastern and Western artists. Her preliminary studies, for example *How Do You Draw a Tree Dancing?*, show the impact made on her by Chinese artists of the Sung (960–1279 C.E.) and Yuan (1206–1368 C.E.) periods and by Renaissance artists such as Fra Bartolommeo (c. 1472–c. 1517), who made a celebrated series of drawings showing trees in the Tuscan countryside.

Orphaned Tree
from Thinking about
Trees, 1995.
Mixed media on
Magnani paper;
22in x 30in (56cm x 76cm).
Collection: The artist.
(right)

A Cottonwood
Trying to Live
from Fifteen Studies
for Thinking about Trees,
1996.
Mixed media on bark paper;
30in x 22 in (76cm x 56cm).
Collection: The artist.
(far right)

**How Do You Draw
a Tree Dancing?**

from Fifteen Studies for
Thinking about Trees, *1994.*
Mixed media on rag paper;
10in x 6¾ in (25cm x 15cm).
Collection: *The artist.*
(below)

Treewoman Dying,

from Fifteen Studies for
Thinking about Trees, *1994.*
Mixed media on rag paper;
10in x 6¾ in (25cm x 15cm).
Collection: *The artist.*
(below)

Looking at the Los Lunas Hill from the North
1996.
Watercolor on Arches paper;
22½in x 30in (57.5cm x 76cm).
Collection: Elizabeth A. Sackler,
New York, New York.
(far right)

Los Lunas Hill from the North at Sunset
1996.
Watercolor and gouache
on rag paper;
15in x 22½in (38cm x 57.5cm).
Collection: Ellen Poss,
Boston, Massachusetts.
(right)

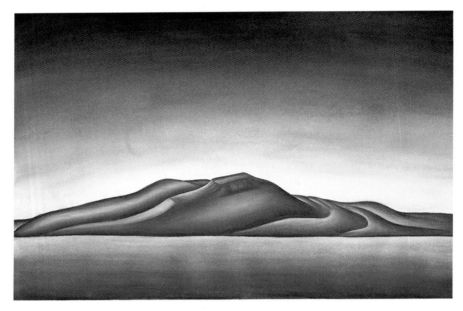

Some of these preliminary drawings, such as *Tree Woman Dying*, show an anthropomorphic approach to the subject matter, which is carried through into the images of the finished sequence, for example, *Orphaned Tree*. For Chicago, there is no element of sentimentality in this. She sees trees, animals, and human beings as occupants of a planet whose very existence is increasingly threatened by unthinking human actions. Her trees are things keenly observed, but are also allegorical emblems, which in turn present social and moral truths. She perceives

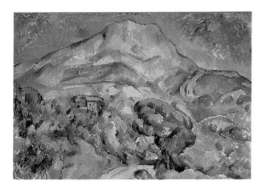

Paul Cézanne (1839–1906)
Mont Sainte-Victoire
1900.
Oil on canvas.
Collection: Hermitage Museum,
Saint Petersburg, Russia.
(above)

her concern for ecology as being simply another aspect of a system of feelings and philosophical ideas that are represented in another way by her feminism. To put it another way, she could not be a feminist without also interesting herself in ecological ideas. *Thinking about Trees* is not simply, or even primarily, a sermon. It also has a strongly celebratory element, exemplified in the final drawing in the sequence, *Trees Twisting with Joy*.

Related to *Thinking about Trees* in the concern it expresses for the natural world is a series of watercolors entitled *Looking at the Los Lunas Hill*. Made after Judy Chicago's move to her present residence in the town of Belen, New Mexico, the watercolors have a double origin—first, the knowledge that a hill she saw almost every day when driving to and from Albuquerque would soon become the site of a golf course and, second, her wish to acquire a new skill,

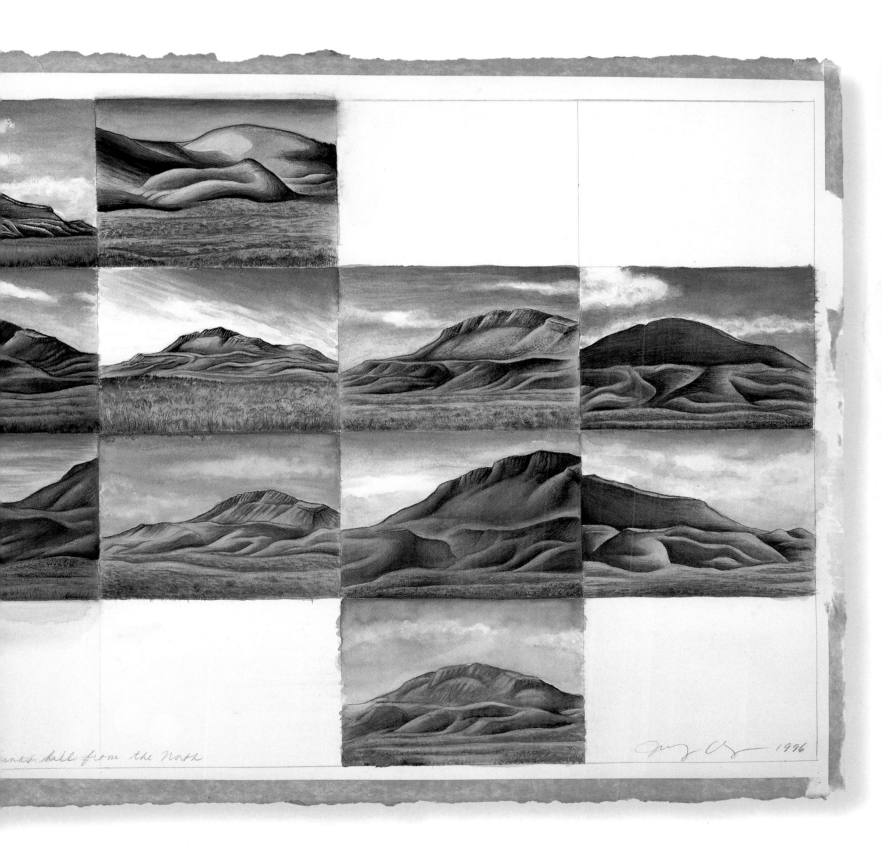

nis hill from the North 1996

Diptych,
My Dove in the
Cleft of the Rocks
from Voices from the
Song of Songs, *1999.*
Lithography, heliorelief,
and polymer;
40in x 24in (102cm x 61cm).
(above and center)

O, For Your Scent
from Voices from the
Song of Songs, *1999.*
Lithography, heliorelief,
and polymer;
40in x 24in (102cm x 61cm).
(above)

that of working in watercolor. Conscious of her lack of experience in this demanding medium, she enrolled in a watercolor class at the local branch of the University of New Mexico under an assumed name:

"I didn't want the instructor looking over my shoulder to see what Judy Chicago would do."
INTERVIEW, MAY 1999

It was in fact these classes that took her so frequently to Albuquerque.

The watercolors have several points of interest. Simply because of their subject matter, they are the most recognizably "New Mexican" works Judy Chicago has produced. One can see in them resemblances to the images produced by other artists who have worked in the region such as Georgia O'Keeffe and, in this case more particularly, Andrew Dasburg (1887–1979). They also look back to Judy Chicago's beginnings as an artist, when she used to study a painting by Claude Monet (1840–1926) from his *Grainstacks* series (1891) in the collection of the Art Institute of Chicago. Monet's aim in this series, and in other series related to it, such as the *Poplars* (1892) and the paintings of the facade of Rouen cathedral (1892–93), was to study a given motif under all conditions of weather and light. This is exactly what Chicago does here. One can also make a comparison with the

**How Fine You
Are My Love**
from Voices from the
Song of Songs, *1999.*
Lithography, heliorelief,
and polymer;
40in x 24in (102cm x 61cm).
(above)

**Let Us Go Out
into the Open Fields**
from Voices from the
Song of Songs, *1999.*
Lithography, heliorelief,
and polymer;
40in x 24in (102cm x 61cm).
(above center)

**There You Stand
Like a Palm**
from Voices from the
Song of Songs, *1999.*
Lithography, heliorelief,
and polymer;
40in x 24in (102cm x 61cm).
(above right)

paintings of Mont Sainte-Victoire in Provence done by Paul Cézanne (1839–1906), and in this case, especially with the watercolors he made of it. Tackling a subject of this sort, Chicago places herself within a hierarchy that inevitably contains both men and women, and comparisons with the work of male artists, so often and so angrily resisted by feminist art historians, seem both necessary and appropriate. One must also note, however, the way in which she moves the convention forward, fragmenting and multiplying views of the hill on the same sheet.

The case is slightly different with the fourth sequence of images that finds a place in this chapter, a suite of illustrations to the Old Testament *Song of Songs*, done at Graphicstudio in Tampa, Florida. The version of the text Chicago chose is a new translation of the biblical text by Marsha Falk, which stresses mutuality of pleasure between male and female. The selected excerpts enabled the artist to juxtapose a man's voice and a woman's.

There are several points of connection between this series and some of Judy Chicago's earlier works—for example; with the small sequence of erotic works that the artist executed during the 1970s, and with drawings of the early 1980s, such as *Holding On to the Shadow* and *Pressing Herself against Her*. However, the anxious mood expressed in the latter is here replaced by a positive celebration of ecstatic union.

Eric Loving the Wall Tree
study for There You Stand
Like a Palm, *1998.*
Mixed media on paper;
22in x 15in (56cm x 58cm).
Collection: The artist.
(above)

Yes, I Am Black and Radiant
from Voices from the
Song of Songs, *1999.*
Lithography, heliorelief, and polymer;
40in x 24in (102cm x 61cm).
Collection: The artist.
(right)

The *Voices from the Song of Songs* suite offers a particularly good example of Judy Chicago's present methods of work. The prints for the series were prepared with numerous studies. First came sketches, then photographs and studies of the model, Eric. Chicago also studied the information offered by traditional Near Eastern decorative motifs featuring trees, flowers, and plants. Finally, she made watercolors in which all this preliminary material was synthesized before going to work in the printshop to produce a final result. The painstaking search for information and the care with which Chicago constructed her motifs were typical of the way in which the artist has worked throughout her career.

She describes her printshop work as being "traditionally collaborative," with input from the printers as well as from the artist. The basic technique suggested to realize the images was heliorelief, which is a modern form of woodcut printing. The disadvantage of this technique was that, like traditional woodcut, it requires completely contained forms, which Chicago thought went against the spirit of the text she was illustrating. Then Tom Pruitt, one of the printers and the project manager, proposed that they combine heliorelief with lithography, which would therefore allow them to blend shapes and colors where required. A final elaboration was the occasional use of visible wood grain. In most helioreliefs the wood grain is deliberately filled in so as to present a completely smooth "industrial" surface.

She wanted, she says, something that looked simple and effortless, though it turned out to be very complicated to achieve. The effort was always to obtain a perfect technical result while preserving the initial spontaneity of feeling. That is, the basic underlying principle is still the same as that of the apparently very different *Autobiography of a Year*—the search for complete authenticity of emotional expression. The fact that the result seems so deliberately rough in one case and so polished in the other is irrelevant to the intention, which remains the same in each case: To search for pyschological truth and record it as truthfully as possible once it has been found.

Chapter Ten

Resolutions

A STITCH IN TIME

Judy Chicago's latest enterprise, *Resolutions: A Stitch in Time*, began life in 1994 as what she describes as "a modest little project" (INTERVIEW, 1999). At the time of writing, six years later, it is nearing completion, but is not as yet quite finished. Despite its original modesty of aim, *Resolutions* has its roots in the deeply serious *Holocaust Project*, completed the year before *Resolutions* was begun:

"Perhaps it was the imminent approach of the change in century, a century marked by genocides on a scale previously unknown to humankind, that caused me to think that the time might be ripe for some images that appeal to the best in people, images that would help us believe in our capacity for change."

CHICAGO, DESCRIPTIVE STATEMENT; PP. 1–2

In the course of thinking further along these lines, she also began to look back at a very specific component in two earlier but equally major projects, *The Dinner Party* and the *Birth Project*: that is to say, the wide range of needle techniques involved, and her own pleasure and interest in designing for these skills, which are historically associated with women.

Detail from
**It's Always Darkest
Before the Dawn**
from Resolutions:
A Stitch in Time, *1999.*
Painting and embroidery,
needlework by Pamella Nesbit;
24in x 40in (61cm x 102cm).
Collection: The artists.

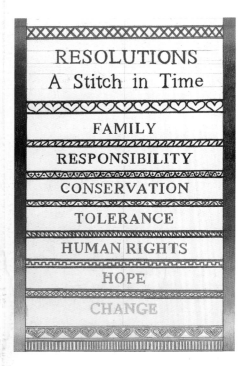

Study for
Needlework Sampler
1998.
Prismacolor on rag paper;
37in x 25⅛in (94cm x 65cm).
Collection: The artist.
(above)

Resolutions: Concepts and Execution

The further conceptual element in the *Resolutions* series was the decision that the various designs in the new work should illustrate traditional proverbs:

"At some point, the thought had popped into my head that it might be interesting to look back at traditional wisdoms, as they have been embodied in and imparted through proverbs, adages, and homilies.... As usual, I wished to introduce a new twist, in this case turning round English proverbs—which too often transmit a narrow, white, male Eurocentric perspective—in order to present a larger, more inclusive worldview."

CHICAGO, DESCRIPTIVE STATEMENT; P. 3

A fourth consideration was her desire to develop and refine the relationships she had already formed with skilled needleworkers during the making of *The Dinner Party* and the *Birth Project*:

"I thought it would be best if the needleworkers collaborated on developing the ideas for the images with me, not only in order to provide crucial information as to how to expand the use of needle techniques, but also because it seemed to me that a project such as the one I was contemplating required input from a number of people. After all, the very notion of values seemed to signify a set of attitudes that are shared...."

CHICAGO, DESCRIPTIVE STATEMENT; PP. 4–5

One of the problems in assessing *Resolutions* is that in order to be fully understood it has to be looked at in a number of ways. It can, for example, be seen as a postmodernist artwork or series of artworks, which achieve originality through the deliberate subversion of established and familiar traditional forms. But this is really a quite insufficient description. The forms it subverts are often ones that have long been established in folk art—quilts and samplers, for example; the kind of folk art traditionally associated with women.

Another way of looking at *Resolutions*, however, is precisely through the prism of skill. Today the barriers between the world of high art and those of applied arts or crafts have become extremely permeable. One distinction survives, and that is in attitudes toward skill. The virtuoso handling of materials is now something that attracts suspicion in the field of contemporary art. In particular, artists whose hand

Center panel from

Rainbow Shabbat

from the Holocaust Project, *1992.*

Stained glass; constructed by Bob Gomez and

hand-painted by Dorothy Maddy from Judy

Chicago's full-scale cartoon;

4ft 6in x 16ft (1.37m x 4.88m).

Collection: The artists.

See Holocaust Project: From Darkness into Light, *pages 118–139.*

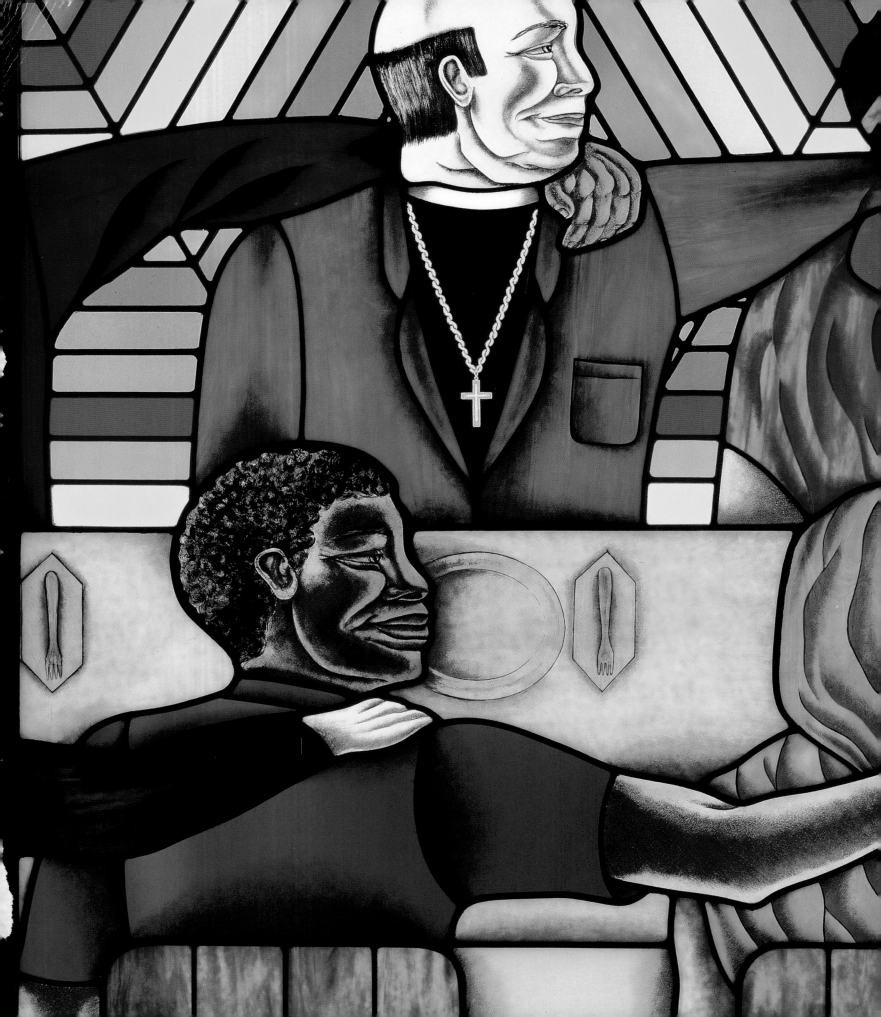

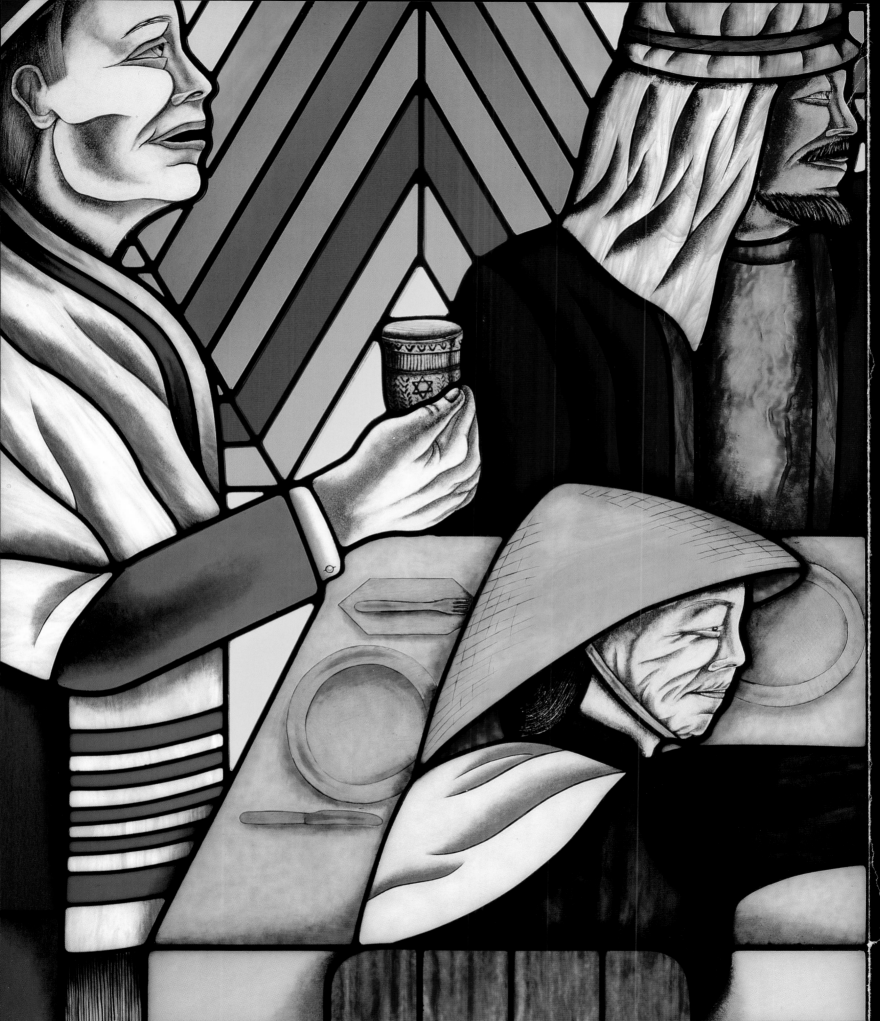

"*Rainbow Shabbat* offers a vision of a different world through an image of the Jewish Friday night Shabbat service as an international sharing across race, gender, class, and species."

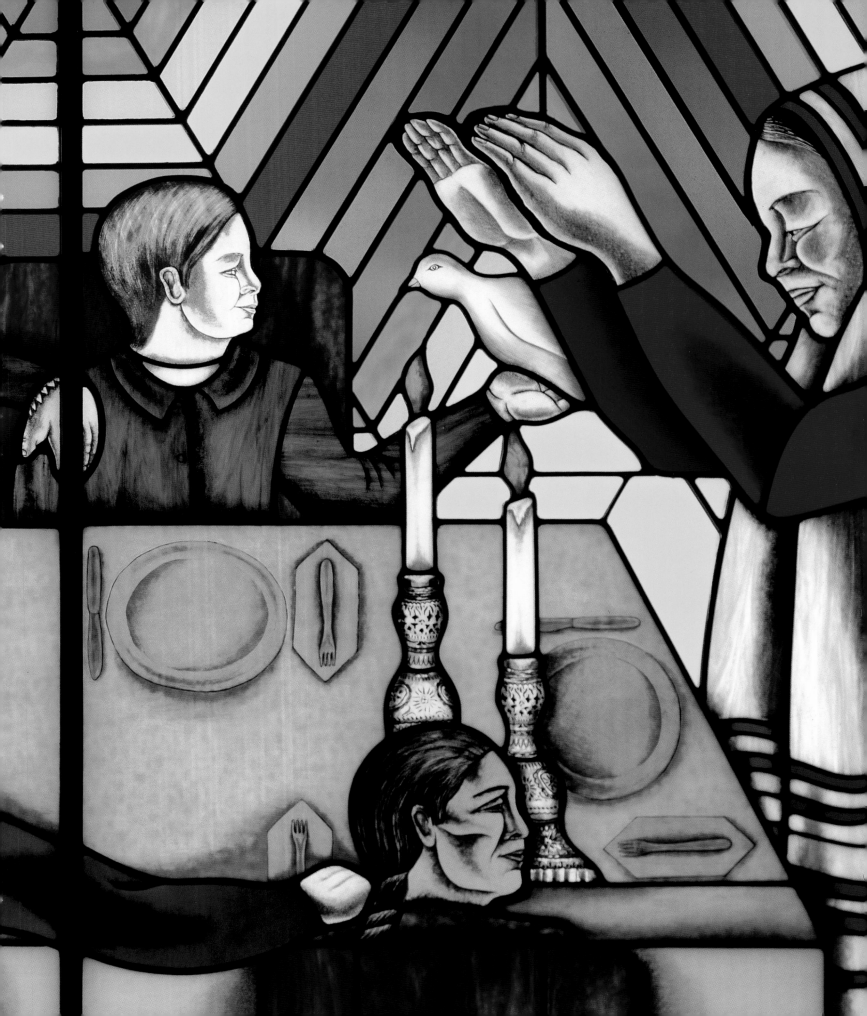

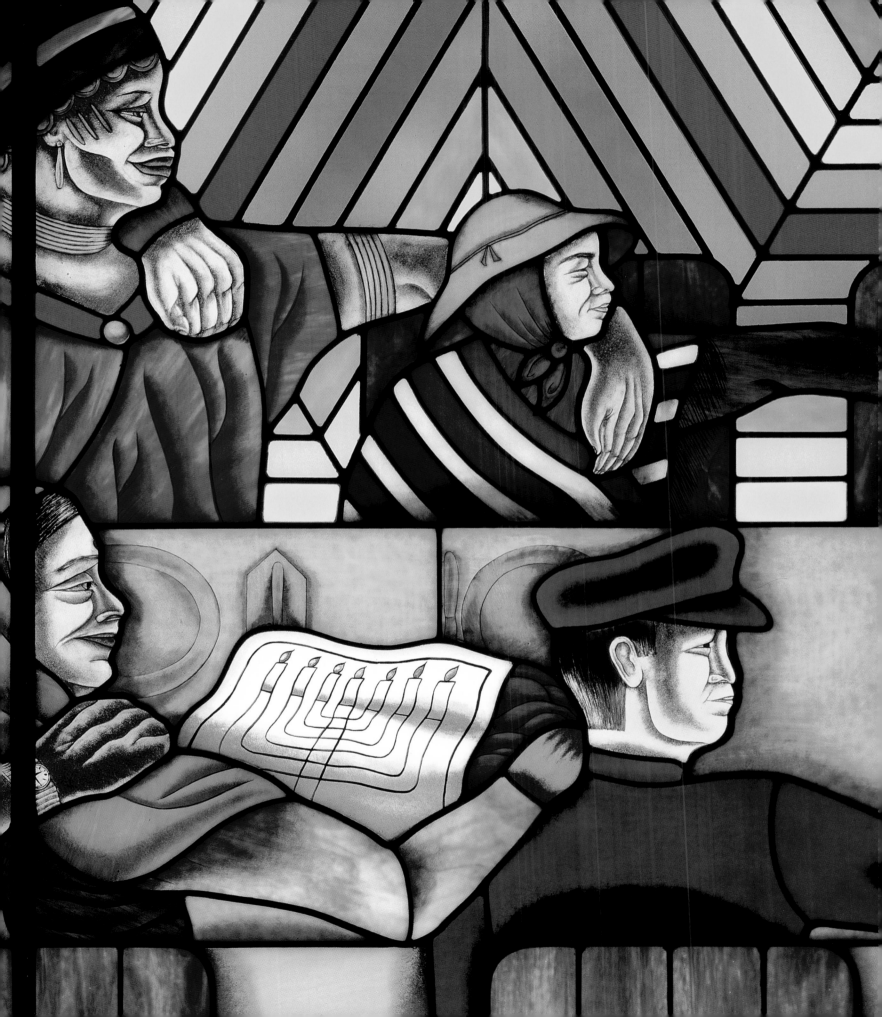

RESOLUTIONS
A Stitch in Time

FAMILY
RESPONSIBILITY
CONSERVATION

skills are obviously fluent tend to be accused of superficiality and slickness. When an artist requires a slick finish—for example, Jeff Koons with some of his sculptures—he or she distances him or herself from the issue by hiring specialists with the requisite skills.

The situation is different in the crafts. North American craft, certainly from the 1960s onward, has been energized both by the competition to acquire skills of an ever-higher order and by the generous impulse to share these skills once their possession has been demonstrated. It is a dynamic of this kind that has powered the careers of senior North American craftsmen like the metalsmith Albert Paley (b. 1944) and the furniture-maker Wendell Castle (b. 1932).

Detail from
Needlework Sampler
in progress, from Resolutions:
A Stitch in Time, *1999.*
Counted cross-stitch and
embroidery, needlework by Pat
Rudy-Baese, Jane Thompson,
and Joyce Gilbert;
57in x 25½in (94cm x 64cm).
Collection: The artists.
(above)

Details from
Home Sweet Home
from Resolutions:
A Stitch in Time, *1999.*
(above and below right)

Home Sweet Home
from Resolutions:
A Stitch in Time, *1999.*
Painting and embroidery,
needlework by Pamella Nesbit;
24in x 18in (60cm x 46cm).
Collection: The artists.
(right)

This kind of competitiveness is usually, and perhaps rightly, considered to be more characteristic of males than of females. Among women, the competitive impulse may be less obvious, but pleasure in the acquisition of refined skills is certainly found among practitioners of crafts that are associated with the feminine gender, needlecraft chief among them. In addition to this, needlework and the sharing of skills and tasks have long been associated; one only has to think of 19th-century quilting bees.

There is yet a third way of looking at *Resolutions*. It has to do with the division between those who are thought of as fully professional and those who are thought of as amateur. Apart from Judy Chicago herself, nearly all the women involved in this project would be classified by art world elitists as amateurs. In a strictly objective application of the term, the description is exact. They do not make work for sale—they practice their skill for its own sake, for themselves, their families, and their friends. The work they do is too labor intensive to be calibrated on any scale for financial reward.

It is, of course, true that before their association with Chicago, most of her needle-workers existed in an aesthetic realm different from that of contemporary museums and galleries—a realm that arguably occupies a wider territory in contemporary culture than the one occupied by what we are pleased to label "contemporary art." Does "different" in this case also mean "inferior"?

This line of argument, however, ignores the role of Chicago herself in the making of *Resolutions*. Though the designs for the various pieces included in the show evolved in collaboration with her needleworkers, they are recognizably hers and often have close connections with earlier work, particularly with the *Holocaust Project*.

The *Needlework Sampler* that begins the sequence of *Resolutions* splits the work that follows into the seven basic values everyone in the project agreed are essential to human survival: family, responsibility, conservation, tolerance, human rights, hope, and change. The works are exhibited in a sequence that corresponds to these keywords. Each work is

The Hands That Rock the Cradle Shape the World

from Resolutions:
A Stitch in Time, *1999.*
Painting, appliqué, macramé,
embroidery, and beading,
needlework by Pat Rudy-Baese;
36in x 24in (91cm x 61cm).
Collection: The artists.
(above)

based on a familiar proverb or truism, interpreted in a new way. *Home Sweet Home*, with embroidery by Pamella Nesbit, the first work in the first, or "Family," group, interprets the worn phrase in a new fashion. "Home" is the globe itself, the only habitation we have. Clustered around it are dwellings typical of different parts of the world. The image is an intricate fusion of sprayed acrylic paint and embroidery. The two media are fused in such a way that it is almost impossible to tell where one leaves off and the other begins. In common with the majority of the works in this series, the dimensions are quite modest—24in x 18in (60cm x 46cm). This reflects not only the labor-intensive nature of the process itself but also the fact that Chicago and her collaborators feel that pictorial rhetoric is out of place. They want the message to come across when the piece is quietly and minutely examined.

The Hands That Rock the Cradle Shape the World, with needlework by Pat Rudy-Baese, seeks to shift preconceptions by portraying the family group that is its subject as African-American. The techniques used include macramé—familiar from the *Birth Project*, but here employed in a particularly refined way—and beading. *Do a Good Turn* involves a sudden jump in scale and exhibits a totally different range of techniques—reverse appliqué and quilting as well as embroidery and needlework. The piece is rooted in the tradition of eye-dazzler quilts, and the rotating design alludes to this as well as to the actual phrase used for the title.

Paddle Your Own Canoe, which deals with the theme of responsibility, is a tapestry, the weaving by Judy Chicago's long-time collaborator, Audrey Cowan.

Do a Good Turn

from Resolutions:
A Stitch in Time, *1999.*
Reverse appliqué, quilting,
and embroidery, needlework
by Jacquelyn Moore;
4ft 4in x 4ft 4in
(1.32m x 1.32m).
Collection: The artists.
(right)

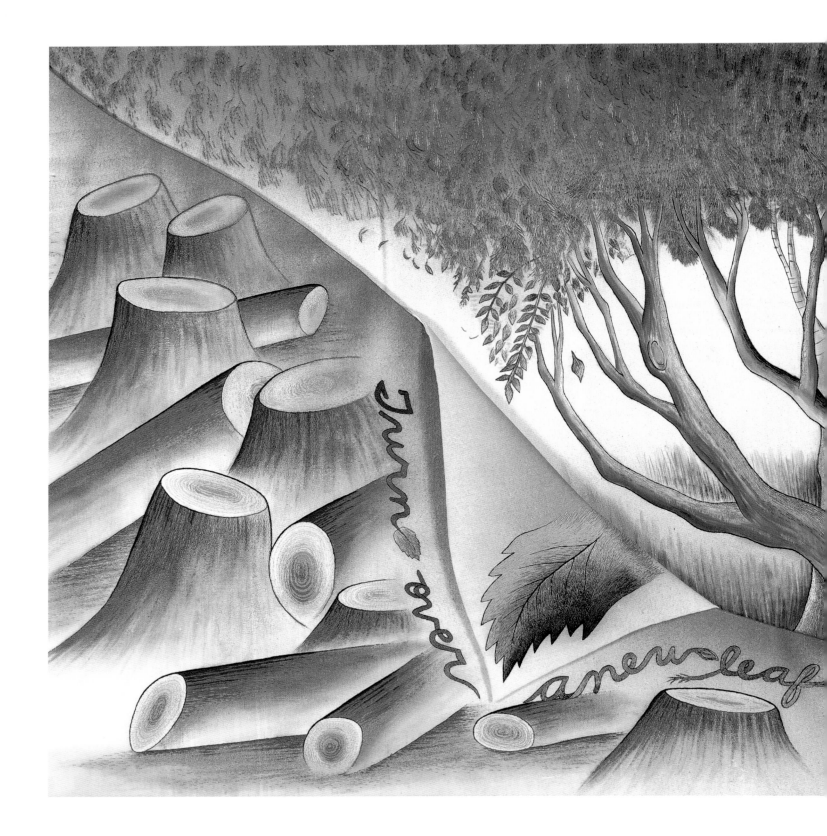

Turn Over a New Leaf
from Resolutions:
A Stitch in Time, *1999.*
Painting, embroidery, and
appliqué, needlework by
Jane Thompson;
18in x 24in (46cm x 61cm).
Collection: The artists.
(far left)

Study for
Paddle Your Own Canoe
1998.
Prismacolor on Arches paper;
22in x 30in (56cm x 76cm).
Collection: The artist.
(above)

Judy Chicago and Audrey
Cowan working on
Paddle Your Own Canoe.
(left)

The forms the works in the series take are often tailored to the specific skills of the needlewoman responsible for it. *Turn Over a New Leaf*, embroidered by Jane Thompson, literally folds over so as to contrast a desecrated forest and a pristine landscape—the kind of transition that is very difficult to achieve in stitchwork alone.

Another complex work, *Keep the Ball Rolling*, required petit point by Gerry Melot, embroidery by Pamella Nesbit, and needlepoint by Jane Thompson and Louise Otewalt, plus Chicago's painting, additional painting by a textile conservator, and work by a silk-screen shop. The theme is shared responsibility—it shows people from different classes and ethnic groups cooperating.

The same theme of collective responsibility recurs in *We're All in the Same Boat*, a tongue-in-cheek image that shows a crowd of people in a leaking boat, some paddling, some bailing, some apparently panicking, while one man complacently continues to fish, oblivious to what is going on around him. The piece combines sprayed acrylic and oil painting with appliqué, embroidery, and smocking. The needlework is the work of Jacquelyn Moore and Mary Ewanoski.

Keep the Ball Rolling
from Resolutions:
A Stitch in Time, *1999.*
Painting, petit point,
needlepoint, embroidery,
and appliqué, needlework
by Gerry Melot,
Jane Thompson,
Louise Otewalt, and
Pamella Nesbit;
22in x 28in
(56cm x 71cm).
Collection: The artists.
(far left)

Detail from
Keep the Ball Rolling
from Resolutions:
A Stitch in Time, *1999.*
(left)

When compared with the extreme rapidity with which many contemporary artworks are produced, the component parts of *Resolutions* impress by the almost superhuman degree of patience required to create them. *Live and Let Live* is a good example. The position of each minute bead is dictated first by the outline drawing Chicago made to guide the beadworker, Lisa Maue, then by a series of colored sketches. These sketches served as the basis for small trial pieces, and the actual position of each bead in the final work was determined with the use of a computer. The bead loom was arranged so that single threads could be taken out and revised if any detail seemed unsatisfactory. Though the complete piece

We're All in the Same Boat

from Resolutions:
A Stitch in Time, *1999.*
Painting, appliqué,
embroidery, and smocking,
needlework by Mary Ewanoski,
assisted by Jacquelyn Moore;
22in x 28in (56cm x 71cm).
Collection: The artists.
(full work, far right;
detail, right)

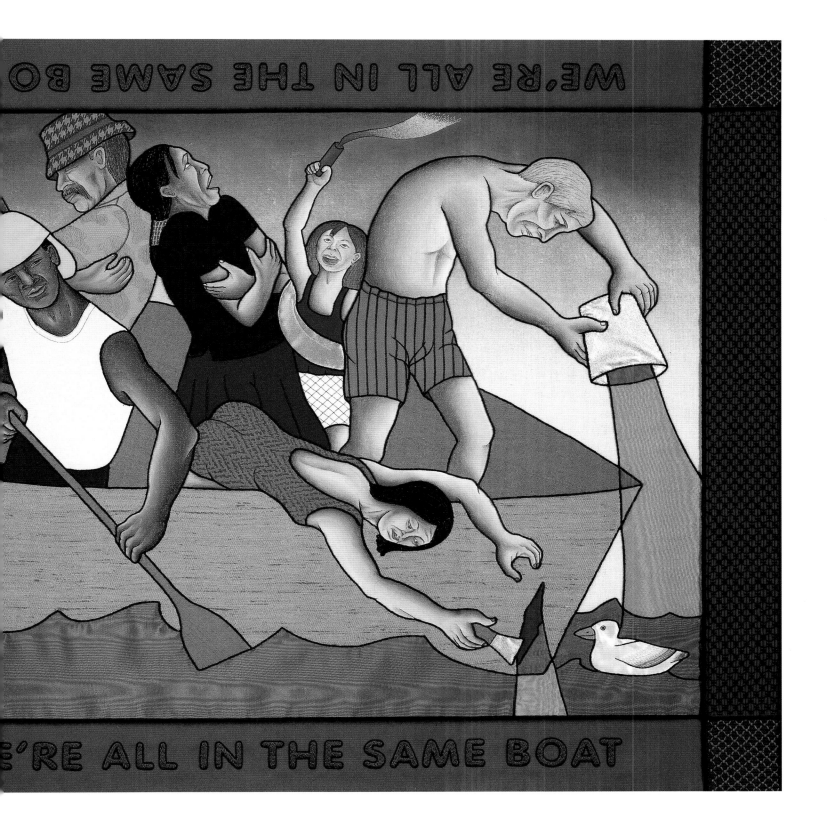

measures only 20in x 24in (51cm x 61cm), it is very large for a piece of fine beadwork. Making it required pretty much the amount of time a leading Renaissance painter would have devoted to a large fresco, prepared and painted with the help of several assistants.

The pieces in the *Resolutions* series sometimes make allusions to earlier North American art in the same moralistic vein. One immediately recognizable example is *A Chicken in Every Pot*, which borrows its main compositional elements from *American Gothic* (1930; Art Institute of Chicago) by Grant Wood (1892–1942).

The primary medium used for *A Chicken in Every Pot* is needlepoint, with details, such as elements of the facial features, added in embroidery. It is a three-way collaboration—Chicago's design and painting, needlepoint by Helen Eisenberg, embroidery by Jane Thompson and Mary Ewanoski, plus appliqué. It belongs to a series within a series—needlepoint pictures of identical size, all 24in x 18in (61cm x 46cm). Other examples are *An Apple a Day*, *Welcome with Open Arms*, *Bury the Hatchet*, *Two Heads Are Better than One,* and *Begin with a Clean Slate*. One constant theme throughout the series is ethnic diversity and the need for reconciliation between different cultures and races. The theme is most explicitly expressed in *Bury the Hatchet*. Chicago and her collaborators are unapologetic about the naiveté of the message—for them, this is part of the point, as is the enormous amount of labor that has gone into creating each needlepoint picture.

Each stitch can be regarded as the reiteration of a simple and self-evident truth. The sequence deals with the need for a global bill of rights, which guarantees food, medical care, housing, religious tolerance, equal opportunities, clean air, and clean water for everyone who occupies this tiny planet.

Live and Let Live
from Resolutions:
A Stitch in Time, *1999.*
Beading and needlework
by Lisa Maue;
20in x 24in (51cm x 61cm).
Collection: The artists.
(left)

A Chicken in Every Pot
from Resolutions:
A Stitch in Time, *1999.*
Painting, needlepoint, appliqué,
and embroidery, needlework by
Helen Eisenberg, assisted by
Jane Thompson, Mary Ewanoski,
and Pamella Nesbit; 24in x 18in
(61cm x 46cm). Collection: The
artists.(full work, above top;
detail, above bottom)

A Chicken In Every Pot

An Apple a Day
from Resolutions:
A Stitch in Time, *1999.*
Painting, needlepoint, appliqué, and
embroidery, needlework by Penny
Harris, assisted by Jane Thompson,
Mary Ewanoski, and Pamella Nesbit;
24in x 18in (61cm x 46cm).
Collection: The artists.
(near right)

Welcome with Open Arms
from Resolutions:
A Stitch in Time, *1999.*
Painting, needlepoint, appliqué, and
embroidery, needlework by Joyce
Gilbert, assisted by Jane Thompson
and Mary Ewanoski;
24in x 18in (61cm x 46cm).
Collection: The artists.
(far right)

Two Heads Are Better than One
from Resolutions:
A Stitch in Time, *1999.*
Painting, needlepoint, appliqué, and
embroidery, needlework by Betsy
Smullen, assisted by Jane Thompson
and Mary Ewanoski;
24in x 18in (61cm x 46cm).
Collection: The artists.
(below near right)

Begin with a Clean Slate
from Resolutions:
A Stitch in Time, *1999.*
Painting, needlepoint, appliqué, and
embroidery, needlework by Louise
Otewalt, assisted by Jane Thompson,
Mary Ewanoski, and Lynda Patterson;
24in x 18in (61cm x 46cm).
Collection: The artists.
(below far right)

Bury the Hatchet
from Resolutions:
A Stitch in Time, *1999.*
Painting, needlepoint, appliqué,
and embroidery, needlework by
Lynda Patterson, assisted by Jane
Thompson and Mary Ewanoski;
24in x 18in (61cm x 46cm).
Collection: The artists.
(facing page)

An Apple A Day

Welcome With Open Arms

Two Heads Are Better Than One

Begin With A Clean Slate

Bury The Hatchet

Resolutions returns to a larger scale with *Hitch Your Wagon to a Star*, which, like *Do a Good Turn*, is an extension of the North American quilt-making tradition. This stands at the beginning of the final two sections, which deal with hope and change.

Hitch Your Wagon to a Star, like *Get into the Swing of Things*, combines stitchwork and painting, as do *Now or Never* and *It's Always Darkest Before the Dawn*. It is interesting to see how the combination of the two works in each case. In *Hitch Your Wagon to a Star*, painting creates the central image in what would otherwise be an abstract traditional quilt design. In *Now or Never*, the design was developed from the patterns used in a commercial needlework kit of a kind used by thousands of stitchers all over the United States. This is supplemented and given meaning by painted designs showing arms clasping one another in friendship, which have been developed from the patterns of Celtic interlacement found in medieval manuscripts.

It's Always Darkest Before the Dawn is the only work in the *Resolutions* series in which painting is predominant. The divided composition—one half gray and mournful, the other bright and optimistic—can be compared not only with *Turn Over a New Leaf* but also with a number of works in the *Holocaust Project* in which this kind of division is used—albeit with a different psychological effect in the latter instance. The intervention of the embroiderer, Pamella Nesbit, is difficult to detect at first glance. It occurs chiefly in the bottom right-hand corner of the composition, and its nature and extent are most easily detected by looking at the back of the picture. The role of the stitchwork is crucial, however, since it adds those touches of brilliance and definition that give force to the optimistic message.

The final piece in *Resolutions* will be *Find It in Your Heart*, a sculpture made by a professional woodcarver from Judy Chicago's maquette. This, too, will be adorned with embroidery—a stitched heart, with a thread of Japanese goldwork springing from it that will wind down the body. Lettering in multiple languages emphasizes the universality of the values celebrated in the series.

In considering the implications of the *Resolutions* project and its place in Chicago's oeuvre, one has to take into account a number of things. The first is that it is the latest, but clearly by no means the last, product of a career that spans almost four decades. Throughout this period Judy Chicago has been a controversial figure, loved by some, excoriated by others. Probably no North

Hitch Your Wagon to a Star

in progress, from Resolutions: A Stitch in Time, *1999. Painting, appliqué, and embroidery, needlework by Jacquelyn Moore, assisted by Mary Ewanoski, Pat Rudy-Baese, and Jane Thompson; 4ft 6in x 4ft 6in (1.37m x 1.37m). Collection: The artists.* (right)

American artist of her generation and her international prominence has attracted such hostile reviews. On the other hand, her work and her career have provided hope and inspiration for women in many places—often women who had little contact with contemporary art until they encountered her work.

It is worth quoting two paragraphs from the biographical statement submitted by Alise Anima, the embroiderer who collaborated with Judy Chicago on *Now or Never*. Anima is 66 years old and has done needlework all her life. She lives in the small, remote New Mexico town of Truth or Consequences:

"Although I have done many types of needlework, after seeing some of the other work in the [*Resolutions*] project, I was anxious and somewhat intimidated... I had to convince myself that I could do such good work... I feel that God chose me to do the piece *Now Or Never* because I know in my heart that in order to survive on this planet... we must heal our wounds and overcome our hatreds now, which is what Judy's design expresses."
ANIMA, 1999

In her statement, Anima says,

"It's taken me a lifetime of struggle to be who I am, not who others thought I should be."
ANIMA, 1999

Get into the Swing of Things
from Resolutions:
A Stitch in Time, *1999.*
Painting and embroidery,
needlework by Candis
Duncan Pomykala;
14in x 20in (36cm x 51cm).
Collection: The artists.
(above left)

Before the dawn

**It's Always Darkest
Before the Dawn**
from Resolutions:
A Stitch in Time, *1999.*
Painting and embroidery,

needlework by Pamella Nesbit;
24in x 40in (61cm x 102cm).
Collection: The artists.
(above)

Now or Never

from Resolutions: A Stitch in Time, *1999.*

Painting, needlepoint, appliqué, and embroidery, needlework by Alise Anima, assisted by Jane Thompson, Mary Ewanoski, Jacquelyn Moore, Pat Rudy-Baese, and Pamella Nesbit; 24in x 24in (61cm x 61cm). Collection: The artists.

(right)

One-third scale clay maquette for

Find It in Your Heart

from Resolutions: A Stitch in Time, *1999.*

Woodcarving, embroidery, and Japanese gold embroidery, assistance by Tamara Norrgard, embroidery by Paula Daves, Japanese gold embroidery by Lynda Patterson; 5ft 7in (1.7m) high. Collection: The artist.

(right)

Judy Chicago can say the same thing. This book stands as a testimony to her energy, industry, and determination to produce art, whatever the immediate discouragements. The impressive thing is not simply the length of her career, nor the enormous amount of work produced, but also the long trajectory of personal development. She has never been content to produce what was expected of her. She has also never been afraid to venture into the most difficult territory—witness her explorations of female sexuality and her involvement with the Holocaust.

From a sociological point of view, one of the interesting aspects of her career has been that it has largely been made outside the framework of the New York art world. Only two of her major enterprises, *Powerplay* and *Resolutions*, have premiered in New York. However, her major exhibitions regularly attract enormous attendances whenever they are shown. Both *The Dinner Party* and the *Holocaust Project* have displayed enormous vitality, with multiple showings over a long time.

Contributing to this vitality is the fact that Chicago is a gifted author as well as an artist. Her two autobiographies, *Through the Flower* and *Beyond the Flower*, are classics of modern feminist literature—they deserve comparison, as I have suggested earlier, with the *Confessions* of Jean-Jacques Rousseau and are just as readable and revealing. With the new globalization of contemporary art, she stands now on the brink of a further expansion of the possibilities open to her. In recent years, the number of US artists who are internationally known has tended to diminish rather than increase. This is due not to a decline in North American art itself but to the breakdown of the old hierarchical structures, which sustained the world of 20th-century art. It is no longer assumed that innovation can come from only one place—Paris at one moment, New York at another. Because her audience now stretches well beyond the boundaries of the art world, Chicago has not had to struggle with this change as much as many of her contemporaries. She retains an international celebrity status that is unique to herself. It will be interesting to see what use she makes of the opportunities now open to her. Whatever she does will undoubtedly be a reflection of her particular brand of idealism that is the product of a uniquely North American vision.

Index

Bibliography and Acknowledgments

From the Author

Grateful thanks are due to Donald Woodman who did most of the photography for this book and in addition answered endless questions, particularly about photography and its role in the *Holocaust Project*. Later, he read my draft manuscript, making valuable corrections and suggestions. Thanks also to Allison Alterman for so efficiently organizing the illustration material, and to Audrey Cowan, who was kind enough to fly from California to New Mexico in order to be interviewed about her long friendship with the artist and about the projects they have carried out together. Last but certainly not least I must thank Judy Chicago herself. She offered me the hospitality of her home and studio, and she too submitted patiently to extensive questioning. She never tried to interfere with questions of critical judgement, and threw open to me both the large reserves of work, much of it previously unpublished, still in her own posession, and the rich archives of the not-for-profit corporation Through the Flower. Few contemporary artists can have kept such careful records. My book is based on this rich store of material. EDWARD LUCIE-SMITH

Picture credits

All photographs by Donald Woodman except for the following:
—from the Through the Flower Archives: pps12–13, p17TL, p17BR, p18TL, p19, p20TL, p20BL, p21TR, p21BR, p22TL, pps22–23, p24, pps26–27, p28TL, p29TL, p29ML, p29BL, p29TR, p29BR, p30T, p30B, p31T, p31B, p32, p33, p34, p35TR, p35TL, p36, p38, p39T, p39B, p40TL, p40TR, p40BR, p41, pps42–43, pps44–45, pps46–47, p46BR, p48, p49T, p50T, p50B, p51, p52T, p52B, p53, p54, p55T, p55B, p56B, pps56–57, p56TR, pps58–59, p63TM, p67, p69TL, p69TR, p70BL, p72TL, p72BR, pps72–73, p76TL, p76BL, p77TR, p77BR, p78B, pps84–85, p87, p90–91, p92 second from bottom, p92 second from top, p92BM, pps92–93T, pps92–93B, p95, p96, p97TR, p97BR, p98BL, p98MR, p98TR, p99B, p99T, p126, pps140–141, p143BR, p144TL, p144BL, p145T
—from other sources: p8, Frederic Edwin Church: AKG, London. p10, Thomas Hart Benton: New Britain Museum of American Art, Connecticut; Harriet Russell Stanley Fund. p18, Arshile Gorky: The Museum of Modern Art, New York; Purchase Fund and gift of Mr and Mrs Wolfgang S. Schwabacher (by exchange); photograph © 2000 The Museum of Modern Art, New York; © ADAGP and DACS, London 1999. p19, Billy Al Bengston: photo © Billy Al Bengston, Venice, California. p34, Faith Wilding: photo © Judy Chicago and Faith Wilding. p44, Andrea Mantegna: Bridgeman Art Library, London/Louvre, Paris, France. p46, Georgia O'Keeffe: The Metropolitan Museum of Art, New York; Alfred Stieglitz Collection, 1969; photograph by Malcolm Varon; © ARS, NY and DACS, London 1999. p60, Leonardo da Vinci: Bridgeman Art Library, London/Santa Maria delle Grazie, Milan, Italy. p74, *The Hunt of the Unicorn*: The Metropolitan Museum of Art, New York; gift of John D. Rockefeller, Jr; The Cloisters Collection, 1937; photograph © 1993 The Metropolitan Museum of Art. p82, *Louis XIV's Visit to the Gobelin Factory*: Agence photographique de la réunion des musées nationaux, Paris, photo © RMN. p90, François Boucher: Bridgeman Art Library, London/Louvre, Paris, France. p102, Andrea Mantegna: Bridgeman Art Library, London/Pinacoteca di Brera, Milan, Italy. p110, Michelangelo Buonarroti: AKG, London. p120, Jacques Callot: AKG, London. p121, Francisco Goya: Bridgeman Art Library, London/private collection. p142, Samuel Palmer: Bridgeman Art Library, London/Fitzwilliam Museum, University of Cambridge, UK. p160, Paul Cézanne: Bridgeman Art Library, London/Hermitage Museum, St. Petersburg, Russia.

Bibliography

Printed sources

Brenson, Michael, "Why Segal Is Doing Holocaust Memorial" in *New York Times*, 1983, April 8

Butterfield, Jan, *Judy Chicago: The Second Decade* (exhibition catalog), ACA Galleries, New York, 1984

Chicago, Judy, *Through the Flower*, New York: Penguin Books, 1975
—*The Dinner Party*, Garden City, NY: Anchor Books, 1979
—*Embroidering Our Heritage: The Dinner Party Needlework*, Garden City, NY: Anchor Books, 1980
—*Birth Project*, Garden City, NY: Doubleday & Co. Inc., 1986
—*Holocaust Project: From Darkness into Light*, New York: Penguin Books, 1993
—*Beyond the Flower: The Autobiography of a Feminist Artist*, New York: Penguin Books, 1996

Game, Mike, ed., *Baudrillard Live: Selected Interviews*, London: Routledge, 1993

Feinstein, Stephen C., *Witness and Legacy: Contemporary Art about The Holocaust*, Minneapolis: Lerner Publications Company, 1995

Harper, Paula, *Powerplay*, catalog of an exhibition held at the ACA Galleries, New York, October–November 1986

Hughes, Robert, "An Obsessive Feminist Pantheon: Judy Chicago's 'Dinner Party' Turns History into Agitprop" in *Time*, 1980, December 15

Jones, Amelia, ed., *Sexual Politics: Judy Chicago's "Dinner Party" in Feminist Art History*, UCLA at the Armand Hammer Museum of Art and Cultural Center, in association with the University of California Press, Berkeley, Los Angeles and London, 1996

Knight, Christopher, "More Famine than Feast" in *Los Angeles Times*, 1996, May 2

Kramer, Hilton, "Judy Chicago's 'Dinner Party' Opens at the Brooklyn Museum" in *New York Times*, 1980, October 17

Kuperstein, Isaiah, *The Holocaust Project: From Darkness into Light—Description and Concepts*, 1991, May 21 [copy in Through the Flower archives]

Lippard, Lucy R., "Uninvited Guests: How Washington Lost 'The Dinner Party'" in *Art in America*, 1991, December

Muchnic, Suzanne, "An Intellectual Famine at Judy Chicago's Feast" in *Los Angeles Times*, 1979, April 15

Newhall, Beaumont, ed., *Photography: Essays and Images*, New York: Museum of Modern Art, 1980

Sandler, Irving, *Art of the Postmodern Era*, New York: Icon Editions, 1996

Spiegelman, Art, *Maus II*, New York: Pantheon Books, 1991

Thompson Wylder, Viki D., Catalog note in *Judy Chicago: Trials and Tributes*, Tallahassee: Florida State University Museum of Fine Arts, 1999

Other sources

Conversation with Judy Chicago, 1997

Judy Chicago, descriptive statements, Through the Flower Archives, various dates

Anima, Alise, letter, Through the Flower Archives, 1999, January

Interviews with Judy Chicago, 1999, January and May

Interview with Audrey Cowan, 1999, January

Interview with Donald Woodman, 1999, May

From Darkness into Light: The Creation of the Holocaust Project (video, 1993; edited by Kate Amend)

Holocaust Project (audio guide, 1993; from the exhibition)

"Revelations of the Goddess," 1975, unpublished typescript manuscript, Through the Flower Archives